As Good as it Got
The 1944 St. Louis Browns

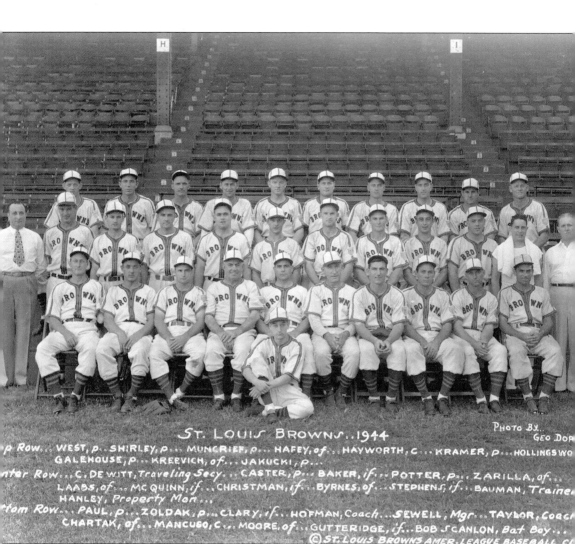

TEAM PHOTO. The 1944 St. Louis Browns. (SM)

for Laben and Kieran
you will always be my champions

As Good as it Got

The 1944 St. Louis Browns

David Alan Heller

ARCADIA
PUBLISHING

Copyright © 2003 by David Alan Heller
ISBN 978-0-7385-3199-1

Published by Arcadia Publishing
Charleston, South Carolina

Printed in the United States of America

Library of Congress Catalog Card Number: 2007276413

For all general information contact Arcadia Publishing at:
Telephone 843-853-2070
Fax 843-853-0044
E-mail sales@arcadiapublishing.com
For customer service and orders:
Toll-Free 1-888-313-2665

Visit us on the Internet at www.arcadiapublishing.com

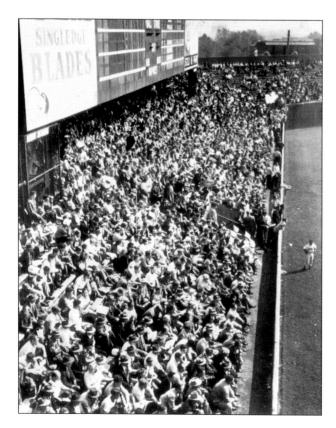

BLEACHERS. A rare site at a Browns' game at Sportsman's Park–the bleachers are full in anticipation of the first all–St. Louis World Series. (SM)

Contents

Preface		6
Introduction and Acknowledgments		7
1.	A Brief History of the Browns	9
2.	Warmups: Building a Champion and the All 4-F Infield	13
3.	First Inning: Going to Camp and the First Look at the Cardinals	19
4.	Second Inning: Anatomy of a Winning Streak	25
5.	Third Inning: Losing Faith and Losing First Place	35
6.	Fourth Inning: Falling Popups, the Falling Axis and Why the Potter Family Grew by One	47
7.	Fifth Inning: A Hot Scrabeenie and the Unhappy Brown	67
8.	Sixth Inning: If We Ever Win One, We'll Clinch It	75
9.	Seventh Inning: Fighting for a Pennant	87
10.	Eighth Inning: One Last Game	101
11.	Ninth Inning: The Series	109
12.	Extra Innings: Gray Times and No More Next Years	125
Appendix: Statistics		128

Preface

When casual baseball fans think of the St. Louis Browns, unfortunately the two images that most likely pop into their minds are those of Eddie Gaedel and Pete Gray—two baseball players whose minuscule moments in the sun overshadow the franchise's 52-year history.

But the Browns were more than Gaedel, a 3-foot-7 midget who was inserted as a pinch-hitter in 1951 by then-owner Bill Veeck (the P.T. Barnum of the baseball world) and Gray, a one-armed outfielder brought up to the bigs in 1945 who nearly single-handedly (no pun intended) cost St. Louis the pennant.

The St. Louis Browns competed, and that term is used loosely, in the American League from 1902 to 1953. The Browns had some good players, most notably Hall of Famer George Sisler, arguably the greatest all-around first baseman of all-time. However, the team's history is more about defeats than accomplishments. In short, with all due respect to the Washington Senators who are often thought of as the game's biggest losers, the Browns were the worst franchise ever to grace the fields of Major League Baseball.

The Senators had a memorable slogan, "first in war, first in peace and last in the American League," which was much catchier than the Browns saying, "first in shoes, first in booze and last in the American League." Despite the parlance, the Senators (Washington actually was known as the Nationals from 1901-56 but still referred to as Senators) did go to three World Series, winning in 1924 and losing in 1925 and 1933.

When Washington won the World Series in 1924, they were the seventh of the eight charter American League teams to have won the world championship in the 23-year existence of the league. Only the Browns remained. Not only had the Browns not yet won a World Series, but they also had never even finished in first place.

In 52 years, St. Louis finished in the top division—meaning in at least fourth place—just 12 times. They finished in dead last 11 times and ended up more than 40 games behind the league frontrunner on 17 occasions. The Browns hold the worst winning percentage of any franchise in baseball history at .433 (the original Senators, who played in Washington from 1901-1960 before moving to Minnesota, are at .465).

Mixed in with all the defeats, though, were moments of excitement. None more so than the thrill that occurred when the Browns made their first and only appearance in the Fall Classic. The year was 1944. It just happened to be during World War II, when the quality of talent in the game was diluted as ballplayers were drafted into the armed forces.

Thus the season in which the Browns achieved their greatest success will be forever tainted, whether that label is justly deserved or not. Regardless, it was a year that featured records broken, players suspended, bench-clearing brawls, quite possibly the best pennant race of the decade and some of the most interesting characters ever to play Major League Baseball.

What follows is an account of how the Browns proved in the end that they were not just a fluke of circumstance—instead finally emerging the conquering hero.

Introduction and Acknowledgements

Why the St. Louis Browns? Well, I grew up a Baltimore Orioles fan and with my taste for baseball history discovered at an early age the Browns were the forerunner to the Orioles.

I immediately found myself a Browns fan as well, always defending the team and trying to include George Sisler into any discussion involving all-time great first basemen.

I found it funny that the 1944 Browns were always looked down upon, like they were some sort of freak team because they won during a war season, while the 1945 Chicago Cubs, the last time that franchise went to the World Series, were looked at with glory. I guess that's because the Cubs have a different place in the hearts of baseball fans.

Later in life, I thought, hey, the St. Louis Cardinals, New York Yankees and Detroit Tigers—all teams that won World Series titles during war years—don't hang their championship flags any lower or treat those winners with any less respect. That got me wondering what the '44 Browns were like; maybe I could champion their cause.

I'm not going to make any great claims and compare the Browns to the '27 Yankees or any other powerhouse team from baseball's past, and I'm not going to say that the talent in 1944 was greater than before or after the war, but I did discover that this was a legitimate pennant winner, just like the Cardinals in '42, '43 and '44, the Yankees in '42 and '43, and the Tigers and Cubs in '45. Only a scant portion of the players on the '44 Browns played exclusively during the war years and just one of those, Sig Jakucki, had any real impact with the club. Many of them even had a part on later pennant winners.

As it turns out, Jakucki was perhaps the biggest character on a team of characters. His story is interesting, as are those for a number of players on the club. In turn, so is the story of the 1944 pennant chase of the Browns—a truly thrilling race, an interesting story. I found it to be. I hope you do, too.

I would like to thank the following for helping make this book come to fruition:

Mike Bass and John Erardi for all their advice.

The Baseball Hall of Fame Library for their invaluable assistance and use of their archives.

The Cincinnati Public Library and its lending libraries.

Ms. Judy Anderson, Floyd Baker, Ellis Clary, Bill DeWitt, Hal Epps, Mrs. George Fallon, Denny Galehouse, Don Gutteridge, Tom Hafey, Myron "Red" Hayworth, John Hopp, George Kurowski, Max Lanier, Danny Litwhiler, Marty Marion, Boris "Babe" Martin and Jimmy Outlaw for their correspondence (and Jack Smalling's great address book for enabling me to find them all).

Josh Stevens of the Missouri Historical Society for pointing me in the right direction.

Jeff Reutsche of Arcadia Publishing for his continued persistence in getting this manuscript published.

My grandfathers and my brother, Steve, for instilling in me a love of baseball at a very young age.

My mom, Elaine Lyon, and dad, Mel Heller, not only for their help and support with this project but also for everything they've done for me.

And of course, my wife, Shelly. Without her constant encouragement and support I never would have started, continued or finished this book, nor would you be holding it in your hands reading this.

Key to photo credits:
SM—Stephen Milman Collection (or provided by Stephen Milman)
NBH—National Baseball Hall of Fame Library
AC—Author's collection

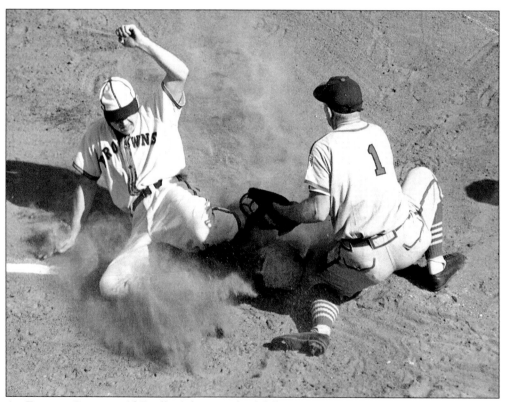

AL ZARILLA SLIDING. Al Zarilla slides into third following the Browns' fifth consecutive single in the third inning of Game Three. Zarilla would then score on a wild pitch. (SM)

One

Introductions
A Brief History of the Browns

American League President Ban Johnson wanted his new league, established in 1901, to be immediately considered a major league and to be on par with, if not better than, the 25-year-old National League. And what better way to do battle with the opposition than to place teams in cities that already housed National League clubs?

After the American League's inaugural campaign, Johnson mandated that Milwaukee Brewers owner Matt Killea move his franchise to St. Louis, which housed the National League's Cardinals. St. Louis, at that point the fourth most populous city in the United States, became the fourth metropolis to have a team in each league, joining Chicago, Boston and Philadelphia. New York, which already had two NL teams, entered the interleague war in 1903.

The new St. Louis club quickly tried to align itself with fans by raiding the rival Cardinals and signing a number of their players, including future Hall of Famers Bobby Wallace, a slick fielding shortstop, and outfielder Jesse Burkett, who led the NL with a .382 batting average in 1901. The American League team also robbed the Cardinals of three of their four pitchers, most notably Jack Powell, who would win 22 games in his first season with the new club.

Players weren't the only thing the new St. Louis team stole to try and gain followers. They chose the nickname "Browns" purposely. It was the moniker of the St. Louis club that won American Association titles from 1885 to 1889, and later adapted by the National League team formed in 1892 after the former league was dissolved. The "Browns" nickname was left open after the National League team abandoned it in 1899 in favor of "Perfectos," which was ultimately changed to "Cardinals" in 1900.

Due to the transfer of so many key players, the Cardinals, who had finished 76-64 in 1901, slipped to 56-78 in 1902 and 43-94 in 1903. The Milwaukee Brewers had occupied the American League cellar in 1901, winning merely 48 times in 137 games. But with the infusion of 12 new team members, ten of whom played in the National League the previous season (including seven from the Cardinals) the Browns claimed 78 victories in their initial season in St. Louis—good enough for second place.

This was not the first time the "Mound City" had two ball clubs, but the coexistence of more than one team had never worked, the weaker organization always coming to its inevitable demise. In 1875 the city had two entries in the National Association (the predecessor to the National League), the Brown Stockings and Red Stockings, the latter of which played only 18 games. In 1884, St. Louis had both the American Association Browns and the Saints of the newly formed Union League. Each team finished in first, but the Saints and the rest of the Union League folded after that season.

The National League unsuccessfully tried to take away the American Association's (and thus the original Browns') stranglehold on St. Louis with the "Maroons" in 1885, but they moved to Indianapolis following the 1886 season.

Challenging the Cardinals in 1902 must have seemed a good idea at the time for the American League; after all, despite decent finishes from 1899 to 1901 the Browns/ Perfectos/

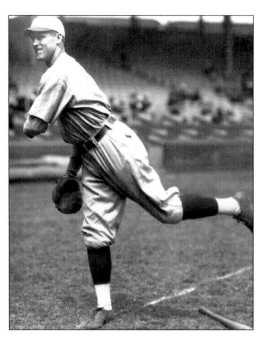

GEORGE SISLER. Sisler, arguably the greatest all-around first baseman, was inducted into the Hall of Fame in 1939. (SM)

Cardinals were consistently at the bottom of the league standings since entering the National League in 1892 (they had a 29-102 record in 1896!).

However, neither the new American League team nor the established National League club could grab hold of the fan base. After the Browns' second-place finish in 1902, neither club ended up in the top division until 1908, when both teams placed fourth in their respective leagues.

The early American League Browns were headed by slugger George Stone, the first Brown to lead the league in any offensive statistical category. Stone led the American League in hits (187) in 1905 then topped the major leagues in batting average (.358) and slugging percentage (.501) the following year. But after hitting .320 in 1907, Stone's production declined and he was out of baseball after batting .256 in 1910.

The Browns as a whole were on the decline as well. They lost 100 games in three successive seasons starting in 1910 and fell 97 times in 1913. It took an equally putrid New York squad in 1912 to deny the Browns the not-so-prestigious distinction of finishing in last four straight years.

Things got a little brighter for the Browns with the addition of a converted pitcher-turned-first baseman named George Sisler. After playing in 81 games as a 22-year-old in 1915, Sisler hit .305 in 1916, the first of ten times he eclipsed the .300 mark as a Brown. Sisler possessed a combination of a great batting eye, power, speed and impeccable fielding ability.

Sisler hit .407 in 1920, 19 points higher than AL runner-up Tris Speaker and 37 points better than NL batting champion Rogers Hornsby. His 257 hits that year is still a major league single-season record.

Sisler topped the .400 mark again in 1922 on what probably was the best Browns team that was ever fielded. Sisler finished at .420, tied for the third-highest average in the 20th Century, led the league with 246 hits, 18 triples, 134 runs scored, and 51 stolen bases while also driving in 105 runs. It would be the only times a Brown led the league in either triples or runs and the last time one captured a batting crown. But Sisler wasn't a one-man gang. Left fielder Ken Williams became the first player in major league history to club 30 home runs and steal 30 bases in the same season—a feat that wasn't duplicated until Willie Mays turned the trick in 1956. Williams batted .332 with a league-leading 39 homers and 139 RBI while swiping 37 bases, second in the AL only to Sisler.

The Browns outdid any team in either league in 1922 with a .313 average, thanks also in part to second baseman Marty McManus (.312, 11 HR, 109 RBI), right fielder Jim Tobin (.331, 13 HR, 122 runs), center fielder Baby Doll Jacobson (.317, 102 RBI) and catcher Hank Severeid (.321). The pitching staff wasn't shabby either, posting a major-league best 3.38 earned run average. The ace was Urban Shocker, who had a 24-17 record with a 2.97 ERA and major league high 149 strikeouts. Along with Shocker, Elam Vangilder (19-13), Ray Kolp (14-4), Dixie Davis (11-6), Rasty Wright (9-7, 5 saves, 2.92 ERA) and Hub Pruett (7-7, 7 saves, 2.33 ERA) rounded out a fine staff.

The Browns won 93 games, the only time in franchise history they topped the 90-win plateau, yet still finished in second place one game behind the New York Yankees. St. Louis rested atop

the American League for 69 days during the season, but the Yankees finally overtook them on September 8th. The Browns had a good chance to regain the top spot, but lost two of three games to New York in a late September series. The Browns lost the third game of the series when the Yankees scored once in the eighth and twice in the ninth to win 3-2. Browns fans were none too pleased when the Boston Red Sox sent a rookie, Alex Ferguson, out against the Yankees on the second-to-last day of the season. He proceeded to give up seven runs in one inning to New York while veteran Herb Pennock, who relieved but was available to start, allowed just one hit over the next eight innings. The Yankees win clinched the pennant for New York. The people of St. Louis did come out to see the club, though, as the Browns drew 712,918 fans, a franchise record, nearly 100,000 more than the previous high set in 1908.

In 1923, Sisler suffered from poisonous sinusitis and missed the entire season. He came back in 1924, but was never the same. Sisler exceeded the .300 mark six more times, including his final three years which were spent with the National League's Boston Braves, but never for the record-setting numbers that he tallied prior to falling ill. Over half-a-million fans turned out to see Sisler's return and a Browns fourth place finish, 533,349 to be exact, a figure that would never be topped again. Sisler's induction into the Hall of Fame in 1939 might be the only good thing that happened to the Browns in the 1930s. They seemed to have a knack for accumulating losses and trading away good players in that decade.

On June 13, 1930, St. Louis dealt outfielder Heinie Manush, who hit .378 in 1928 and .355 in 1929 for the Browns, and pitcher General Crowder, who holds the distinction of being the only Brown to lead the league in winning percentage when he had a 21-5 record in 1926, to Washington in exchange for outfielder Goose Goslin. Goslin was subsequently dealt back to Washington (with two other players) prior to the 1933 season for three players and, perhaps most importantly, $20,000. Manush, Goslin and Crowder all played for the Washington Senators 1933 American League champions, while Goslin moved onto the 1934 World Champion Detroit Tigers. Crowder won 68 games in three years for the Senators. Manush was elected to the Hall of Fame in 1964; Goslin in 1968. Such personnel moves, plus a low cash flow, kept the Browns in the bottom division for the entire decade. They lost 90 or more games eight times in the '30s. For the decade the Browns on average lost 95.1 games a year and finished 44.1 games behind the league winner. Very few people wished to view such pitiful performances. The highest yearly attendance in the decade was 179,126. In 1933, only 88,113 fans showed up to Browns games. On one occasion that season just 34 people attended a home game. The attendance woes would plummet to 80,922 in 1935.

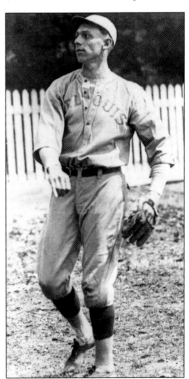

Worse yet was the emergence of the Cardinals as a baseball powerhouse. The National League franchise went to the World Series three times in the first five years of the decade, winning twice. With their winning ways coupled with a newly formed radio network, the Cardinals not only expanded their fan base and took in the few dollars that were being spent on baseball during the depression era, but they also established lifetime loyalists.

The Browns reached their nadir in 1939, losing a franchise record 111 games and finishing an amazing 64.5 games out of first place. The team's pitching was so bad that

KEN WILLIAMS. In 1922, Ken Williams hit 39 homers and stole 37 bases to become the inaugural member of baseball's 30-30 club. (SM)

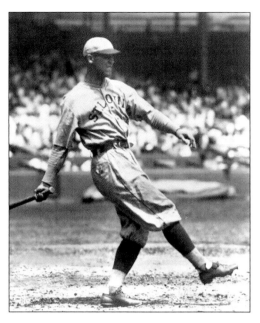

GEORGE SISLER. George Sisler's mark of 257 hits in 1920 still stands as the major league record. Sisler hit .407 that season, one of the two times he eclipsed .400 in his career. (SM)

their 739 walks allowed was over 100 more than the next worst team in either league. Browns hurlers also posted a woeful 6.01 ERA. No major league team would again eclipse the six earned runs a game mark until the 1996 Detroit Tigers, over half a century later, were tagged for a 6.38 ERA.

A syndicate led by Don Barnes and Bill DeWitt bought the Browns for just over $325,000 from the estate of former owner Phil Ball in 1935. They tried to field a winner, of course, but lack of funds didn't permit it. If it wasn't obvious in prior years, 1941 shed some light on the fact that St. Louis couldn't support two teams. The Cardinals drew over 600,000 fans, the Browns barely over 175,000.

The Browns owners thought they had finally caught a break, though, when they made a deal with Los Angeles to become baseball's first West Coast team. The L.A. Chamber of Commerce guaranteed an attendance of 500,000 per year, a figure the Browns hadn't seen since 1924. The Browns would play in the stadium used by the Pacific Coast League's Los Angeles Angels, which the team would buy along with other holdings. The major league owners were expected to approve the move—which would be a tremendous financial boon for the struggling franchise—at the annual winter meetings.

However, the day before the meetings were to begin the Japanese bombed Pearl Harbor. California remained closed to Major League Baseball, the Browns stayed in St. Louis, and the United States was about to enter World War II.

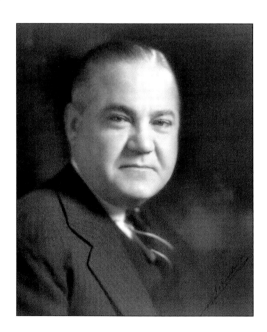

DON BARNES. Don Barnes bought the Browns in 1935. He had plans set to move the club to Los Angeles right before the U.S. got involved in World War II. (NBH)

Two

Warmups
Building a Champion and the All 4-F Infield

The rise of the Browns can actually be traced back nearly six months prior to the Pearl Harbor raid, on June 5th to be precise. On that date, just three days after Lou Gehrig succumbed to the disease that now bears his name, Luke Sewell was named manager of the St. Louis Browns. At the time, Sewell, who was coaching for Cleveland, wasn't even sure if he should take the job. After all, the Browns were often referred to as the "graveyard of managers." The title was not without merit. Of the seven managers that preceded Sewell dating back to 1930, five never managed in the major leagues again while the other two had prolonged intervals until their next big league head coaching job.

Bill Killefer, Alan Sothoron, Jim Bottomley, Gabby Street and Oscar Melillo all had the Browns managing post be their last in the major leagues. Street had managed the St. Louis Cardinals to back-to-back World Series appearances in 1930-31, but apparently fell out of favor after overseeing the Browns for just 143 games in 1938.

Rogers Hornsby held the reins from 1933 until shortly into the 1937 season. He wouldn't return to the majors until 1952 when he was hired by, ironically, the Browns, who canned him after 51 games following his rehiring.

Fred Haney led the team from 1939 up until being replaced by Sewell. He managed again, but not for another 12 years after his dismissal. It's no wonder that people considered Sewell's acceptance of the Browns managerial post as a "suicide job."

James Luther Sewell was born January 5, 1901 in Titus, Alabama. He and his older brother Joe, who ended up playing 14 years in the majors and was elected to the Hall of Fame, attended the same one-room red schoolhouse. One of his early teachers gave him the nickname "Luke," which stuck with him for the rest of his life.

Luke displayed a higher than average intelligence at an early age. By the time most of his peers had even started to attend kindergarten, Luke had already learned how to write. He advanced through school so rapidly that he graduated from Wetumpka High School in the same graduating class as Joe, who was three years his senior.

Luke, who was just 15 years old, went off with Joe to the University of Alabama, both with the intent of playing baseball. Joe started playing immediately while Luke didn't earn his first baseball letter until he was a junior. Luke was initially a second baseman and outfielder, but his coach, Ken Scott, moved him to catcher after the player had suffered a sprained ankle.

Luke had played some semi-pro baseball while in college, but after getting his degree in 1921 he moved onto the professional ranks. After playing 17 games with a minor league team in Columbus, Ohio, Luke joined his brother on the defending World Champion Cleveland Indians.

Unlike his brother, Luke Sewell wasn't known for his hitting. In 20 major league seasons he hit a modest .259 and swatted just 20 career home runs. He was known for defense and for calling a good game. In 1926, Sewell's first year as a full-time player, the Indians staff earned run average went from 4.49 the previous season to 3.40 as Cleveland climbed from seventh place to second. After acquiring Sewell from Cleveland prior to the 1933 season, the Washington Senators saw their earned run average dip nearly 30 points from the previous year. By no small

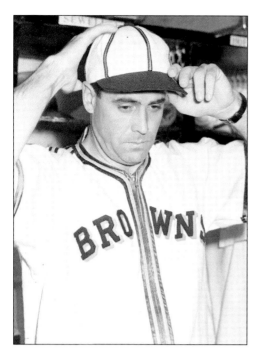

LUKE SEWELL. Luke Sewell donned the cap as St. Louis Browns manager June 5, 1941 and quickly put his stamp on the ballclub. (SM)

coincidence, the Senators won the American League pennant in 1933. He repeated his first-year wonders in Chicago, where the White Sox pitching staff, which had posted a major league worst 5.41 ERA in 1935, improved to a more reasonable 4.38 in Sewell's initial season in the Windy City.

Sewell also caught three no-hitters in his career: Wes Ferrell's in 1931, Vern Kennedy's in 1935, and Bill Dietrich's in 1937. He was sold to Brooklyn in December of 1938, but never played a game for the Dodgers. He eventually signed back with the Indians, but mainly to be integrated in as a coach. Sewell played in only 16 games in the '39 season, managing just three hits in 20 at-bats.

Sewell's impact as manager on the Browns was immediate. With Haney in charge, the club had won just 43 games in 1939, 67 in 1940, and was off to a 15-29 record before Sewell's arrival in 1941. Under Sewell, the team finished the season at a .500 clip (55-55), despite losing outfielder Rip Radcliff, who batted .342 in 1940 when he tied for the AL lead in hits. Radcliff was sold to Detroit for $25,000 in May. Only three of the teams in the American League finished at .500 or above that season, so the club's record under Sewell was impressive indeed.

After that first season, it was Sewell's desire to mold a team of winners. Sewell discovered that Browns players had developed a defeatist attitude after so many years of ineptitude.

But would there be a team to manage in 1942? With armed forces inductions through the draft expected to rob baseball of many players, there was some question as to whether the game should continue or be halted for the duration of the war. In all, of the 12 million men drafted during World War II, about 500 players were plucked from the major leagues and another 3,500 from the minors. With only 16 major league teams, each with 25 players, a manpower shortage was a realistic concern.

It was the major league owners who had the final say along with baseball commissioner Judge Kenesaw Mountain Landis, but they received a boost from the President of the United States. Franklin D. Roosevelt issued his famous "green light" letter January 15, 1942. He wrote:

"I honestly feel that it would be best for the country to keep baseball going. There will be fewer people unemployed and everybody will work longer hours and harder than ever before. And that means that they ought to have a chance for recreation and for taking their minds off their work even more than before. Baseball provides a recreation which does not last over two hours or two hours and a half, and which can be extended because it gives an opportunity to the day shift to see a game occasionally."

With baseball given the go-ahead, Sewell made his first moves by bringing in former Cardinal third baseman Don Gutteridge in 1942 and moving him to second base alongside 22-year-old shortstop Vern Stephens, a legitimate prospect called up from the minors.

Second baseman Don Heffner, who played 110 games in 1941, appeared in just 19 games for Sewell in '42, and after hitting just .121 in 18 games was sold in June of 1943 to the Philadelphia Athletics. Third baseman Harlond Clift had been with the Browns since 1934. He had experienced a decade of losing, a major factor in him being dealt away in August of 1943

along with 40-year-old hurler Johnny Niggeling to Washington. The pair was traded for backup infielder Ellis Clary, seldom-used reliever Ox Miller and cash.

Roy Cullenbine epitomized the type of Browns player Sewell didn't want around. Cullenbine hit .317 in 1941, but Sewell considered him a lazy hitter who wasn't aggressive enough at the plate, evidenced by the outfielder's 121 walks. Bill DeWitt once said of Cullenbine, "Cullenbine wouldn't swing the bat. Sewell would give him the hit sign and he'd take it, trying to get the base on balls. Laziest human being you ever saw." So on June 7, 1942, Sewell shipped Cullenbine and ineffective reliever Bill Trotter to Washington for power hitting Mike Chartak, a backup outfielder-first baseman, and pitcher Steve Sundra, who took the place of Bob Harris in the starting rotation. Harris hadn't posted an ERA lower than 4.93 in his first four seasons and had been dealt six days earlier along with catcher Bob Swift to the A's for catcher Frankie "Blimp" Hayes.

Hayes, however, didn't want to be in St. Louis, and it showed. The catcher batted an anemic .188 with only five homers in 1943. He was shipped away February 17, 1944 to the Athletics for minor league pitcher Sam Zoldak and outfielder Barney Lutz, plus "a moderate amount of cash." The team's other catcher, Rick Ferrell, also was dealt. Ferrell was sent packing to Washington on March 1, 1944 for cash and a former Browns farmhand, catcher Angelo "Tony" Giuliani, who later refused to report.

Some changes Sewell had no control over. With America's involvement in World War II, the country needed able bodies and baseball players weren't immune to being drafted into the armed services. The Browns didn't lose household names like Joe DiMaggio, Hank Greenberg, Ted Williams or Bob Feller to the war effort, but St. Louis did have some quality, if unheralded, players drafted.

The most notable player called to duty was outfielder Walt Judnich. As a 23-year-old rookie in 1940, Judnich hit .303 with 24 home runs, 97 runs scored and 89 runs batted in. In 1941 Judnich batted .284 with 40 doubles. The following year he hit a career-high .313 while hitting 17 homers and driving in 82 runs. The Browns would struggle for years to find a significant replacement for the power that Judnich offered.

Glen "Red" McQuillen took over for Cullenbine in 1942 and in only 339 at-bats hit .283 with 12 triples, fourth best in the American League, but the Browns lost his services when he was drafted following the season. St. Louis lost other notables to the war, including outfielder-catcher Joe Grace (.309 in 362 AB in 1941), shortstop Johnny Berardino (16 HR in 1940; .271 in 1941) and second baseman Johnny Lucadello (.279 in 351 AB in 1941), all of whom were selected prior to the 1942 campaign. (A side note of interest, Berardino later dropped the second "r" from his last name and became an actor, starring as Dr. Hardy on the soap opera General Hospital for years.)

Al Milnar was signed by the Browns late in 1943. Big things were expected from the pitcher in 1944 because he had his best years when Sewell was a coach in Cleveland. But Milnar only pitched three games in 1943 for St. Louis before he too was drafted.

Sewell replaced his lost players by bringing up youngsters or signing veterans who could

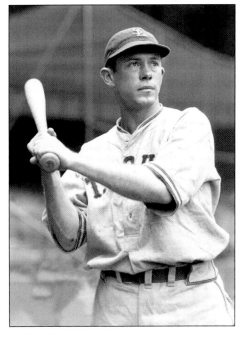

HARLOND CLIFT. Manager Luke Sewell felt Harlond Clift had a defeatist attitude after being on so many losing Browns teams, so he dealt the third baseman. (SM)

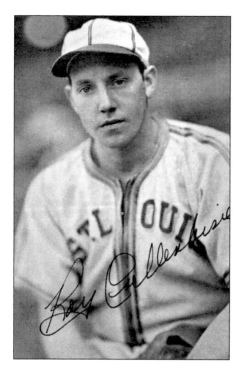

ROY CULLENBINE. Roy Cullenbine frustrated manager Luke Sewell by not swinging the bat when given the hit sign, so the Browns traded him to Washington on June 7, 1942. (SM)

bring a winning attitude to the team. Pitcher Al Hollingsworth, who had pitched for the Cardinals and five other major league teams, was signed in 1942 along with outfielder Mike Kreevich, who played in the 1938 All-Star Game and had a number of successful years following that. An influx of youngsters was brought up in 1943, including third baseman Mark Christman, outfielder Milt Byrnes and pitchers Nelson Potter and Jack Kramer.

St. Louis won 82 games in 1942, the most wins for the club in 18 years. The .543 winning percentage was the franchise's highest since 1922. The Browns winning ways did not go unnoticed. *Newsweek* magazine praised Sewell following the Browns third-place finish: "It cannot be said that the Browns have vulgarly bought their way up in the world for the management has no money to spend on such foolish luxuries as good baseball players. Instead, the credit for the incredible devolves on one man, Luke Sewell, a lead-pipe cinch for the title of Manager of 1942."

The Browns dipped to 72 wins in 1943, but that year a different type of baseball was used, a balata ball which had hard plastic at the core. As a result, baseballs didn't travel as far and lower scoring games were more common. A few "bad apples" like Hayes and Clift didn't help matters.

By 1944, only one member from the Browns' 1941 starting lineup was on the team, first baseman George McQuinn. Of the other seven potential starters, only Kreevich was a starter three years previous, in his case with the Chicago White Sox.

But with more and more players being called into the armed forces, there were still questions as to whether Major League Baseball should continue. Some wondered if baseball was relying too much on 4-F players—those who were dismissed from the armed forces because of an injury or couldn't serve due to various physical ailments—and minor leaguers who didn't belong in the big leagues.

Things could change even more drastically if the armed forces decided they needed more personnel and/or to use those who couldn't fight in other positions. "A move to use Army rejects in essential industry would blow up baseball," said New York Giants Vice President Leo Bundy.

Amidst rumors of the Army about to loosen their stringent draft needs, baseball continued—albeit cautiously. "This season will be on a day-by-day, week-by-week basis," warned National League President Ford Frick.

Others were more optimistic. "Baseball can survive the war-time emergencies without shirking its responsibilities in any manner," Washington Senators owner Clark Griffith said in October of 1943. "As long as we can put nine men on the field, we will operate and there should be enough rejectees to man our ball clubs. Under no conditions should baseball throw up the sponge. Our game fills a need."

"No government action will shorten the season," Chicago Cubs general manager Jim Gallagher succinctly stated.

As happens in time of war, an angle of patriotism—bordering on propaganda—was used to defend the continuation of playing the national pastime. Illinois Senator Scott W. Lucas

pointed out that both Russia and England didn't stop playing their spectator sports and further said, "It is also interesting to note that the treacherous Japs dropped baseball because it is an American game—another added reason for us to keep the game going."

Said writer Quentin Reynolds: "Hitler has killed a great many things in the past few years. Do not let him kill baseball."

Perhaps the people at home needed convincing, but those overseas didn't. Soldiers wrote into *The Sporting News* saying how much they enjoyed being able to look at the box scores and standings. It was a pleasant diversion from the reasons they weren't back in the United States. "4-F's or no 4-F's," wrote Technical Sergeant Simon Dorman, "we of the armed forces want the big leagues to go on."

Baseball would go on and the Browns needed to acquire players to fill some holes. A number of players decided to work at a war plant, thus keeping a 2-B status—meaning they couldn't be drafted as long as they held down what was considered an essential job—instead of playing baseball which meant a 1-A classification and first dibs on being called. Among those who weren't expected to be around at the start of the season were outfielders Chet Laabs, Mike Chartak and Al Zarilla, third baseman Mark Christman, starting pitchers Denny Galehouse and Bob Muncrief, and reliever George Caster.

Sewell intended to bring up rookie Hal Epps to fill a missing outfield spot. He signed veteran Frank Demaree, who had been let go by the Cardinals, to further bolster the position. The Browns also signed former A's pitcher Newman "Tex" Shirley and Sigmund Jakucki, a world traveling pitcher who came with a tough guy reputation.

The Browns drafted Henry Helf in the minor league draft with the intention of putting him at catcher. Helf was said to have the best arm in the American Association. Years earlier he had proven the ability to catch popups, no matter how high. (Helf made history, along with fellow catcher Frankie Pytlak, by establishing a record for catching a baseball thrown from the highest point above street level, in their case 675 feet. On August 20, 1938 both Helf and Pytlak caught baseballs thrown by Cleveland Indians teammate Ken Keltner who was located on the upper ledge of the Cleveland Terminal Tower.) But Helf was drafted into the war effort, and with Giuliani deciding to retire from baseball to accept an offer to be a salesman with a Minneapolis company, Sewell had to make due at catcher with a pair of rookies, Myron "Red" Hayworth and Frank Mancuso.

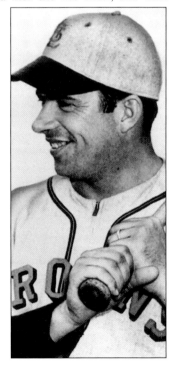

Despite the expected absence of Christman, who still planned on attending spring training, Sewell had things pretty much set in the infield. McQuinn, Gutteridge, Stephens and Clary all were excused from the armed forces, making up what was dubbed an "All 4-F infield."

The outfield situation was a bit more messy. In addition to the trio who were away at war plant jobs, Kreevich had yet to sign his contract. That left Byrnes, a player Sewell regarded as nothing more than a wartime fill-in, the just released 33-year-old Demaree, and rookies Epps and Lutz (both of whom could receive their draft notices at any moment).

The pitching was also a question mark; Galehouse was working at a war plant job in Akron, Ohio, Muncrief decided to retire for the duration of the war, instead working as an electrician at the Brown Shipyards in Houston; while Sundra was available but awaiting the call for his physical examination

WALT JUDNICH. The Browns lost power-hitting outfielder Walt Judnich, who hit a career high .313 in 1942, to the war effort. (NBH)

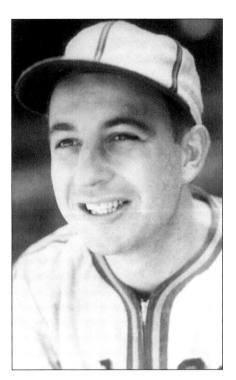

MILT BYRNES. Outfielder Milt Byrnes was brought up to the Browns in 1943, although manager Luke Sewell regarded Byrnes as nothing more than a wartime fill-in player. (SM)

prior to induction. Besides Hollingsworth, who was 1-A but at 34 years old probably wouldn't be drafted, Sewell was stuck with a bunch of unproven rookies, has-beens and unknowns: Al Lamachhia, Virgil Brown, Ray Campbell, Earl Jones, Jakucki, Kramer, Sid Peterson, Potter, Bill Seinsoth, Shirley, Weldon "Lefty" West and Zoldak. Only five of those 13 had ever pitched in the major leagues and their combined record was 50-74.

To make matters worse, there was snow on the ground at the Browns' spring training site.

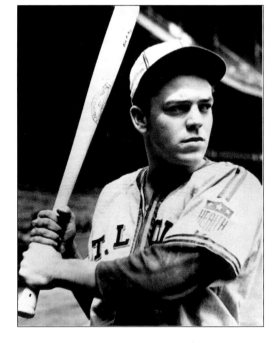

VERN STEPHENS. Vern Stephens was the Browns' starting shortstop in 1942 at age 22. Being classified 4-F meant he'd be able to play during the war years. (NBH)

Three

First Inning
Going to Camp and the First Look at the Cardinals

Because of war travel restrictions, Commissioner Landis ruled in 1944, as he did the previous year, that baseball teams were limited in their spring training sites to "nothing south of the Potomac or West of the Ohio." Both St. Louis teams were granted an exemption from that ruling, Landis allowing them to train in Missouri. The Browns took Landis up on his special offer and headed to Cape Girardeau, Missouri. The Cardinals, however, took their spring training outside the state to Cairo, Illinois.

Other clubs stayed close to home. For example, the Chicago Cubs and White Sox both went to French Lick, Indiana, while the New York Giants headed to nearby Lakewood, New Jersey. The Browns asked the Pittsburgh Pirates to share their spring training camp site with them, but the Pirates needed special permission from Landis and didn't pursue the matter.

When the Browns opened camp March 20, snow prohibited any outdoor workout. Fortunately the team had availability of an indoor arena in which a batting cage was housed as well as about six inches of dirt the Browns put in so they could hold practices during inclement weather. The building also was heated, allowing pitchers the ability to break a good sweat and thus loosen up faster.

The first day crew was not large. Only nine players were present: pitchers Ray Campbell, Al Hollingsworth, Sigmund Jakucki, Al LaMacchia, Norman "Tex" Shirley, Weldon "Lefty" West and Sam Zoldak, catcher Frank Mancuso and outfielder Frank Demaree. Manager Luke Sewell and coaches Freddy Hoffman and Zack Taylor rounded out the small group.

A few more players trickled in as the days went by. First baseman George McQuinn, shortstop Vern Stephens, second baseman Don Gutteridge, catcher Joe Schultz and pitchers Virgil Brown, Jack Kramer, Nelson Potter and Steve Sundra raised the total to 17 players in camp, but 11 of those were pitchers.

Stephens almost wasn't allowed to report. A number of major league players, including Stephens as well as Browns teammates Al Zarilla and George Caster, played in some exhibition games in their native Southern California following the 1943 World Series. However, Major League Baseball rules forbid any exhibition games from being played ten days after the close of the World Series. On November 1st, Landis ordered all players who participated in those games to report their earnings or face suspension, beginning with the opening of the 1944 season. Each player was also fined for his actions.

Because of war jobs or draft classification, many players weren't sure what to do and decided to stay home until their military situation was cleared up. Pitcher Bob Muncrief passed his military examination in Houston but the Browns still asked him to join the club and play for as long as possible. Muncrief decided to stay in Houston for the time being.

Even with the arrival of infielder Ellis Clary and third baseman Mark Christman, who was able to leave his wartime job at the Central Fire Truck Co. in St. Louis for a short time to play in a few games, by the time the first exhibition contest rolled around March 26, St. Louis was still shorthanded. In the first of seven games to be played against the Toledo Mudhens, the Browns' farm club, St. Louis had to borrow a couple of players from

its minor league team to fill out the roster. The Browns did have 19-year-old, 180-pound Eddie Broombaugh, a hometown kid from Herculareum, Missouri, in camp trying to make the big league squad, but Sewell instead chose to enlist a couple of outfielders from Toledo. To complete his starting lineup, Sewell was forced to use 31-year-old Virgil Brown, a pitcher who had off-season surgery to correct an arm problem, in right field.

Despite the abbreviated roster, the Browns won their preseason opener thanks to rookie Frank Mancuso who clubbed three hits, including a double and a triple. Mancuso's single in the bottom of the ninth drove home Brown with the winning run as St. Louis edged Toledo 5-4. A pair of rookies pitched for the Browns. LaMacchia started the game but gave up five hits and four runs in three innings. Zoldak followed with three innings of shutout ball while Jakucki, who hadn't pitched in the majors since 1936, earned the win finishing with three innings of one-hit ball.

Sewell inserted another youngster into the game as a pinch runner in the sixth inning, 15-year-old Teddy Atkinson. With the war on, there were some players who wouldn't be in a major league spring training camp under normal circumstances and Atkinson was no exception. A few, like 16-year-old Nellie Fox, who was with the Philadelphia Athletics in spring training, were legitimate prospects. Atkinson, though, who was brought to Cape Girardeau from Kansas by Gutteridge, did not fit that category. "We needed ballplayers and he wanted to go play so his dad said, 'yes, go ahead and take him,'" Gutteridge recalled. "He was a pretty good ballplayer but he was real young. You know it's tough to play ball with a lot of guys who have been playing ball for several years and be a 15-year-old. He had to be exceptional."

Fox eventually broke into the major leagues in 1947 and was inducted into the Hall of Fame in 1997. Atkinson played some in the minor leagues but never cracked the majors.

With the next exhibition game five days away, it gave St. Louis an opportunity to get more bodies into camp. Rookie outfielder Hal Epps reported, but the Browns roster got even more depleted as several players went down with illnesses. Infielder Ellis Clary, catchers Joe Schultz and Mancuso, and starting pitcher Nelson Potter each came down with the flu. Pitcher Al Hollingsworth was struck with tonsillitis and both he and Potter, who also had a throat ailment, were taken to the hospital in Cape Girardeau.

Perhaps it was because of the spreading influenza, but the Browns managed just four hits off Toledo pitchers in a 4-2 loss March 31. Newcomer Epps immediately made a mark, though, collecting two of the four St. Louis hits. Jakucki, the winner in relief in the first contest, started and lost this one, giving up three runs in the third inning.

Two more players arrived April 1st, catcher Myron "Red" Hayworth and outfielder Mike Kreevich. That gave the Browns 20 players in camp, meaning they no longer needed to rely on Toledo for players.

Kreevich actually reported to Camp Girardeau unsigned. Unlike some other players, he didn't have to worry much about being drafted. Not only was Kreevich into his mid-30s, putting him at the bottom of the draft list, but he also had two children born before the start of World War II, which eventually provided him with a draft deferment. In an age where players often were out of the major leagues by the time they reached their mid-30s, the fact that Kreevich was still playing at age 36 (although at the time Kreevich said he was 34) was amazing, especially considering the abuse he had put his body through.

Michael Andreas Kreevich was born June 10, 1908 (in his early days in the big leagues he listed his birthday as January 4, 1910 and later as June 10, 1910) in Mount Olive, Illinois. His future wasn't going to be in baseball. Like many of his neighbors, Kreevich started working in the coal mines, in his case at age 16. Although just 5 feet 7 1/2 inches tall, Kreevich developed a muscular build while working in the mines for four and a half years.

But Kreevich's coal mining career came to an end when the mines closed in 1930. Coincidentally, it was around that time that Kreevich received a letter asking him to play baseball for a team in McCook, Nebraska. Remarkably, he went from that small town team to the National League's Chicago Cubs in the matter of one year, making his major league debut September 7, 1931. Kreevich played in five games for the Cubs, managing just two hits in 12

plate appearances. Of the ten outs he made, six were strikeouts. Kreevich didn't appear in the majors again for four years but he stayed in Chicago, going from the North Side to the South Side, when he was called up by the cross-town American League White Sox club in 1935. He appeared in six games as a third baseman and had a little more success than when he was with the Cubs, getting ten hits in 23 at-bats.

Kreevich must have made a good impression because the next year he was moved back into the outfield, to center field, and became a part of the White Sox everyday lineup. His first full year in the majors was a fruitful one. Kreevich batted .307 with 32 doubles, 11 triples, five home runs, 99 runs scored (a career high), 69 runs batted in and ten stolen bases. He topped the .300 mark again in 1937, hitting .302 while leading the American League in triples with 16 and smacking a career-best 12 homers. Kreevich scored 94 runs in '37 while driving in 73.

Kreevich reached the peak of his profession in 1938, being named to the American League All-Star team. He again had another solid season, batting .297, with 73 runs and 73 RBI. Playing in a personal-best 145 games in 1939, Kreevich set career highs in batting average (.323) and stolen bases (23). He also had the ignominious distinction that season of being just one of three players in major league history to hit into four double plays in one game. (For trivia buffs, the other two are Goose Goslin of Detroit and Joe Torre of the New York Mets.)

Despite the stellar season, Kreevich was one of the heaviest drinkers in the game and his affinity for alcohol started to take its toll. His average plummeted nearly sixty points in 1940, to .265. It was during that season that Kreevich also uttered possibly his most famous words. During Bob Feller's opening day no-hitter of the White Sox, Kreevich took a called strike from the fireball-throwing Cleveland hurler. The umpire turned to Kreevich and asked, "What's wrong with it?" To which Kreevich responded, "It sounded a little high."

After seeing Kreevich's batting average dip to .232 in 1941, Chicago dealt the man teammates called "little Ikey Pikey" because of his short stature and Polish heritage to Philadelphia on December 9th, along with pitcher Jack Hallett, who the A's eventually released, for outfielder Wally Moses, who previously batted .300 or better in seven consecutive seasons. Despite being traded for such a high quality player, Kreevich didn't reward Philadelphia for the faith they showed in him. He batted .255 and drove in just 30 runs in 116 games in 1942. After stealing 10 or more bases for six straight seasons, Kreevich swiped just seven for the Athletics. Kreevich's excessive drinking was too much for Philadelphia manager Connie Mack. On December 7, 1942, after only one season in Philadelphia and just four years removed from playing in the All-Star Game, Kreevich was given his outright release.

Luke Sewell decided to take a chance on Kreevich and signed him as a free agent in 1943. Sewell figured if he could help Kreevich stay away from booze—no easy task—he'd be a valuable addition to the club. Besides a decent batting stroke, Kreevich was a very good fielder, leading the league in fielding percentage in 1937 and 1941. Many players of his era considered Kreevich the second-best fielding outfielder of the time, behind only Joe DiMaggio.

"Mike Kreevich was an excellent fielder, he really got a good jump on the ball," said Don Gutteridge. "Mike's arm wasn't as good as some of the other center fielders, but Mike was a good, good fielder. He knew where the ball was at all times. When a ball was hit, he seemed to have the sense that he knew right where it was and he went to that spot. He was a good fielder."

But first Sewell had to get Kreevich to cut back on the drinking. Gutteridge relayed a story, often told by Ellis Clary, concerning Sewell's efforts to straighten up Kreevich: "One time Sewell went out looking for some of the players and he went up to a bar and there sat Mike Kreevich. And he said, 'Well Mike, we better go home.' So he took Mike home to the hotel and put him in his room, because Mike was a little inebriated. So then he went back to the same bar to see who was still in there and there sits Mike Kreevich. He [Sewell] had locked him in his room but he [Kreevich] beat him back to the bar."

Recalled Clary: "Kreevich, well he couldn't help but drink. His wife stayed on him all the time. But he wasn't that way (a partier), he just liked that booze. If he hadn't been like that we never

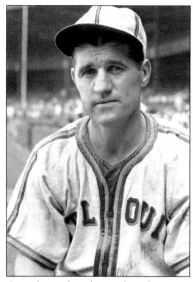

MIKE KREEVICH. Mike Kreevich was considered one of the best fielding outfielders of his era by his peers. Teammate Ellis Clary called Kreevich the most underrated ballplayer he ever saw. (SM)

would have got him. He was with the White Sox and they got tired of that shit. And Luke Sewell could handle him, our manager, and he got him over there. (Kreevich) was the most underrated ballplayer I ever saw."

Under the watchful eye of Sewell, Kreevich appeared in 60 games for the Browns in 1943, hitting .255 while continuing to demonstrate strong fielding skills, committing only one error.

Kreevich wasn't the only player on the team who was known to enjoy a drink now and again. Jakucki and Shirley came to the club with hard drinking reputations, while Stephens was known as a ladies man who stayed up all hours of the night. Even in a sleepy town like Cape Girardeau, the players found a way to have a good time. "In a town like that there isn't much to do. I think they only had one or two shows and you know ballplayers are looking for something to do at night," explained Gutteridge, one of the teetotalers on the club. "Maybe we didn't work hard enough in the daytime to make 'em tired and go to bed. They frolicked a little bit, shall I say it that way? They frolicked a little bit."

While the bars and women of Cape Girardeau may have attracted some of the players at night, there were still some games left to play during the day. In a game halted after seven innings, St. Louis topped Toledo 6-4 on April 1st. Right fielder Milt Byrnes provided the big blow, hitting a three-run double in a four-run fifth inning. Toledo came back on April 2nd to defeat the Browns 12-4. The game was tied 3-3 after six innings, but the Mudhens scored nine runs off pitcher Bill Seinsoth over the final three frames.

Seinsoth pitched despite just arriving to camp, along with outfielder Al Zarilla, following a tiring drive from Los Angeles. It didn't help matters for the pitcher that the temperature was 40 degrees, thus making it tougher for him to get loose. Seinsoth, who had a 9-15 record for Toledo in 1943, was battered by his former teammates for ten hits and five walks in his three innings.

As on the previous day, weather conditions weren't so friendly April 3rd. A bitterly cold win caused Sewell to stop the fifth exhibition game after six innings. Hal Epps was again the standout player for the Browns, collecting two of their three hits as the Browns once again fell to the Mudhens, this time 1-0.

Sewell's squad rounded out some more April 4th. Potter, Hollingsworth and Mancuso returned to workouts, Kreevich inked his contract, and the Browns received Gene Moore from Washington to complete the Rick Ferrell trade from a month earlier.

When Angelo Giuliani refused to report and eventually retired from baseball after being dealt for Ferrell, the Browns demanded to be compensated since in essence they had traded Ferrell for nothing. Washington owner Calvin Griffith, a man who was known to try and stretch a dollar as far as possible, refused to send another player to St. Louis, saying, "In these times, everybody must take their chances." But Griffith finally relented, sending the well-traveled 34-year-old Moore, who hit .268 in 92 games for the Nationals in 1943.

The Browns beat Toledo 10-2 but lost another live arm April 5th when pitcher Ray Campbell had his draft status reclassified from 2-B to 1-A. Campbell was ordered to report for a physical exam prior to being inducted into the military. Losing Campbell was not overlooked by Sewell, who felt that because of the weather and sickness, the pitching staff was not getting properly worked into shape. Sewell voiced his concerns to the *St. Louis Post-Dispatch* in an April 5th interview. "The pitchers are not ready," Sewell said. "Why, in most spring camps the pitchers hardly work in batting

practice until they've had more work than ours have had here. At the end of three weeks of work in the South they are usually about able to pitch three innings in exhibition games."

That being said, thanks to a strong pitching effort, the Browns came out and beat Toledo 5-1 on April 6th in the final preseason game between the two clubs. Steve Sundra started the game for St. Louis and gave up one run on three hits in three innings. Jack Kramer followed with three innings of one-hit ball, while Jakucki finished with a hitless three innings.

St. Louis concluded spring training after a brief morning workout April 7th. But expectations for the team were not flying high, especially with St. Louis barely winning the seven-game preseason series against its minor league affiliate and the pitching staff apparently not close to regular-season form.

Those sentiments were expressed in the April 7th edition of *The St. Louis Post-Dispatch*: "The Browns left here today after 19 days of training which could not be called entirely satisfactory. The weather was too cold generally for outdoor work, with the result that most of the time was spent indoors. Fortunately, the location was a good one and enabled the men to get into pretty good physical condition, but that doesn't take the place of actual play out of doors."

Up next for the Browns was their annual spring series with the Cardinals. This was the chance for the Browns to upstage their more successful National League city mates. The status of the two clubs was not lost on Browns management. At a St. Louis Quarterback Club dinner March 29th that featured both Browns president Don Barnes and Cardinals owner Sam Breadon, Barnes offered this joke, which was probably too close to the truth to his liking, to the crowd of 200: "It's always nice sitting next to Mr. Breadon. It's about as close as I ever get to first place."

Because the Browns usually had worse records than the Cardinals, they often had more to play for, the proverbial David trying to knock off Goliath. The Cardinals players didn't take the games so seriously. Coming into the 1944 spring series, the Browns held a 17-9 edge, with 13 ending in ties. "It meant you were getting ready for the season to start," former Cardinals shortstop Marty Marion explained. "Exhibition games don't mean a great deal. [There was] no pressure."

The Cardinals had gone to back-to-back World Series, winning in 1942 and falling the next year to the New York Yankees. Easter Sunday marked the first time the people of St. Louis could see the defending National League champs in person and 3,744 were in attendance for the exhibition opener. They didn't see a pretty ballgame. The two teams combined for 25 walks, compared to just 16 hits, as the Cardinals won 8-6. The game wasn't as close as the score indicated—the Cardinals led 8-1 going into the top of the ninth. The Browns got four runs on four hits (they had seven in the game) in their half of the inning, highlighted by a three-run homer by Vern Stephens.

The Browns got some good news before playing the next game April 11th. Veteran relief pitcher George Caster, who went 6-8 with a 2.12 ERA in 1943, decided to leave his war plant job and join the Browns while pitcher Tex Shirley failed his induction exam. For Shirley, who had a previous hernia problem, it marked the seventh time he had failed his physical.

Bad weather plagued the rest of the spring series. The April 11th game, a 5-2 Browns victory, drew just 978 fans. An 8-6 Cardinals win the next day saw only 744 in attendance. The Browns also officially lost the services of outfielder Barney Lutz on April 12th as he was inducted into the Navy. Don Gutteridge hit an inside-the-park home run in exhibition game number four, but the Browns still lost 5-4. Rain limited the fifth and final game of the spring series to five innings. The Cardinals scored three times in the last two innings and won 3-2 to give them a four-games-to-one series victory. Thanks to a week of bad weather, which forced a number of cancellations, the series attracted only 4,121 paying customers. In 1943, the first five games of the spring series drew 11,988 fans.

Browns batters struggled against Cardinal pitching. The non-pitchers combined to hit .226. When asked for a prediction of where his club would finish in the American League in 1944, perhaps it was that statistic that caused Sewell to utter, "I can't tell you what the Browns will do this year, but I know darned well we won't finish last. A lot depends on our pitching." However, there were a couple of bright spots on offense as rookies Hal Epps (.294) and Frank Mancuso (.364) hit well, as did the newly-acquired Gene Moore (.500). The Cardinals did exploit the

AL HOLLINGSWORTH. Pitcher Al Hollingsworth arrived to spring training on time, but a case of tonsillitis curtailed his workout time. (NBH)

inexperienced trio of Browns catchers, however, swiping ten bases in the five games.

On April 15th—the day that Army Air Corps Captain Elmer Gedeon was shot down over France on his 27th birthday, thus becoming the first of two major leaguers to be killed in service during World War II (Harry O'Neill, killed on Iwo Jima in March 1945, was the other)—third baseman Mark Christman left his war job to join the Browns full-time, thus seeing his draft classification change from 2-B to 1-A.

Despite having a few players still off at war plant jobs, most notably pitchers Denny Galehouse and Bob Muncrief and outfielder Chet Laabs, the Browns roster was basically set. Sewell was asked to evaluate his team prior to the season: "Our infield, of course, is our strongest point; but there will be a definite improvement behind the bat, I think, because I believe Mancuso and Hayworth will be better than were [Frankie] Hayes [.188, five home runs, 30 RBI] and [Rick] Ferrell [.239, 0 HR, 20 RBI] last season. I'll start with Hal Epps in center field. That's about the only thing I'm sure of in the outfield. I would like to have a power hitter out there, but we don't have any. I like the looks of Mike Kreevich this spring. I believe he's twice as far ahead as he was at this time last year. The illness of Nelson Potter and Al Hollingsworth retarded our practice. If they had not become ill, we would have been able to have more batting practice. I only hope they can snap back quickly."

Around the country, the Browns were generally thought of as being a middle-of-the-road kind of team. In projecting the 1944 season, *Time Magazine* described the Browns as having "more bewilderment and secrecy." As with most prognosticators, noted New York writer Dan Daniel had New York winning the American League flag with Washington and Chicago challenging for the top spot. Daniel predicted a fifth-place finish for the Browns.

Baseball writers' predictions also had St. Louis finishing fifth in the AL, while all sources had the Cardinals repeating as National League champions. The Cardinals registered 57 of 67 first-place votes in the baseball writers' survey. The Browns received one first and one second place vote, five third place, ten fourth place, nine fifth place, 14 sixth place, 15 seventh place and nine eighth place votes. The only writer to pick the Browns to win the AL pennant was *St. Louis Post-Dispatch* sports editor and columnist John E. Wray, but the selection was made as more of a lark than anything else.

"What's that—nuts?" wrote Wray of his prediction. "Well, what isn't, when you scan the season's possibilities?"

Wray's prediction may have been made in jest, but American League President Wil Harridge turned out to be quite the sage. He offered no prediction for a pennant winner, instead saying that "the American League will have its best pennant battle since 1940."

Fred Lieb of *The Sporting News* wished the Browns well, only because it would keep things interesting. Wrote Lieb: "Should the vicipsitudes [sic] of a third war season see this unlucky club rise to the top, it might put spice into an otherwise drab diamond season."

Regardless of the predictions and despite the inclement weather during spring training and the preseason, the Browns were ready to begin the 1944 season, whether they liked it or not.

Four

Second Inning
Anatomy of a Winning Streak

They are certainly not ready for their best baseball now.
St. Louis Post-Dispatch *on the Browns just prior to the start of the 1944 season.*

Winning season openers was nothing new to the St. Louis Browns. Since Don Barnes bought the team after the 1935 season, the Browns had won all eight opening day games under his ownership. Of course, it helped that the Browns pitchers had extra motivation. Each season, if the Browns were victorious, Barnes gave a brand new suit to the opening day winning pitcher.

Righthander Jack Kramer got the surprise opening game nod from manager Luke Sewell. Kramer, who pitched in just three games—all in relief—for St. Louis in 1943 was chosen instead of Steve Sundra, who led the Browns with a 15-11 record in '43 but was waiting induction into the military.

Kramer had no easy task in trying to collect some new duds from Barnes. The Browns opened the season with a three-game series in Detroit. The Tigers featured first baseman Rudy York, who led the majors with 34 homers and the American League with 118 RBI in 1943. Kramer also had to duel against Dizzy Trout, a 20-game winner the previous season.

A few new faces graced the St. Louis starting lineup from the year before. Thirty-year-old Hal Epps won the center field job with an impressive spring training. Even though he was considered a rookie, Epps already had 100 at-bats (and a .280 average) in the major leagues, including 35 in eight games with the Browns in 1943. Epps previously totaled 28 games for the Cardinals in 1938 and 1940. Other newcomers included rookie Frank Mancuso and recently acquired Gene Moore. Sewell's batting order for the first game was: Don Gutteridge, second base; Epps, center field; George McQuinn, first base; Vern Stephens, shortstop; Moore, right field; Milt Byrnes, left field; Mark Christman, third base; Mancuso, catcher and Kramer, pitcher.

As had been the case in the preseason, the Browns opening day game was played on a chilly afternoon. Over 28,000 fans came out despite temperatures that hovered in the upper 40s. The cold weather didn't stop the Browns from getting out of the gate quickly. Gutteridge opened the season with a single to left field. He then went to third as Epps singled to right. McQuinn staked Kramer to an early lead, hitting into a force out, second to short, with Gutteridge scoring.

Kramer whizzed through the Detroit lineup, keeping the Tigers off the scoreboard through eight innings. He received some help from his defense as the Browns turned two double plays in the first three innings. Kramer got out of a two-out, bases-loaded jam in the fifth by getting former Brown Don Heffner to take strike three.

The score stood at 1-0 into the ninth when Stephens gave the Browns a much needed insurance run, homering off Trout in the top of the inning. Kramer was still going strong into the ninth, striking out Doc Cramer and York to begin the frame. But the next batter, Pinky Higgins, spoiled the shutout by hitting a home run on a 3-2 pitch. When Jimmy Outlaw followed with a single, Sewell took the starter out and put in 36-year-old George Caster to try and save the game.

HAL EPPS. Thirty-year-old rookie Hal Epps, known as "The Reindeer," won the starting job in center field with an impressive spring training. (SM)

Caster was nicknamed "Ug," and there are at least three explanations as to the origins of that name. One theory had it that he was called "Ug" ever since rooming with a player who was of American Indian heritage. Another is that the nickname is a reference to the reaction one gets when taking a sip of the pitcher's sound-alike product, Castor Oil, which is notorious for its bad taste. Journalist Red Smith had what he thought was the definitive answer to the roots of "Ug": "[They] called him 'Ug' short for 'Ugly' because when he was clowning around in the locker room he would remove his bridgework and bare his remaining fangs for a vicious smile."

Caster began his career as a starting pitcher. After spending two years at San Bernardino College and one-and-a-half years at the University of Southern California, Caster bounced around professional baseball. From 1929 to 1932 he pitched for the San Bernardino Missions, also spending part of 1930 with Globe of the Arizona-Texas League. After a brief appearance with Los Angeles of the Pacific Coast League in '32, Caster headed to Seattle from 1933 to the beginning of 1934. He spent part of 1934 with Portland before finally getting the call to the big leagues, joining the Philadelphia Athletics later in the year.

Caster created quite a stir when he joined the American League team because he pitched without a windup. His pitching performance, however, didn't elicit the same kind of reaction. In 1935, his first full season in the bigs, Caster posted an inflated 6.25 ERA while working mainly out of the bullpen. But his time in Philadelphia was well served. Veteran pitcher Eddie Rommel taught Caster how to throw the knuckleball. Using the knuckler, along with a sinker pitch he taught himself, Caster went 25-11 with 254 strikeouts for Portland in 1936. Philadelphia manager Connie Mack took note of the performance and moved him into the A's starting rotation for 1937.

Pitching for one of the worst teams in the majors, Caster put up decent numbers, especially considering the caliber of the club he played on. He fashioned a 12-19 record in '37, then finished with a 16-20 record for an A's team that won only 53 times in 1938. His 40 starts and 20 losses both led the American League. Following a 9-9 season in 1939, Caster suffered the worst year of his career. In 1940 he won just four games and lost an American League high 19 times while sporting an ERA of 6.56. He was waived in the offseason.

The Browns took a chance on Caster, signing him in November of 1940. Caster made nine starts in 1941 for St. Louis, but Sewell moved him to the bullpen sensing that his "out" pitch, the knuckleball, would be more effective late in the game. Sewell figured hitters might have trouble adjusting to the slow, darting pitch. Caster pitched in 74 games during the 1942 and '43 seasons, all in relief, winning 14 games for the Browns and saving 13 others. He posted a career best 2.82 ERA in '42, and then topped that with a 2.12 ERA the next season. After being nearly washed up in Philadelphia, Sewell had saved Caster's career by converting him into a reliever.

Caster, though, hadn't pitched for the Browns at all in the preseason in 1944. He missed spring training while deciding whether to sit out the season and remain at his war plant job in Long Beach, California. Nor did he get a chance to pitch in the spring series against the Cardinals, meaning that when he took the mound on opening day with the Browns holding on to a 2-1 lead with two men out in the ninth against the Tigers, it was Caster's first live action of 1944.

With Outlaw stationed on first, Caster walked the first batter he faced, Don Ross, pushing the tying run into scoring position. But Caster settled down and retired former Brown Bob Swift to end the game, giving St. Louis the win, Caster the save, and Kramer a new set of clothes.

After getting passed over for the opening day start, Sundra was slated to go against Detroit in the second game of the series. The sandy blond haired, blue-eyed Sundra was not only easily the Browns best pitcher in 1943 but also one of the best in the American League. He tossed three shutouts in '43 and also had three one-run and three two-run games, finishing with a 3.25 ERA to go along with his career-high 15 wins.

Sundra, who earned the nickname "Smokey" as a 17-year-old hurler when he was averaging 12 strikeouts a game for the Holacek Meat club, a Cleveland sandlot team, was on borrowed time with the Browns. Despite being married, having a 1-year old son and working as a steam fitter for a Coast Guard Station in Atlantic City the previous two years in the offseason, Sundra was notified in December of 1943 that he was to be inducted into the military. He even sent back his 1944 contract to the Browns unsigned, claiming that since he wasn't going to be around for the entire season he deserved more money for the few games he did appear in. But he eventually came to terms and was among the first players to make it to spring training.

Like Caster, Sundra's career was revived after joining the Browns. After posting an 11-1 record with a 2.76 ERA for the Yankees in 1939, Sundra saw his ERA balloon to over five runs a game in each of the next two seasons, which he spent in New York and then Washington. Sundra was sporting a 1-3 record and 5.67 ERA for the Nationals in 1942 when he was traded, along with Mike Chartak, to St. Louis for Roy Cullenbine and Bill Trotter. Sundra took a quick liking to St. Louis. In 20 games with the Browns in 1942, he won eight games and lost three—his first winning record in three years—and had his ERA back down to a respectable 3.82. Sundra proved that his short time in St. Louis in '42 was no fluke by responding with a solid year in 1943.

Sundra's success continued with his first start in 1944. He did give up a 350-foot home run to Rudy York in the fourth—York's 1,000th career hit—that tied the game 1-1, but he surrendered just two other hits in the contest. The Browns retook the lead on a Vern Stephens sacrifice fly in the fifth and added one more in the sixth when Milt Byrnes scored on Mark Christman's long fly out to center. Sundra got into some trouble in the eighth, though. Pinch hitter Chuck Hostettler led off by singling to center. Pinch-hitter Red Eaton then bounced a grounder to short, but second baseman Don Gutteridge dropped the toss from Stephens, putting runners at first and second with nobody out. Sundra induced Heffner to loft a pop fly into foul territory, which McQuinn caught for the first out. Eddie Mayo then flied out to center field. Hostettler tried to advance to third on the play, but Hal Epps threw him out to end the threat. St. Louis ended up with a 3-1 win and were on top of the American League with a 2-0 record, one of three undefeated teams along with Chicago and Philadelphia, both which had won their only game played to date.

JACK KRAMER. Jack Kramer, who pitched in just three games in 1943 and all in relief, was the surprise starter on opening day for the Browns. The move helped net him a new suit. (NBH)

GEORGE CASTER. George Caster was converted into a reliever by Luke Sewell in 1941 and he responded by posting career-best ERAs in both 1942 and 1943 while combining to win 14 games and save 13 others. (SM)

After the win, Sundra traveled to Cleveland to see if he could delay the date of his induction.

When Sigmund Jakucki took the mound for the Browns on April 20th, it marked his first appearance in the major leagues in eight years. There was no celebration marking Jakucki's return to the bigs, but St. Louis hitters provided some fireworks of their own.

For the third straight game the Browns got on the scoreboard in the first inning. With one out, Epps and McQuinn laced back-to-back singles. Epps scored the first run when catcher Bob Swift couldn't handle a Hal Newhouser pitch. McQuinn, who had moved to second on the passed ball, then scored on a Stephens single to left field. But the Browns, who had scored a combined five runs in their first two wins over Detroit, weren't done yet. Epps and McQuinn again got things started, both drawing walks to begin the third inning. Stephens then clubbed a double to center—the fifth hit off Newhouser—both Epps and McQuinn scoring. That gave the Browns a 4-0 lead and sent Newhouser to an early trip to the showers. Reliever Joe Orrell couldn't keep St. Louis from scoring either, however, giving up a two-out single to Mark Christman that scored Stephens.

Detroit got a couple of runs off Jakucki in the bottom of the third, but the Browns piled on three more runs in the fourth. Don Gutteridge led off the inning with a walk, and then proceeded to steal second and third base, scoring when Swift's throw to third went wide of the base and into the outfield. Frank Demaree tagged Orrell with an RBI double and Mike Kreevich an RBI single to finally chase the pitcher. Tigers pitcher Chief Hogsett didn't give up a run the rest of the way but it didn't matter, the eight runs were enough for Jakucki. Jakucki wasn't sparkling in his return—giving up five runs—but he went the complete game and earned his first major league win.

Following the three-game sweep of the Tigers, St. Louis headed home for its home opener against the White Sox on April 21st. The 3-0 Browns were treated to a parade—literally. Pregame festivities included a parade of soldiers by the U.S. Naval Armory and music played by the Coast Guard band. The Mayor of St. Louis, Aloys P. Kaufmann, even threw out the ceremonial first pitch. But not everyone was caught up in the hoopla. Just 3,395 fans, only 2,021 of which were paying customers, showed up to see Nelson Potter try and protect the Browns undefeated record.

The Browns again staked their starting pitcher to an early lead, scoring four times in the first inning. Three of those runs scored on a Mike Kreevich home run into the left field bleachers. Kreevich—who hit just one homer in the previous three years—deposited another Thornton Lee pitch into the seats in left in the sixth, this time with no one on base.

Thanks to a sore throat incurred during spring training, this was Potter's first time on the pitching mound against live competition. It certainly didn't show early on. Potter didn't give up a hit until the fifth when Wally Moses reached on an infield single to deep short. Chicago pushed across a couple of hits in the sixth, but Potter didn't allow a run through seven innings.

Visibly tired in the eighth, Potter allowed singles to Moses and Thurman Tucker before surrendering a home run to Hal Trosky.

Ironically, the Browns almost acquired Trosky in the off-season. Because he suffered from severe migraine headaches, Trosky retired from baseball after the 1941 season at the age of 29. The headaches limited Trosky to just 89 games in 1941, but previously he had proven to be a serious home run threat, averaging 29 homers a season from 1934 to 1940. He also owned a .313 career batting average. Trosky's combination of power and average was tempting for a Browns team that lacked a legitimate home run threat other than Stephens, who clubbed a team-high 22 homers in 1943.

When he announced his attention for a possible comeback in the middle of 1943, Trosky said he wanted to play only for teams which were an overnight trip away from his farm in Norway, Iowa. That narrowed Trosky's choices down to either Chicago or St. Louis. The Browns reportedly made a proposal to Cleveland, which owned Trosky's rights, in which the Indians could have either Mike Kreevich, Mike Chartak or Hal Epps. St. Louis planned to use Trosky—a first baseman—in the outfield. Indians Vice President Roger Peckinpaugh told the Browns no deal for Trosky would be made until the winter meetings. But on November 6th, shortly after that assurance and a month before the start of the winter meetings, Peckinpaugh sold Trosky to the White Sox, much to the chagrin of Browns Vice President Bill DeWitt.

Now here was Trosky, a player DeWitt thought the Browns would have for the 1944 season, supplying some power against St. Louis. But even with Trosky's three-run homer, Potter and the Browns still led Chicago 5-3. Sewell got the Browns bullpen working but it wasn't necessary. Potter got out of the eighth inning then retired the White Sox 1-2-3 in the ninth. The Browns winning streak went to four and they remained the last team in the American League without a loss.

With a Saturday game rained out, St. Louis and Chicago played a doubleheader April 23rd. Chicago's Bill Dietrich, 14-6 lifetime against the Browns, opposed Kramer, making his second start of the season, in game one. For the fifth straight game St. Louis scored in its first time up. The Browns got a quick run when Dietrich walked the bases full and Gene Moore hit a sacrifice fly that scored Don Gutteridge. Kramer, who once listed on his major league personal data sheet that he could play the outfield, helped his own cause by powering a two-run homer—the second of his career—to the seats in left field in the second inning.

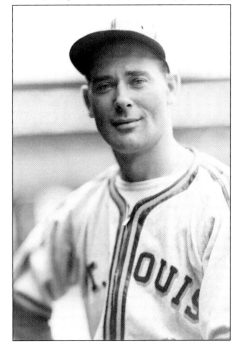

As in his first start, Kramer mowed down the opposition without giving up a run until late in the game. Kramer threw seven shutout innings before a two-out error in the eighth by George McQuinn opened the door for an eventual two-run triple by Trosky. But Kramer allowed no more White Sox to cross home plate and he earned his second win of the season.

Now riding a five-game winning streak, Sewell put Newman "Tex" Shirley out on the mound as the starting pitcher for the second game of the doubleheader. Shirley, making his second major league start, fell behind early. For the first time in the young season the Browns didn't score in the first inning and when Shirley walked a couple of batters and gave up a two-run single to Myril Hoag in the

STEVE SUNDRA. Steve Sundra was the Browns' best starter in 1943, but he was scheduled for inductions into the military, meaning his contributions to St. Louis in 1944 would likely be minimal. (SM)

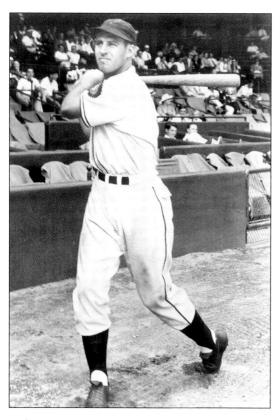

HAL TROSKY. The Browns had hoped to acquire Hal Trosky in the offseason to add some much-needed power to their lineup, but instead saw the slugger dealt to the White Sox. (SM)

third, St. Louis trailed in a game for the first time all year.

Shirley pitched well, but when he was yanked for a pinch hitter in the seventh inning the Browns trailed 3-1. However, with Milt Byrnes batting for Shirley, the Browns cut the lead to one as Mark Christman scored on a passed ball. Christman had singled, stole second and advanced to third on a wild throw by catcher Tom Turner.

As happens during a winning streak, the bounces were going the Browns way. In the bottom of the eighth, Vern Stephens barely missed giving St. Louis the lead with a two-run homer, the ball landing about 15 feet foul. Stephens then hit a double play ball to Leroy Schalk, but the second baseman booted it and George McQuinn, who was on first base, raced all the way to third with Stephens safe at first. Gene Moore and Al Zarilla then hit back-to-back singles off White Sox starter Orval Grove, each hit driving in a run to give St. Louis a 4-3 lead. George Caster, who had pitched a scoreless eighth inning, kept Chicago off the scoreboard in the ninth and St. Louis had its sixth win in a row.

While Shirley didn't pitch a complete game—the Browns had tossed four complete games in the first five games with Kramer getting all but one out in the other—Sewell was pleased with the 25 year old's performance. However, Sewell did take note of a problem that haunted Shirley throughout his pitching career—walks. Shirley walked five Chicago batters in his seven innings, while giving up six hits and striking out three. "Shirley showed me excellent pitching," Sewell remarked after the game. "He had good stuff and except for a little wildness probably wouldn't have needed any help."

The Browns' six wins to start the season was not only the best opening mark in team history, but it was also just one shy of the American League record set by the 1933 New York Yankees. St. Louis tied the mark on April 26th, beating Cleveland in St. Louis 5-2. Sundra started and went the distance, despite giving up 10 hits. The Browns got to Indians starter Allie Reynolds in the sixth, touching him for four runs, the big damage coming from Stephens who belted a two-run double.

The New York Yankees were then dealt a blow while the St. Louis pitching staff, already performing well above expectations, received a boost. The Yankees' Spud Chandler, the American League's Most Valuable Player in 1943 when he went 20-4 with a 1.64 ERA, was drafted after getting just one start in the new season. Meanwhile, Bob Muncrief, who earlier stated he wasn't going to play baseball for the duration of the war, left his job as a marine electrician for the Brown Shipbuilding Company in Houston to come play for the Browns following his passing of the military preinduction physical exam. Expected to be drafted at any time, Muncrief, who went 13-12 with a 2.81 ERA in '43, reported to St. Louis on April 27th in time to throw batting practice and declare himself ready to pitch.

While in Houston, Muncrief stayed in shape by pitching in a war plant league, the South Coast League. He pitched 19 innings there, surrendering just one run while striking out 20. "I've pitched 20 [sic] innings, six of them last Sunday and all I need is a little running," Muncrief said upon his arrival. "I weigh less than at any other time in the last five years and I'll be ready in a few days."

The Browns bid for an eighth straight win began like the majority of their previous games, with the St. Louis offense providing an early lead for its starting pitcher. St. Louis hadn't been knocking the stuffing out of the ball during its winning streak—only once had it reached double figures in hits in a game—but the hits it did get were timely. St. Louis had three hits in the first two innings against Cleveland but scored five times. Vern Stephens took advantage of two walks and a wild pitch by Indians starter Charles Embree, driving in a pair with a first-inning single. St. Louis loaded the bases in the second thanks to a single by Mark Christman and two more walks by Embree, who was pulled after his fourth free pass. Eddie Klieman relieved Embree and got Don Gutteridge to groundout, but another run scored. After Gutteridge stole second base—his third steal of the season—Hal Epps singled to drive in Gutteridge and Red Hayworth, who was on third.

Browns starter Nelson Potter had a wildness problem of his own, walking five batters in the first five innings. But Cleveland scored only one run in that time as a good Browns defense prevented the Indians from getting back into the game.

St. Louis got only one hit after the second inning but they didn't need any as Potter settled down, not walking a batter in the final four innings. Potter gave up just the one run in getting the complete game win—the sixth St. Louis complete game—as the Browns set a new American League record for most games won in a row to open a season. No other team in the AL had yet to even reach four victories and only one—Philadelphia—was above .500.

The accomplishment didn't set the town on fire, as only 1,761 made it out for the historic game. The Browns didn't seem too caught up in the excitement either. "I still get hungry at meal time, and still get sleepy at bed time," responded Sewell when asked about the record streak. "Maybe I'm pleased, but otherwise I don't feel any different from the days before the season started."

With photographers capturing the moment in the congratulatory St. Louis locker room, Don Gutteridge jokingly declared, "We only have to win 146 more to finish the season without a loss."

While the fans and players may not have put much stock into the winning streak, the business community did. Browns shares which sold at $2.25 at the onset of the season were up to $3.50 in smaller transactions and $3.25 in larger ones.

Playing at Chicago on April 28th, St. Louis stood just one victory away from tying the all-time best start in major league history, nine wins set by the 1918 New York Giants and later tied by the 1940 Brooklyn Dodgers. The man who started the streak with an opening game win at Detroit was now poised to extend it to record proportions. Jack Kramer had come a long way since being told to give up baseball seven years earlier.

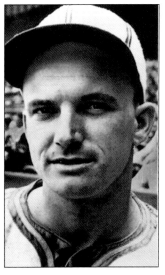

After he completed his first professional season for the Lafayette, Louisiana Class D minor league club in 1936, team management suggested to Kramer that he quit the game and find different employment. But Ray Cahill, the scout that signed Kramer, convinced the organization to keep the pitcher for another year. "He's a great kid, with a great arm and he loves to pitch," Cahill said of Kramer. "He's the kind of a kid we scouts would like to run into every day."

Cahill didn't just say he believed in Kramer, he backed it up, endorsing the New Orleans native by paying the club the pitcher's salary if the team kept him for a month. Kramer

BOB MUNCRIEF. Bob Muncrief changed his mind about not playing baseball during the war and joined the club in late April. He stayed in shape by pitching in a war plant league. (NBH)

lasted much longer than a month in Lafayette. He finished the year with a 12-9 record and 147 strikeouts. Kramer, who was switched from catcher to pitcher under emergency circumstances in an American Legion Tournament championship game, also batted .303. Thus began Kramer's rapid rise through the Browns farm system.

In 1938, Kramer toiled for San Antonio, pitching in 40 games and compiling a record of 20-11 with a 2.52 ERA. In 252 innings pitched he struck out 142 batters and walked 102. Those numbers looked good to Browns management, especially considering what St. Louis pitching staffs had accomplished in the previous few years. In 1938, St. Louis won just 55 games while posting a major league worst 5.80 ERA. That was actually an improvement over the prior two years. In 1937 the Browns ERA was 6.00; in 1936 it was 6.24, the worst mark in American League history. So in 1939, the Browns brought up the 21-year-old rookie and placed him in their starting rotation.

Kramer was not the answer to the Browns woes. He did pitch a club-high 212 innings, start 31 games and relieve in nine others, finishing with a 9-16 record and 5.83 ERA. Unfortunately for St. Louis, that made Kramer the ace of the staff. The Browns ended the season with the worst record in franchise history, 43-111, finished 64 1/2 games out of first place and compiled an ERA of 6.01, the last time a team reached the six run mark for over 50 years.

However, the catcher on that club, Joe Glenn, saw something special in Kramer. Glenn, who played with the Yankees from 1932-38, compared Kramer to a former New York pitcher and future Hall of Famer.

"(Kramer) is another Waite Hoyt," declared Glenn during Kramer's rookie year.

But major league hitters started pounding Kramer with regularity as he went more and more with his slider and Kramer bounced back and forth between the majors and minors over the next couple of years. In 1940 with the Browns, Kramer won three games and lost nine and had an ERA of 6.26. His time in the minors at Toledo fared no better, winning just once in seven tries with the Mudhens.

It was in the minors that Kramer got the reputation of having a quirky personality. Browns manager Luke Sewell once said of Kramer, "Maybe an astrologist could figure out when his moon was in its crescent."

One poor soul who had to deal with Kramer's strange behavior was Stan Keyes, a roommate when the two played in Des Moines. Keyes was a straight-arrow and he'd go to bed at an early hour. Kramer was a night owl, coming back to the hotel room well after Keyes had gone to sleep.

Kramer once disturbed Keyes from his slumber only to say to him, "Wake up, Stan, and let's flip a coin to see who'll turn the lights out." Keyes had a routine of leaving the hotel window open when he went to sleep. So Kramer, of course, closed the window when he came home from his night on the town. After a while, Keyes decided to just leave the window closed—but Kramer then came home and opened it! Keyes finally left the window opposite of how he actually wanted it.

Kramer was drafted into the Navy Seabees, eventually given a discharge in July of 1943 because of sinus troubles due to asthma. Maybe the military discipline did him some good. After leaving the Navy, Kramer was sent to Toledo by the Browns. In his first nine games with the Mudhens, Kramer didn't allow more than six hits in any contest. He threw a no-hitter and also pitched two-hit and three-hit shutouts. After losing his first start, Kramer reeled off eight consecutive wins. After compiling an 8-2 record he was summoned back to the majors late in the season. But his success in Toledo didn't translate to St. Louis. In three games, all in relief, Kramer pitched in nine innings and allowed eight earned runs on 11 hits and eight walks while striking out only four.

Despite his strong performance in Toledo and having 88 major league games under his belt, Kramer was not included in *The Sporting News 1944 Baseball Registrar*, "An omission which to the major leagues is like having your name left out of the phone book," pointed out Sewell.

One of Kramer's big problems in the majors prior to the 1944 season was his wildness, having walked almost twice as many batters as he had struck out. But in his first two starts in '44, Kramer walked just three and struck out 11.

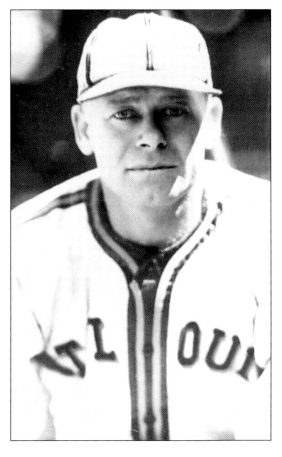

SIG JAKUCKI. Sigmund Jakucki, who started the third game of the season, entered the year having not pitched in the majors in eight years and with no career victories. (SM)

His control against Chicago on April 28th was impeccable as well. While he only struck out one batter—Skeeter Webb to open the home half of the first—Kramer didn't issue a single walk. The White Sox did take a 1-0 lead, however, when Hal Trosky doubled in the fourth and scored following two infield groundouts. Bill Dietrich, the aforementioned pitcher who had great success against the Browns coming into the year, walked just two batters, one of them providing St. Louis with the tying run. Dietrich walked George McQuinn in the fourth, who went to second after Webb committed an error then scored on a single by Milt Byrnes.

St. Louis took the lead on a run scoring double by Vern Stephens in the sixth, his league leading 10th RBI, and got an insurance run in the eighth when McQuinn scampered home on a ground out by Gene Moore.

Kramer held the White Sox in check until the eighth when Chicago threatened with two outs. The White Sox got only four hits off Kramer in the game, but two came on back-to-back singles by Mike Tresh and pinch hitter Guy Curtright. However, Kramer retired Webb on a slow grounder to end the inning. Chicago didn't score off Kramer in the ninth either and the pitcher who was once told to quit baseball had his third win in as many starts and the Browns had themselves their ninth straight triumph.

Taking note of the good starts by both St. Louis teams—the Cardinals also resided in first place over in the National League—John Wray wrote: "One swallow doesn't make a summer . . . or quench a thirst . . . But it's a good start, in either case . . . All of which makes me wonder if our facetious selection of the two St. Louis clubs to meet in next October's World Series is still just a joke."

With the Browns undefeated and having tied the major league record for most wins to start a season, manager Luke Sewell was kiddingly asked who his game one World Series starter was going to be.

"I'll tell you what, if you start the World Series tomorrow I'll tell you right quick who my first game pitcher will be," Sewell responded. "But they haven't ever played one of those things in May yet."

Perhaps Sewell knew the history of the teams that had such prolonged season-opening winning streaks. The 1918 New York Giants and 1940 Brooklyn Dodgers, who shared the record of nine straight victories, both ended their seasons in second place more than 10 games back of the front runner. The 1933 New York Yankees, who held the old American League record that the Browns ended up breaking, also finished in second, seven games behind Washington—whose catcher was Luke Sewell.

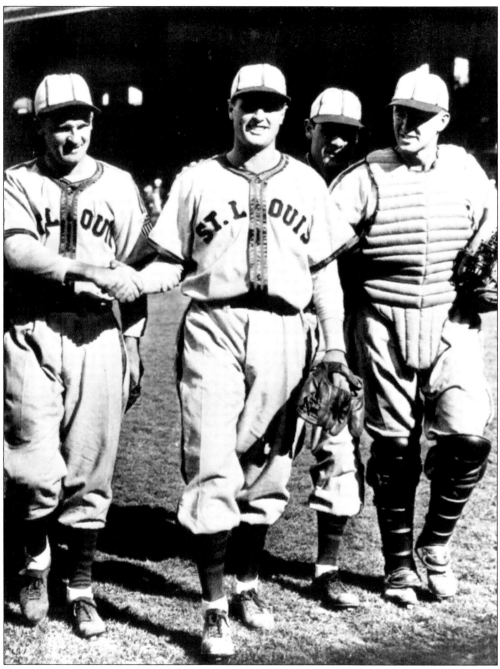

GEORGE MCQUINN, JACK KRAMER, RED HAYWORTH. George McQuinn shakes the hand of Jack Kramer after the team's record-tying ninth consecutive win to open a season. Catcher Red Hayworth is on the right. (NBH)

Five

Third Inning
Losing Faith and Losing First Place

There is an old baseball axiom that says pitching and defense wins championships. But the two can carry a team just so far during the regular season. While an American League pennant was still far from their grasp, the Browns pitching and defense had helped them to a major league record-tying nine-game winning streak to start the season.

St. Louis pitchers gave up just 2.1 runs per game during the win streak, with the starters pitching complete games in seven of the nine contests. The Browns committed just five errors in those games, which, if they continued that pace for the rest of the season, would give them a total of 85.5 in 154 games. St. Louis made 152 errors in 1943—fewest in the American League.

The Browns bats weren't keeping pace with their gloves and arms, though. St. Louis was batting just .227 in the nine games. They were the beneficiary of many a clutch hit, however, as St. Louis still managed 4.4 runs a game despite the paltry batting average.

With a doubleheader scheduled against Chicago the next day, manager Luke Sewell went with Al "Boots" Hollingsworth, who had yet to pitch in the regular season, to try and pick up the Browns' 10th straight win Saturday, April 29th.

Hollingsworth was with his 15th professional team, although St. Louis was only the fifth major league club he had toiled for.

Hollingsworth was born and raised in St. Louis and rose to the pro ranks out of the sandlots. He originally played first base, but kicked away—or booted—so many balls that he picked up the nickname of "Boots." The moniker stuck with him even after he was converted to a pitcher.

A one-time farm product of the St. Louis Cardinals, Hollingsworth made it to the majors in 1935 at the age of 27 with Cincinnati. He played for the Reds until he was traded to Philadelphia on June 13, 1938 along with catcher Spud Davis and $50,000 for pitcher Bucky Walters, who became a standout in Cincinnati.

The stay in Philadelphia for Hollingsworth wasn't long. He was dealt to the New York Yankees for infielder Roy Hughes on July 13, 1939. Hollingsworth never pitched for the Yankees however. New York sent him to its minor league club in Newark, eventually selling him to Brooklyn on August 12th. The Dodgers cut him following the conclusion of the regular season.

There may have been good reason why teams were in such a hurry to get rid of Hollingsworth. In 23 games combined with the Phillies and Dodgers in '39, he posted a 2-11 record with a 5.67 ERA. Washington signed Hollingsworth in 1940, but he pitched in only three games for the Senators. According to *Current Biography*, Hollingsworth "thought he was about ready for semi-pro ball," but after spending 1941 in the minors with Sacramento, the Browns signed the pitcher. Hollingsworth responded with his finest year, recording career bests of 10 wins—with only six losses—and a 2.96 ERA in 1942. Hollingsworth's 1943 season wasn't as stellar; he went 6-13 with a 4.21 ERA.

The Sporting News hypothesized that after having his appendix taken out in January of 1944, Hollingsworth's pitching fortunes might turn around. But it wasn't Hollingsworth's appendix that was the problem, it was his arm. He didn't get much velocity on the ball and years later Sewell admitted that Hollingsworth had a bad arm.

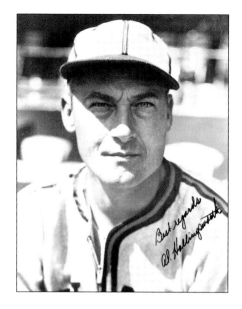

AL HOLLINGSWORTH. The Browns were the 15th pro team for Al Hollingsworth, who was signed by St. Louis after he spent 1941 in the minors in Sacramento. (SM)

"He had good control [but] he couldn't throw the ball hard at all," recalled Don Gutteridge, who was a teammate of Hollingsworth's both with the Browns and Sacramento. "But he was an older pitcher, he knew how to pitch. He pitched with finesse."

Writer Kyle Crichton, who didn't have the bias Gutteridge might, wasn't as kind. Crichton wrote in *Colliers*: "Hollingsworth . . . had labored all over the National League for years and had been heaved out as worthless by the Washington Senators as far back as 1940."

To add to his arm problems, poor weather and a case of tonsillitis limited Hollingsworth to just one inning pitched in the preseason in 1944. Although he kept Chicago off the scoreboard through six innings in his first appearance of the year, some rustiness was evident. Hollingsworth gave up five hits and four walks in the first six innings in addition to tossing a wild pitch in the second inning. Hollingsworth got out of each jam, however, including a bases loaded situation in the first.

At the same time, the Browns took advantage of Buck Ross' wildness. Ross, also making his first start of the season, walked two batters in the first then threw a wild pitch with the bases loaded later in the inning to put St. Louis on top early. The Browns added a run in the sixth on a sacrifice fly by Vern Stephens and an RBI single in the seventh from Don Gutteridge.

Hollingsworth lost his shutout in the seventh. Chicago scored twice, thanks to an RBI double by Myril Hoag and a run scoring ground out by Hal Trosky. Hollingsworth escaped the inning with St. Louis still ahead, 3-2, and retired the first two batters he faced in the eighth. But he then walked the number eight hitter, catcher Mike Tresh. White Sox manager Jimmy Dykes sent pinch hitter Vince Castino up to bat for pitcher George Maltzberger, who pitched in the eighth after Ross was lifted for a pinch hitter the previous inning. Castino came through, lacing a double that tied the score and sent Hollingsworth to the showers.

George Caster entered and retired Leroy Schalk to end the eighth. After St. Louis couldn't score off John Humphries in the ninth, Caster took the hill to try and preserve the tie and send the game into extra innings. Skeeter Webb led off by hitting a grounder toward short, but Vern Stephens bobbled the ball, Webb reaching safely on the error. Webb went to second base as Hoag was out on a slow grounder. Trosky, who now had six runs batted in against St. Louis in five games, was intentionally walked. Right fielder Guy Curtright, robbed of an extra base hit in the sixth when Milt Byrnes held onto the ball after crashing into the wall chasing down his long fly ball, stepped in and powered a hit into left center field, Webb scoring easily on the play to give Chicago the victory.

The Browns not only tasted defeat for the first time in 1944, but St. Louis also lost third baseman Mark Christman to an injury. Christman suffered a tear between two fingers on his right hand, his throwing hand.

Ellis Clary took over for Christman at third base the next day as St. Louis lost its second straight game to Chicago, 6-5 in 10 innings. St. Louis rallied for three runs in the eighth to tie the score, but Schalk's two-out run scoring double off Nelson Potter in the bottom of the 10th won the game for the White Sox. The Browns came back in the second game of the double header, posting a 5-4 win. Stephens' solo homer in the seventh, his second round-tripper of the

season, proved to be the game winner. The Browns' brief four-game road trip was over and St. Louis headed back home with a 10-2 record, placing them easily in first place in the American League over New York and Philadelphia, who were tied for second with identical 5-4 records.

On the train on the way back to St. Louis from Chicago, Sewell commented to a reporter, "We're getting our spring training done as we go along. The weather kept us from getting outdoors much at Cape Girardeau, and the fellows like to get all the batting they can."

The Browns returned to Sportsman's Park for a three-game series with Detroit before embarking on their first extended road trip of the season, a 16-day, 17-game swing against the Eastern ballclubs. Steve Sundra, victorious in his first two starts of the season, was sent to the mound in the series opener against the Tigers on May 2nd.

Sundra began the game by giving up a single to Joe Hoover, but forced Eddie Mayo into a double play, Stephens to McQuinn. After Chuck Hostetler singled to center, Sundra finished the inning by inducing Rudy York to hit into a force play, Gutteridge to Stephens. That was the last batter Sundra faced in the 1944 season.

A sore arm kept Sundra from returning to the mound in the second inning, but the military prevented him from pitching the rest of the year. Three days after his one-inning outing, Sundra received his notice to report for military duty and on May 9th he was inducted into the Army.

Sigmund Jakucki took over for Sundra and pitched six innings, allowing eight hits and four runs. Thirty-eight-year-old Hostetler scored the eventual winning run in the seventh when he tripled off Jakucki and scored on a York fly out. Hostetler went 3-for-5, raising his average to .462. The 4-3 loss was the first by either the Browns or Cardinals at home (the two teams each played their home games at Sportsman's Park) on the young season.

Hostetler showed his age in the second game of the series, pulling a muscle in the first inning while chasing a fly ball off the bat of Clary, who ended up with a triple on the play. St. Louis trailed 2-0 but scored five runs on five hits in the fourth inning to take the lead. The inning featured back-to-back doubles by McQuinn and Stephens followed by a triple by Gene Moore and yet another double by Floyd Baker, who was filling in for Gutteridge at second base. Ironically, McQuinn, who was stationed at second base thanks to his double, was thrown out at home on Stephens' double as it appeared left fielder Jimmy Outlaw was going to catch the ball, but instead lost it in the sun.

"For me it was a tough ballpark to play in . . . the sun was the toughest sun field in the major leagues," recalled Outlaw, who played ten years in the major leagues. "It came right over the top of the stands . . . and it was just hard to see the ball coming off the bat. It was tough."

Jack Kramer earned his fourth victory against no defeats, although he needed some help in the ninth inning. With one out, Kramer surrendered three singles in the ninth, with one run scoring, but Al Hollingsworth and George Caster each recorded a fly out on the first pitch they threw to give the Browns a 7-4 win.

On May 4th, Nelson Potter kept the Browns rolling by tossing the team's first shutout of the year, a 2-0 win in the home finale. It was also the first time Detroit had been kept off the scoreboard in 1944.

That same day Sundra received his orders to report to the military, also the day the parents of Lou Gehrig became United States citizens—nearly three years after the death of their famous son—the Browns made a move to bolster their pitching staff. St. Louis announced they had signed pitcher Denny Galehouse, who went 11-11 with a 2.77 ERA in 1943 but was spending 1944 in a war plant job at a rubber factory in Akron, Ohio, to pitch weekend games.

The idea of using a player who worked at a war job just on weekends, so he could continue to have a 2-B draft status instead of 1-A, was a subject of controversy around the league. It was an idea originally proposed by the Philadelphia A's on behalf of their catcher, Hal Wagner. Wagner held a job at a plant in Riverside, New Jersey, close enough so he could catch on weekends and holidays in Philadelphia, Washington and New York. The advantage for the team was that they had another useful body, especially since rosters had been expanded until June 15th because of the amount of players in the military. For the player, it gave him a chance to play some baseball while

retaining a 2-B war worker status, thus ineligible to be drafted. One player, Ken Keltner of the Cleveland Indians, became a small hero among fans when he gave up his war plant job in March, thus losing his 2-B classification in favor of the awaiting-to-be-called 1-A status, to play baseball full-time. Following his decision Keltner said, "I'm a ballplayer by trade and I'm going to play until I'm called." Regardless of Keltner's move, the Browns and Bill DeWitt quickly backed the part-time player plan; the Yankees and Ed Barrow opposed it.

"A man is either a major league player or a war worker or bricklayer," Barrow said when the suggestion of using Wagner as a part-time player originally came up. "I think using part-timers would demean big league ball. It would give it a semi-pro tone."

Perhaps because the crosstown Yankees were against it, Branch Rickey of the Brooklyn Dodgers gave the plan his approval even though he had no plans for implementing the policy.

"I would have to be in pretty great need to use one of those part-timers, but these are emergency times," Rickey said. "Certain clubs may find the need of players very extreme and decide to follow the DeWitt suggestion."

Much to the chagrin of Barrow, baseball commissioner Judge Kenesaw Mountain Landis agreed with the so-called DeWitt plan, issuing a statement in April on the use of part-time players, one that turned out to be critical to the Browns' pennant drive:

"Player Wagner of the Athletics is on their active list. No special ruling is necessary in connection with his being deferred (in a war plant) and 'planning to catch week-end and holidays.' That is a matter between himself and the club."

Ironically, Wagner played only five games for Philadelphia and was traded to the Boston Red Sox just four days after the Browns signed Galehouse.

As St. Louis prepared for its long road trip, the Browns still remained in first place, just one of three American League teams to have a .500 or better record. The other two .500 clubs, New York (8-4) and Washington (6-6), were opponents on the upcoming Eastern city swing, along with Boston (6-8) and Philadelphia (5-7).

"I haven't the slightest idea what we'll encounter in the East. We've done alright against the Western Clubs," Sewell noted before leaving St. Louis. "We have given signs lately that we might hit a little better and barring accidents, it looks as if our pitching is in shape for the first Eastern trip.

"But there have been so many changes in the lineups of various teams that it's foolish to try to put the yardstick on them. We'll just have to play 'em and see. One fortunate thing—perhaps it's fortunate—is that there's no standout team in the East, no team that has cleaned up thus far against other clubs out that way."

St. Louis headed to Cleveland a little shorthanded. Not only was Sundra leaving the team to enter the Army, but also two Browns players suffered injuries forcing them to miss some playing time. Second baseman Don Gutteridge injured a finger on May 2nd that hampered his hitting ability, while catcher Myron "Red" Hayworth broke a finger on a foul tip in the fourth inning of St. Louis' 2-0 win over Detroit.

 Luke Sewell had been platooning his rookie catchers, Hayworth and Frank Mancuso, to date, but with Hayworth injured Mancuso figured to get the load of action behind the plate. In the first 15 games, Hayworth played in nine contests, starting eight, and was hitting .276 (8-for-29). Mancuso also appeared in nine games with eight starts, but he was batting just .154 (4-for-26). Another catcher, Joe Schultz, graced the expanded roster but he had yet to appear in a game. Schultz played in 46 games in 1943, but he was a defensive liability, someone Sewell liked to use more for pinch hitting purposes.

There was some good news: Mark Christman, although not fully healed from the cut he suffered on his hand the previous week, was ready to return.

The opening game at Cleveland was a harbinger of what was to come on the road swing. The Browns faced left handed 20-year-old St. Louis native Hal Kleine—who, to illustrate the difference of the times, the *St. Louis Post-Dispatch* reported to live at 3620 North Main Street in St. Louis—and lost 3-2. It not only would be both Kleine's first major league win and first

complete game, it also was his last. Kleine pitched in 10 other games in 1944—five starts—totaling 31 2/3 innings. He pitched in three games in relief in 1945 with no decisions before forever disappearing from the major leagues. To make matters worse, Roy Cullenbine, the ex-Brown whose attitude Sewell didn't like, thus leading to his trade from St. Louis, provided the game-winning blow with a monstrous home run to right field off Sig Jakucki in the eighth inning. St. Louis loaded the bases in the ninth with two outs, but Vern Stephens popped out to shortstop Rusty Peters, ending his miserable hitting day in which he went 0-for-4 without once getting the ball out of the infield.

Despite the fact that St. Louis was still in first place with a 12-4 record and each loss was by just one run, fans weren't being swept away by the Browns success. Only about 4,300 paying customers combined came out to the ballpark for the last three-game home stand against Detroit. Fans seemed to be waiting for the inevitable Browns collapse as in previous seasons. In his Extra Innings column, J. Roy Stockton of the *St. Louis Post-Dispatch* wrote about a person calling himself Scout No. 7, who said "we're all wet if we take the Browns seriously . . . He says they won't break even in their first 50 games."

On May 7th, St. Louis split a doubleheader with Cleveland, meaning the Indians took two of the three games, the first time the Browns lost a series on the season. St. Louis rapped out 12 hits in the opening game—its highest total of the season to date and only the third time the team reached double figures in hits on the year—in a 7-4 win. Kramer threw his third complete game in improving his record to 5-0 despite allowing four runs in the eighth inning.

Mancuso and Christman each had two hits in the first game, but Sewell started Schultz and Clary in game two. The Indians quickly took advantage of the substitutions.

Lou Boudreau led off the bottom of the first with a single then stole second base. After Mickey Rocco bounced out, Cullenbine grounded back to starting pitcher Al Hollingsworth who had a play on Boudreau. But Clary got in the way of the Indians player-manager and Boudreau was awarded third base. The next batter, Jeff Heath, hit a ball to first baseman George McQuinn. The Browns once again had Boudreau trapped between bases, but this time Schultz threw the baseball off Boudreau's back, the ball rolling into left field. Boudreau scored, Cullenbine went to third and Heath made it to second. Sewell decided to walk Ken Keltner intentionally to load the bases and set up a potential double play. The move paid off initially as Buddy Rosar popped out. But Pat Seerey doubled home two runs, giving Cleveland a 3-0 lead. Hollingsworth didn't give up a run the rest of the game but St. Louis managed just two runs off Indians starter Allie Reynolds, inevitably falling 3-2.

Despite losing two of three games to Cleveland, St. Louis was still in first place and boasted a few league leaders. Hal Epps led the American League in runs scored (14), Vern Stephens in runs batted in (16) and Don Gutteridge in triples (3). At 5-0, Jack Kramer was the circuit's top pitcher.

The Browns were off until Wednesday, May 10th, however they still had a couple of eventful days.

With pitchers Al Hollingsworth, Jack Kramer, Bob Muncrief and Nelson Potter left behind with coach Zack Taylor in Washington, D.C. where the Browns were going to be playing the Senators, the rest of the team traveled to Norfolk, Virginia to play an exhibition game against the Navy Bluejackets, a contest they dropped 9-4.

On May 9th, Steve Sundra was officially inducted into the army, outfielder Al Zarilla passed his physical exam at Jefferson Barracks in Missouri, paving his way for acceptance into the Navy, and outfielder Hal Epps was hit in the head in an errant pickoff attempt during the Browns 11-1 win over a Camp Patrick Henry baseball team in Newport News, Virginia.

St. Louis returned to Washington for a three-game series with a different twist—each contest was to be played at night. Over the first half-century, baseball was played mainly in daytime. The first night game between two major league teams wasn't played until May 25, 1935 when the Cincinnati Reds hosted the Philadelphia Phillies. Still, the majority of games were played during the day (the Chicago Cubs played only day games at home until 1988). But with the war, night baseball became more and more frequent so workers of all shifts could see games.

Some teams, like the Browns and Senators, embraced the idea of night baseball. Washington scheduled 43 night games in 1944, more than double the amount of St. Louis, which had 21 such games scheduled, the second most in the league.

Nighttime baseball didn't take hold in New York and Boston, however. Both American League teams in those cities had just day games scheduled for their home contests. Even the New York media was taken aghast at the thought of playing games under the lights. In June 1944, Dan Daniel wrote: "Night ball in too large doses undoubtedly would not be good for baseball in times of peace. You cannot take youngsters to night games, and if there is too much electric night play, there will be danger of baseball interest dying out with the current generation of patrons."

Night ball definitely was a hit in Washington. Big crowds were usually the domain of Sunday doubleheaders, but Wednesday, the first game of the series, the Senators drew 19,756 paying customers. The home faithful saw a 5-1 win by the Senators, including the first ball hit over the fences at the Washington ballpark that season. Roberto Ortiz, one of a number of Cuban ballplayers on Washington (including his brother, pitcher Oliverio "Baby" Ortiz) brought over by Senators owner Clark Griffith to help round out his team during wartime, hit the homer that tied the game at 1-1. Washington scored four runs in the sixth off Nelson Potter en route to a 5-1 win. Former Brown Johnny Niggeling, one of four knuckleball pitchers in the Washington starting rotation, picked up the victory while pitching a complete game.

In the fourth inning of the loss, catcher Frank Mancuso ran into the railing while chasing a foul pop fly off the bat of shortstop John Sullivan. Mancuso remained in the game for a while before eventually being replaced by Joe Schultz. Mancuso woke up the next day with his knee swollen. With Mancuso now sidelined and Hayworth still out because of a fractured finger, Sewell had to go with Schultz as the starting catcher for the contest against Washington on May 11th.

Joe "Dode" Schultz was the son of Joe "Germany" Schultz, a .285 lifetime hitter who played outfield and infield for seven major league teams from 1912 to 1925. Ironically, the elder Schultz didn't play during 1917-18 seasons, the span in which America fought in World War I. Following his playing career, "Germany" Schultz became a minor league manager. In 1932 he was piloting Houston. The mascot for that team was his son. That season, Joe "Germany" Schultz sent in his son, who was just 13 years old, to pinch hit during a regular-season contest. Despite his youth, Schultz singled. That made Joe Schultz the youngest player ever to appear in a professional baseball game. The mark eventually was broken by 12-year-old Charles Ralford, a bat boy in the Georgia State League (Ralford, though, grounded out, making Schultz the youngest ever to get a hit).

The pinch single wouldn't be the last hit in professional baseball for Schultz. He appeared in 22 games for the Pittsburgh Pirates from 1939 to 1941, collecting 12 hits in 52 at-bats for a .231 batting average. Schultz ended up with Memphis of the Southern Association in 1942. He hit .313 for the Chicks while posting career highs of 113 games and 358 at-bats. St. Louis bought Schultz from Memphis and he appeared in 46 games in 1943 for the Browns, hitting .239 with five doubles.

Although he didn't turn 26 until August, Schultz was not considered the Browns' catcher of the future. After all, St. Louis had two rookies, Hayworth and Mancuso, starting in front of him and had selected 31-year-old Henry Helf, who eventually was called by the Army, in the minor league draft. And, unfortunately for him, Schultz wasn't taking advantage of his opportunity.

Schultz's fielding gaffes helped the Browns to defeat in their recent series finale in Cleveland. Against Washington, he had another hand in a loss.

With the score tied 2-2 in the eighth inning, Washington put runners on first and third with two outs. Joe Kuhel was the batter with a count of no balls and two strikes. On the next pitch, the runner on first, Stan Spence, sprinted for second. Schultz inexplicably pegged the ball down to second baseman Don Gutteridge. However, Gutteridge didn't break for the bag, but was conceding the steal and playing back at his normal spot on the diamond. Schultz, who was not noted for a strong arm, one-hopped the throw to Gutteridge. Upon seeing Schultz's puzzling fling, George Myatt, who was on third base, raced for home. Gutteridge attempted to gun down Myatt, but instead threw the ball away. Both Myatt and Spence ended up scoring on the

play. The runs proved to be the difference as Washington won 4-2. Jack Kramer picked up his first loss of the season, undone by four Brown errors, including one on outfielder Milt Byrnes, who committed just one miscue the previous season, which led to three unearned runs. With the defeat, St. Louis (13-7, .650) fell to second place by percentage points behind New York (10-5, .667) although the Browns technically were still one-half game ahead of the Yankees.

Schultz's recent play did not go unnoticed. W.J. McGoogan, the Browns beat writer for the *St. Louis Post Dispatch*, summarized the game the next day: "Joe has proved that he just isn't a major league catcher. He cost the Browns a game in Cleveland Sunday, and last night he brought an end to Jack Kramer's great five-game winning streak with about as weird a piece of throwing as you ever saw."

Manager Luke Sewell obviously was not impressed with Schultz's play either. Despite the injuries to the other Browns catchers, Schultz didn't see any more action with the Browns in 1944. He was sent down to Toledo five days after starting against Washington.

Sewell reinserted Frank Mancuso into the lineup May 12th, and as the *St. Louis Post-Dispatch* reported, "Frank Mancuso carried a load of bruises and contusions behind the plate to catch." Nevertheless, Mancuso collected three singles in five at-bats as St. Louis tallied a season-to-date best 15 hits. The Browns left 13 runners on base, but scored five times in the first inning which was just enough to beat Washington. The 6-4 victory snapped an eight-game losing streak for St. Louis in Washington. New York also lost, meaning St. Louis was now back on top of the Yankees by not only percentage points, but also by one and a half games.

While Pensive galloped to a win at the Preakness on Saturday, May 13th, in New York the Yankees beat Cleveland 5-1. The Browns, now in Philadelphia, lost to the Athletics 8-3 to once again drop percentage points behind New York. The A's rocked Al Hollingsworth, Sig Jakucki, Sam Zoldak and Weldon "Lefty" West for 17 hits. Ford Garrison, obtained May 7th for Hal Wagner, rapped out three hits including a homer as he ran his hitting streak with Philadelphia to eight games. Bobby Estalella also homered and former Brown Frankie Hayes collected a triple and a single. All nine players had at least one hit for the A's, including pitcher Don Black, who gave up five hits in tossing a complete game.

Things didn't get any better in the Sunday doubleheader. St. Louis rallied with three runs in the ninth, the final two coming on a triple by Mike Kreevich, to tie the game 3-3 and eventually send the contest into extra innings. But reliever George Caster, who entered the game in the bottom of the ninth and was making his first appearance since pitching one-third of an inning May 3rd back in St. Louis, walked two batters and gave up a single to Jo-Jo White to help the Athletics load the bases with two outs in the 11th inning. Garrison then ripped his fifth hit of the game and knocked in his third run to hand Philadelphia a 4-3 triumph. In game two of the doubleheader, Tex Shirley and Luman Harris both kept the opposition off the board until the bottom of the eighth when Hayes, the ex-Brown purged out of St. Louis by Sewell, hit a two-run home run, his fourth of the year. St. Louis had no ninth-inning comeback in them this time. The Browns managed just two singles off Harris, getting shut out for the first time on the season.

Worse yet for St. Louis was that New York swept its doubleheader with Cleveland. The Yankees (13-6) now claimed a one-and-a-half game lead over the Browns (14-10), losers of seven of nine games since embarking on their road trip. For the first time on the season, St. Louis was trailing another team in the standings.

One anonymous Brown voiced his thoughts to the *St. Louis Post-Dispatch* following the doubleheader loss, saying, "Nobody expected us to win nine games at the start, did they? And if we hadn't done that, everybody would have been pleased with the way we stand now. Of course, that's no excuse. While we had 'em down, we should've choked 'em."

Manager Luke Sewell had his own thoughts about the losing streak. His involved making changes in the lineup. For the most part, Sewell had been using the following lineup: Leadoff, Don Gutteridge, second base; 2nd, Milt Byrnes, left field; 3rd, George McQuinn, first base; Cleanup, Vern Stephens, shortstop; 5th, Gene Moore, right field; 6th, Mark Christman, third base; 7th, Mike Kreevich, center field; 8th, Frank Mancuso, catcher. Following the

doubleheader loss to the A's, Sewell singled out outfielder Milt Byrnes. The Browns hit into eight double plays in the three losses at Philadelphia; Byrnes had hit into two of them.

"We can't have a left fielder, batting second, hitting into double plays every day," Sewell said, hinting he was going to replace Byrnes with Al Zarilla, back from his military physical, in the upcoming series in Boston.

It didn't help Byrnes that he was hitting just .220 on the season and had only three hits in his last 22 at bats (a .130 batting average) after beginning the month by going 8-for-22 (.360).

A St. Louis native who worked at City Hall in the offseason, Byrnes was a "muscularly built athlete" at 5-foot-10 1/2 inches, 176 pounds. Nicknamed "Skippy" after a comic strip character, Byrnes was classified 4-F because of a bronchial condition. The Browns brought him up in 1943 after he spent the previous season with the club's top farm team in Toledo. Byrnes played in 129 games for St. Louis in '43, batting .280 with 28 doubles, seven triples and four home runs. Years later, however, Sewell brandished Byrnes as nothing more than a player who got a chance to make the majors because of the war.

Despite the heated postgame remarks of Sewell, when St. Louis took the field for the series opener at Boston on May 16th, Byrnes was in the starting lineup. However, he was shifted to right field and dropped down to seventh in the batting order. Hal Epps made his first start since being hit in the head with a thrown ball during an exhibition game May 9th, although he really was only starting because Kreevich was sick. Epps, playing center field, took Byrnes' second place hitting spot in the lineup. Gutteridge, McQuinn, Stephens and Christman returned to their spots in the order and "Red" Hayworth came back from his fractured finger to take his place behind the plate and bat eighth. In place of Gene Moore, Sewell inserted another veteran outfielder, Frank Demaree.

The 33-year-old Demaree enjoyed his most success from 1933 to 1940 when he batted over .300 five times, including a career best .350 in 1936 with the Cubs, and played in two All-Star Games. But in 1941, Demaree's career went into a tailspin. After hitting .302 for the New York Giants in 1940, Demaree hit just .171 in 16 games in 1941 and was put on waivers in June. The Boston Braves picked him up, but Demaree hit just .230 in 48 games for the rest of the season and only .225 in 64 games in 1942. As a backup for the St. Louis Cardinals, Demaree hit .291 in 39 games in 1943 and played in his fourth World Series, none of which he ended up on the winning side. Sewell picked Demaree up after the Cardinals released him in March to add an experienced bat to the bench. Demaree appeared in only three games in April, though, and just four so far in May, collecting six hits in 22 at-bats.

The new lineup didn't do much good at first, the Red Sox taking leads of 1-0 and 3-1. But St. Louis narrowed the lead to one by scoring in the sixth, and then tied the game in the ninth when pinch hitter Ellis Clary doubled and eventually scored on a groundout by Kreevich who was batting for Epps. The Browns then won the game in extra innings, scoring four times in the 12th off pitcher Vic Johnson, who was left in for 11 2/3 innings by Boston player-manager Joe Cronin. George Caster, who picked up the loss in the Browns defeat two days prior, pitched four innings of scoreless relief to get credit for the win.

Despite the victory, Sewell continued to jumble his lineup. In a Wednesday doubleheader, Sewell finally put Zarilla into the starting lineup, placing him in left field and batting him second. Moore was put in right field and took McQuinn's third spot in the order, with the first baseman dropping to seventh. Byrnes was moved to center field, his third starting position in three games, and batted fifth behind Stephens. The Browns lost the first game of the doubleheader to Boston, 5-1, but came back to win the nightcap 12-8, although starting pitcher Sig Jakucki helped his own cause by driving in four runs. The Red Sox's Bobby Doerr did hit for the cycle—hitting a single, double, triple and a home run—but the Browns also got out the lumber, knocking 14 hits with four doubles, a triple and a Stephens home run.

Sewell used yet another different lineup in the series finale May 18th, with Kreevich in center and Demaree starting in left, but the Browns got blitzed by Boston, 12-1. Tex Shirley

gave up five hits, six walks and five runs in four innings while Al Hollingsworth, now relegated to relief, was pounded for eight hits and six runs in three innings.

With the Browns loss to Boston, Washington jumped over St. Louis, moving the Browns into third place. The standings were tight, though, with New York (14-9) and Washington (15-10) tied for first followed by St. Louis (16-12), which was just one-half game back. St. Louis had a prime chance to regain the top spot as they traveled to New York for a four-game series to complete its 16-day, 17-game Eastern road trip. However, Hal Epps was headed to Houston instead. Epps received his draft notice and was given permission to travel home before his May 26th induction date.

The Yankees of 1944 weren't the same powerhouse bunch loaded with talent that won six World Series titles between 1932 and 1941. Still, New York had made the fall classic in the first two war-year campaigns, losing to the Cardinals in 1942 then winning the championship over St. Louis in 1943.

New York was missing some key players from its recent pennant winning teams, although it wasn't quite as bad as some might think. Outfielders Joe DiMaggio and Tommy Henrich and shortstop Phil Rizzuto were all in the military in '43 when the Yankees claimed 98 victories to win the American League by 13.5 games then beat the Cardinals, who powered through the National League winning 105 games, four games to one to win the World Series.

Second baseman Joe Gordon joined the Air Transport on March 17th, but he was replaced by the younger, speedier George "Snuffy" Stirnweiss. Catcher Bill Dickey joined the Navy in March, but he was to turn 37 years old in June and had been only a part-time player for the previous two seasons. The two biggest losses from the 1943 squad were power-hitting outfielder Charlie Keller and AL MVP pitcher Spud Chandler.

The Yankees still had some good pitching left over from their championship season with starters Ernie "Tiny" Bonham (15-8, 2.27 ERA in '43), Hank Borowy (14-9, 2.82), Bill "Goober" Zuber (8-4, 3.89) and Atley Donald (6-4, .732 winning pct. in 92 career games entering the season) and reliever Jim Turner (3-0, 3.53). Rookie Joe Page, who later made his mark as an ace reliever, was added to the starting mix. New York also returned several good hitters, including first baseman Nick Etten (.271, 14 HR, 107 RBI in '43). Etten, Stirnweiss, outfielders Bud Metheny and Johnny Lindell and catcher Rollie Hemsley all were starters for New York in 1943. The Yankees also added veterans like outfielders Herschel Martin and Larry Rosenthal and infielder Oscar Grimes in '44.

Years later Sewell admitted that New York obviously didn't have as much talent and firepower as they had in years past, but the 1944 edition of the Yankees still had more skill than the Browns. Sewell indicated that New York manager Joe McCarthy, after years of sitting back and watching the Yankees pound the opposition, didn't know how to adjust to a team that needed to bunt runners over more and do the little things to win ballgames.

Prior to the beginning of the season, Chicago White Sox manager Jimmy Dykes echoed those thoughts, saying, "Joe McCarthy will really have to go to work this season. He won't be able to sit back the way he did in other years and simply push buttons."

The St. Louis-New York series began as a slugfest. In the first inning, Al Zarilla, getting a starting nod with Epps in Houston and Mike Kreevich stuck in the hotel with a 101-degree fever, smacked a solo home run, his first of the season. The Browns scored two more runs in the second, but the Yankees took the lead in the bottom half of the inning, scoring four runs—including a two-run homer by Bud Metheny—off St. Louis starter Nelson Potter. A passed ball allowed the the Browns to tie the game in the fourth inning and St. Louis retook the lead in the sixth when Milt Byrnes singled in Gene Moore, who had doubled. Mark Christman, who was playing first base for George McQuinn, sitting out because of a sore neck and shoulder, blasted his first homer of the season in the eighth off reliever Jim Turner to give St. Louis a 6-4 lead. The Yankees got one more run off Potter in their half of the eighth but could get no more. The 6-5 win put the Browns back in first place as Washington also lost, 4-1 to Detroit.

The show of power was rare for St. Louis. Coming into the contest they had hit only seven home runs in the previous 28 games. It also marked the first time separate players had hit homers in the same game (St. Louis had two homers in one game just once before, when Kreevich hit two in the home opening 5-3 win over Chicago on April 21st). Christman, who went 3-for-3, continued to show he was recovered from his hand injury. He was 6-for-12 in his last three games with two doubles and the home run. Prior to that, Christman had but one extra-base hit (a double April 20th) on the season.

Nevertheless, beyond shortstop Vern Stephens there was no real home run threat on the Browns. The one thing Sewell wished for his team in spring training was a power-hitting outfielder. His request was finally granted.

Bill DeWitt, Vice President of the Browns, announced that St. Louis had obtained the services of outfielder Chet Laabs as a part-time player. Following his passing of a military exam in February, Laabs was scheduled to be inducted into the military April 15th. But following that physical, the drafting rules concerning age changed, which in turn delayed the 31-year-old Laabs' induction. The signing coincided with Laabs changing from a war plant job in Detroit to St. Louis. With Laabs now working in St. Louis, DeWitt figured the Browns could get the outfielder to play in 51 games, what with the team having 22 night games, seven Saturday day contests and 11 Sunday doubleheaders left on their home schedule.

The fact that Laabs found a job in St. Louis was no accident. Laabs, who began his major league career with the Detroit Tigers, had been working in the personnel department of a Chrysler automobile factory. But DeWitt, with an obvious ulterior motive, got Laabs a job with his father-in-law's war plant which built bombers. Laabs was given a position to inspect pipes. Laabs subsequently discovered those pipes, which were roughly 10-14 inches in diameter, were sent to Tennessee for use in the making of the first atomic bomb.

Laabs was described as being "piano-legged," but despite the thin appendages he could hit, thanks in part to a muscular upper body (Laabs stood just 5-foot-8 but weighed 175 pounds). Laabs was not known for getting loft on the balls he hit, but rather for hitting hard line drives that just stayed up and left the park in a hurry. Laabs never hit below .400 in semi-pro ball and he led two different leagues in Milwaukee in hitting in 1933 and 1934 with averages of .468 and .411, respectively.

His foray into professional baseball was a success as well. Laabs, playing for the Fort Wayne Chiefs, won the Triple Crown in the Three-I League in 1935, leading the circuit in batting average (.384), home runs (24) and runs batted in (96). Two years later, at the age of 25, Laabs made his major league debut with Detroit.

Laabs served mainly as a fourth outfielder for the Tigers in 1937 and 1938. While he showed some of the power that he displayed in the minors, Laabs hit just .240 and .237 in his first two major league campaigns with 118 strikeouts in 453 at-bats, or one every 3.8 at-bats, a horrible ratio (Hall of Famer Reggie Jackson, who struck out more than anyone else in major league history, struck out once every 3.8 at bats during his 21-year career). In the second game of a doubleheader played October 2, 1938, Laabs tied a major league record by striking out five times in a nine-inning game. The pitcher, Cleveland's Bob Feller, struck out 18 batters to establish a new single-game strikeout record.

Laabs played just five games for Detroit in 1939 before he was traded to St. Louis in a ten-player deal May 13th. The Tigers sent Laabs, Mark Christman and pitchers Vern Kennedy, Bob Harris, Roxie Lawson and George Gill to the Browns in exchange for outfielder Beau Bell, infielder Red Kress and pitchers Bobo Newsom and Jim Walkup. Only Laabs, Christman and Newsom were still with their respective clubs for the 1941 season. The well-traveled Newsom—he was traded, sold or waived to another club ten times over a 20-year career—lost 20 games for the Tigers that year and was shipped to Washington in the offseason.

The move to St. Louis immediately increased Laabs' playing time. The Browns sold Mel Almada, who hit .342 in 102 games in 1938 after being acquired from Washington, to Brooklyn on June 15th and made Laabs the starting center fielder. In 95 games with St. Louis, Laabs hit

.300. In 1940, Laabs was a part-time right fielder and pinch hitter. He played in 105 games but had just 218 at bats. However, Laabs did post a batting average of .271 and a slugging percentage of .505. He also led the American League with 14 pinch hits.

Laabs played more regularly in 1941 and hit .278 with 23 doubles, six triples and 15 home runs in 118 games. In 1942, Laabs broke out with his finest season. He played in his most games to date, 144, hitting .275 with 27 home runs—second most in the A.L. behind only Boston's Ted Williams, who had 36—90 runs scored and 99 runs batted in. He walked a career-high 88 times, but also had 88 strikeouts. In 1943, Laabs garnered six MVP votes, good enough for 23rd place, after he hit .250 with 27 doubles, seven triples and 17 home runs with 83 runs and 8in 151 games. He also led the American League with a career-worst 105 strikeouts.

With the state of their team, the Browns were willing to trade the inevitable strikeouts for the power potential Laabs presented.

"He had a lot of power, but Laabs struck out quite a bit," Don Gutteridge recollected. "He wasn't a real good fielder, just average. Footspeed he didn't have much of. He did have a good bat but Chet struck out quite a bit. But when he hit the ball it was gone."

Unfortunately for the Browns, Laabs wasn't available until they returned to St. Louis and they still had three more games to play in New York.

The Yankees made a move of their own earlier in the month, calling up pitcher Walter Dubiel and sending down rookie hurler Floyd "Bill" Bevens. Dubiel, called "Monk" because his appearance and traits resembled one of the quiet, robed monastery dwellers, had pitched a couple of no-hitters over the past two seasons in the minors.

Dubiel received some help in his first start against the Browns. In the third inning, Jack Kramer, who walked with two out, was thrown out at the plate trying to score on a double by Don Gutteridge. St. Louis did score once in the fourth, but New York took the lead by tallying twice in the fifth. The second run scored when a controversial balk call on Kramer was made by first base umpire Bill Summers. With Stuffy Stirnweiss on third and taking a considerable lead, the Yankees protested to home plate ump Joe Rue that Kramer paused in his delivery, thus balking. Summers didn't make the call, but Rue eventually did. Luke Sewell, who had stirred the pot the previous season when he said the Yankees got breaks by receiving favorable calls from the umpires, argued at length over the ruling but to no avail. As the teams changed sides at the conclusion of the inning, Tex Shirley, the scheduled starter in the series finale, was thrown out for giving some heat to Summers regarding the call.

Dubiel helped his own cause in the eighth by doubling home Rollie Hemsley, who had reached first on Vern Stephens' second error of the contest. St. Louis got one more run in the ninth, but Kramer's play at the plate haunted them as they got no closer, losing 3-2. Kramer lost his second straight decision after winning his first five and St. Louis dropped back to second place behind the Yankees, who broke a four-game losing streak.

The final two games of the series were played in a Sunday doubleheader May 21st. While St. Louis fans might have been cool regarding the Browns pennant chances, 54,725 fans showed up at Yankees Stadium—the largest New York crowd of the season—to see the top two American League teams do battle. It would be the largest crowd a Browns ballclub ever played in front of.

Bob Muncrief, who entered the contest 0-5 against the Yankees in his career, opposed Hank Borowy in the first game. Muncrief quickly got into a hole, serving up a two-run homer to Bud Metheny in the first. But Muncrief, although allowing a handful of baserunners, kept the Yankees off the scoreboard after that. With subsequent RBI singles by the pitcher himself and Mark Christman, the Browns were able to send the game into extra innings tied 2-2. Both Luke Sewell and Joe McCarthy kept their starters in the game as neither team scored in the tenth or eleventh innings.

Borowy got two out in the twelfth, but an error by third baseman Don Savage put second baseman Gutteridge on board. Al Zarilla was hitless in his first five at-bats and Gene Moore was 0-for-4. But both players followed Gutteridge's fortune by singling, with Gutteridge scoring on Moore's hit to give the Browns a 3-2 lead.

FRANK DEMAREE. Demaree, a two-time All-Star who played on four World Series teams was added by manager Luke Sewell to give the Browns an experienced batter. (NBH)

But Muncrief, who had pitched ten scoreless innings after surrendering the homer in the first, still needed three outs. Stirnweiss opened the frame by pushing a single just past shortstop Stephens. After Metheny was retired, Stirnweiss stole second base then went to third base as Muncrief threw a wild pitch. Muncrief got two strikes on Ed Levy, but the left fielder fought off the next pitch and blooped it into right field. Stirnweiss scored the tying run and Levy was able to advance to second base. With first base open, Sewell elected to have cleanup hitter Nick Etten intentionally walked, the third time in the game he deployed that strategy. With the double play now set up, Savage topped one off of his bat, the ball slowly rolling down toward third base. Mark Christman could do nothing but pick the ball up and return it to Muncrief; the winning run was on third as the bases were now loaded.

Sewell decided to bring in his ace—but sporadic—reliever, George Caster. Caster last pitched May 17th and had given up four hits, two walks and three runs in a St. Louis loss. But the day previous to that loss he had pitched four scoreless innings and picked up the win in the Browns' 7-3 extra inning win over Boston. It didn't take Caster long this time. He threw five pitches to Johnny Lindell, four of them balls. The walk forced in the winning run.

The disheartened Browns had to come out for another game. They should have stayed in the locker room. Shirley couldn't make it out of the second inning as New York pounded him for six runs in the frame. Denny Galehouse made his first appearance of the season, relieving Shirley and going 5 2/3 innings, surrendering seven hits and two runs. St. Louis managed just three hits off rookie Joe Page, one of them Gutteridge's fifth triple, and lost 8-1, falling further behind New York.

To make matters worse, the Browns didn't just leave first place in New York, they also left some of their pride. St. Louis players and coaches had to hustle to get to their outgoing train to St. Louis. With no cabs in sight, the group had to settle for a truck which transported the team to the train station.

The dump truck exit was suitable for the Browns. They had begun their road trip two-and-one-half games up on the rest of the American League but now found themselves two-and-one-half games back and barely clinging to a record above .500. St. Louis went 5-12 on its Eastern tour, hitting a paltry .228 in the 17 games. Many observers felt the Browns' time among the league leaders was over, the decline towards the familiar second division just beginning while the defending World Series winners, the Yankees, further staked their claim as the league's elite team.

The day after the bitter doubleheader loss by St. Louis to New York, Louis Effrat wrote in the *New York Times*, "The results solidified the champions grip on first place to the extent of a two-and-a-half game lead over the same Browns, although, it is questionable if they ever will be the same after what happened to them yesterday."

Six

Fourth Inning
Falling Popups, the Falling Axis, and Why the Potter Family Grew by One

Despite the presence of some Latin players on major league rosters—Washington had several so-called "light-skinned" Cuban players—baseball was still segregated. There hadn't been a black player on a major league roster since Moses Fleetwood Walker and his brother Welday appeared for the Toledo Blue Stockings of the American Association in 1884. The Toledo franchise folded following the season, taking with it the major league careers of the Walkers.

In 1901, Baltimore Orioles manager John McGraw tried to use a black ballplayer, Charlie Grant, by attempting to disguise him as an American Indian, going so far as to give the player the name of Chief Tokohama. But the ruse didn't work, as Chicago White Sox owner Charlie Comiskey—who played for and managed the American Association St. Louis team the year Moses and Welday Walker played for Toledo—put the kibosh on McGraw's plan before Grant could ever play in a regular-season game.

Despite a couple of token tryouts with other major league clubs, Jackie Robinson didn't sign his professional contract with the Brooklyn Dodgers until 1945 and didn't break the color line in Major League Baseball until 1947.

Social segregation was still the norm as well in 1944. Blacks could attend St. Louis Browns and Cardinals games, but only if they didn't mind being confined to the bleachers or pavilion seating.

While it wasn't even close to being on par with Robinson's historic feat, St. Louis and Sportsman's Park took a step toward civility just after the Browns left for their road trip. As an Associated Press report stated, "Negroes now may purchase seats in the grandstand."

Not that turnabout wasn't fair play, either. An advertisement for Satchel Paige pitching against the New York Black Yankees in Atlanta concluded with, "A special section has been reserved for white fans."

St. Louis signed outfielder Tom Hafey, who had been playing in the Pacific Coast League, on May 22nd to add some offensive punch. The Browns didn't need Hafey's slugging in their first game back home though.

The Browns scored three runs in the first inning and four in the fifth in beating Boston 7-3 on May 24th. St. Louis managed just seven hits—six of them singles—but were helped out by nine free passes issued by Red Sox hurlers. Jack Kramer went the distance to improve his record to 6-2.

Bob Muncrief followed up Kramer's effort the next day in the Browns' 3-2 victory, pitching his own complete game win despite the presence of rain, causing about an hour delay during the top of the fifth inning. Muncrief got out of a jam in the sixth thanks to a tremendous catch by Mike Kreevich and struck out Catfish Metkovich, who entered the game batting under .125, to end the eighth with the tying run on second.

St. Louis tagged Tex Hughson for two runs in the bottom of the fifth inning, the first coming on a home run by George McQuinn. It was McQuinn's first homer of the season, but as was written in the *St. Louis Post-Dispatch*, "It was a real old-time McQuinn hit, about 360 feet from the plate, and reminded you of a few years ago when George did that quite often."

GEORGE MCQUINN. Always considered a stellar fielder, George McQuinn showed he could hit, too, after escaping the Yankees' farm system where he labored for years since New York already had Lou Gehrig at first base. McQuinn had a 34-game hit streak in 1938. (NBH)

McQuinn was noted more for his fielding than his batting. In 1936, before he had ever played a game in the majors, McQuinn was already being compared to distinguished first base glovesmen George Sisler, a former Browns player, and Hal Chase. His resemblance to Sisler was no accident. McQuinn modeled his style after Sisler as well as Joe Judge, a stellar fielder in the '20s and '30s with Washington.

Second baseman Don Gutteridge, for one, was glad to have McQuinn at first base. Remarked Gutteridge in 1994: "I'll tell you one thing as an infielder, he made our infield. All you had to do with George is just start the ball in that direction and he'd come up with it. To this day, I don't know any first baseman that's any better fielder than him. Yeah, he saved me a lot of errors I know that. I'd just throw it in that direction and George'd get it, he'd get it."

But McQuinn, known as the Patient Scot because of his Scottish background (he was also part Irish) and quiet demeanor, wasn't a shabby hitter.

In 1933, McQuinn was the MVP of the New York-Penn League after hitting .357. McQuinn, however, was in the New York Yankees organization. As a first baseman that meant being stuck in the minors thanks to Lou Gehrig, who was in the midst of playing 2,130 consecutive games. It was remarked that McQuinn's pals used to pray for the "Iron Horse" to break a leg to allow McQuinn a chance to finally play in the majors.

Cincinnati obtained McQuinn briefly in 1936, but despite the comparisons to Sisler and Chase he was returned to the Yankees' Newark farm club after batting just .201 with three doubles, four triples, no homers, five runs, 13 RBI, 10 walks and 22 strikeouts in 38 games.

McQuinn obviously didn't belong in the minors, proven by his fine 1937 campaign. With the Newark Bears, McQuinn hit .331 in 114 games with 29 doubles, 11 triples, 20 home runs, 95 runs and 80 RBI. He also had a spectacular fielding percentage of .997. After holding McQuinn back in their minor league system since 1930, the Yankees finally allowed McQuinn to leave.

Pat Monahan, a Browns scout, advised St. Louis to obtain McQuinn, and New York, which still owned his rights, allowed the club to draft him. Ironically, Gehrig retired from baseball in 1939 after contracting the fatal disease that soon bared his name.

Nearing his 28th birthday, McQuinn finally got his shot at the majors. Unlike his tryout with the Reds, he didn't disappoint the Browns.

In 1938 he hit .324 with 42 doubles—both of which would turn out to be career highs—seven triples, 12 homers, 100 runs and 82 RBI. McQuinn rapped a hit in 34 consecutive games that season, which at the time tied the eighth-longest hitting streak in major league history and the fourth longest since the advent of the American League in 1901. McQuinn also demonstrated a good batting eye, drawing 58 walks while striking out just 49 times.

McQuinn set a number of career highs in 1939: games played (154), triples (13), homers (20), runs (101), RBI (94) and slugging percentage (.515). McQuinn also hit .316 with 37 doubles that season and was named to his first All-Star team.

He was an All-Star again in 1940. Although his average slipped to .279, McQuinn still powered 39 doubles, 10 triples and 16 home runs while scoring 78 runs and driving in 84. McQuinn hit .297 with 28 doubles, four triples, 18 homers, 93 runs and 80 RBI in 1941, and on July 19th of that season he became the third and last Browns player to hit for the cycle in a game, joining Sisler, who accomplished the feat twice, and Baby Doll Jacobson.

But in 1942, despite making the All-Star team for the third time in four seasons, McQuinn started to develop a back injury and his batting numbers began to slip. He still displayed some power, knocking 32 doubles, five triples and 12 homers, but his average dipped to .262.

The back problems continued in 1943. McQuinn, who converted himself from a pitcher early in his career because he didn't like having to rest three days in between playing games, appeared in just 125 games, his lowest total as a Brown. He hit just .243 with decreasing power—19 doubles, two triples and 12 home runs. By the end of the season McQuinn couldn't even complete the natural motion of his swing because of the pain in his back.

McQuinn had to wear a steel brace at times to alleviate the pain. After playing a game, McQuinn often went home to the Gatesworth Hotel, his inseason residence in St. Louis, and laid down for two or three hours. The tactics to lessen the injury seemed to be helping in 1944. Manager Luke Sewell had enough faith in McQuinn to continually bat him third in the order. McQuinn rewarded Sewell's confidence with his superb fielding, excellent leadership and timely hits.

"McQuinn was one of the best fielding first basemen I've ever seen and he could hit the long ball," said Jimmy Outlaw, who played against McQuinn in both the minor and major leagues. "He wasn't a high-average hitter but he was pretty tough with men on bases. He'd hit a home run once in a while, but he was more of a line-drive hitter.

"But he could field with any of them. He would have been with the Yankees if they didn't have that other guy ahead of him. I played against him in the minor leagues and I wondered why he wasn't up there. One reason was because he belonged to the Yankees and they weren't going to lose [Gehrig] from first base."

On May 26th, Nelson Potter came four outs away from making history. After the first two hitters were retired in the eighth inning, Boston had sent 23 batters to the plate against Potter and none had reached base. There had been 38 no-hitters thrown in the history of the American League, none since Bob Feller's opening day whitewashing of Chicago in 1940, and just three perfect games. The last time a Browns pitcher hurled a no-hitter was in 1917, when Ernie Koob and Bob Groom each twirled one on consecutive days.

But Potter's moment in baseball history was not to come just yet. Red Sox third baseman Jim Tabor, whose playing career and life were both cut short because of his affinity for booze, smacked a Potter pitch back between the pitcher's legs. Potter charged the ball instead of backing up and letting it come to him. The ball rolled slowly towards second base where Gutteridge picked it up and slung it on to first, but the throw was too late to nab Tabor.

The hit rattled Potter. He proceeded to walk Hal Wagner then surrendered a single to Skeeter Newsome, Tabor scoring on the play to narrow the Browns lead to 2-1. Sewell kept

Potter in the game and in the ninth the pitcher gave up two more singles, putting runners on first and third. A sacrifice fly by player-manager Joe Cronin tied the game. Still, Sewell stuck with Potter. The Browns couldn't score in the ninth or tenth—a botched sacrifice bunt by Kreevich in the tenth perhaps spoiling the Browns chance of winning.

Potter retired the first two batters in the eleventh inning, but Metkovich rapped his second single of the contest and Potter walked Tom McBride (just one of eight bases on balls McBride drew in 71 games) putting the go-ahead run in scoring position. Cronin, 0-for-8 in the series, singled to break the tie. Bob Johnson added another run with a single. Sewell finally pulled Potter and inserted reliever George Caster, but it was too late. Mike Ryba finished off his fourth inning of scoreless relief retiring the Browns in order in the bottom of the inning to complete a Red Sox 4-2 win. Potter, just four outs away from baseball immortality, surrendered seven hits and two walks after retiring the first 23 Boston batters.

The loss, coupled with wins by both New York and Washington, dropped St. Louis into third place, trailing the Yankees by two-and-a-half games and the Senators by one-half game.

Sig Jakucki, making his first start since May 17th, helped pitch the Browns back into second place by beating Boston 4-2 on May 27th. Jakucki gave up a run in both the first two innings—the second coming when Bobby Doerr scored after Frank Demaree dropped a Newsome fly ball—but St. Louis matched the Red Sox run total and put two more on the board by scoring single runs in the third and seventh. Jakucki gave up just three more hits in the final seven innings to finish with a four-hit complete game win. He walked one and struck out five to improve to 3-0 as a starter; Jakucki was 0-2 as a reliever.

THE STANDINGS NOW LOOKED LIKE THIS:

Team	W	L	GB
New York	18	11	
St. Louis	20	16	1.5
Washington	18	15	2
Philadelphia	17	16	3
Detroit	16	19	5
Boston	15	18	5
Chicago	14	18	5.5
Cleveland	15	20	6

The Browns, 10-2 at Sportsman's Park, had a prime opportunity to move back into first and distance themselves from third place. They hosted New York for a three-game series and Washington for four.

A crowd of 17,740 (15,810 paid), the highest Browns home turnout to date, showed up for the Sunday New York-St. Louis doubleheader. Weekend pitcher Denny Galehouse made his first start of the year for the Browns in the opener, facing Hank Borowy.

The St. Louis players didn't make Galehouse's first start any easier. In the fourth inning, Vern Stephens got thrown out at the plate following an Al Zarilla single. In the sixth, Gene Moore allowed a Nick Etten single to roll through his legs, Etten getting all the way to third base and eventually scoring on a sacrifice fly. Moore did hit his first home run of the season in the bottom of the inning to knot the score at 2-2.

The score remained that way into extra innings. The Browns blew a good chance to win in the tenth inning when McQuinn was easily nailed at third trying to advance from first on a single by Stephens.

Perhaps forgetting the fate of Potter just two days earlier, Sewell left Galehouse to pitch in the eleventh inning. After retiring Ed Levy and cleanup hitter Etten, Galehouse gave up a solo homer to Johnny Lindell, the outfielder having knocked in all three runs off the Browns hurler. After two more batters reached base, Sewell finally yanked Galehouse, but reliever Tex Shirley

MIKE CHARTAK. Mike Chartak, the "Volga Batman," hit 10 homers for the Browns in 1943. He quit his war plant job in May 1944 to join the team full-time. (SM)

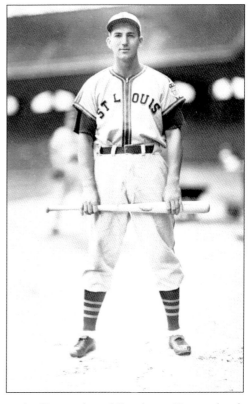

just added fuel to the fire. Shirley allowed a two-run single to Borowy and walked Bud Methany with the bases loaded to force in another run. Weldon "Lefty" West had to be brought in to get the final out.

The outburst left the Browns trailing by four runs, but they scraped across one run to cut the lead to 6-3. With two runners on and two out, Mike Kreevich sent a line drive into center field. Lindell dove for the ball and came up with it in his glove. However, first base umpire Bill Grieve said Lindell trapped the ball. The Yankees insisted umpire Bill Weafer had a better view of the play and Grieve waived his judgment to that of Weafer, who declared Lindell had made a shoestring catch, thus ending the game. The Browns, of course, protested and Gutteridge nearly took a swing at Weafer before cooler heads prevailed.

St. Louis took a 2-0 lead after four innings in the second game, but the Yankees exploded against Browns starter Jack Kramer in the fifth, scoring five runs on six hits and errors by Kreevich and Stephens. Demoralized, St. Louis lost 6-2 to the Yankees. The doubleheader sweep put New York three-and-a-half games up on St. Louis.

A New York sweep looked probable, especially with Bob Muncrief taking the mound for St. Louis in the third and final game of the series. Muncrief entered the league in 1937—although he didn't pick up his first decision until 1941—and had yet to beat the Yankees, compiling an 0-6 record.

Muncrief got off to his usual ways, giving up a run in the first on a Levy RBI single. St. Louis countered with two runs in the bottom of the inning on a McQuinn home run, but New York tied the score in the second.

Muncrief, though, settled down while the Browns exploded off Atley Donald in the third for four runs, highlighted by Moore's three-run homer, knocking the normally reliable pitcher out of the game. The St. Louis bats didn't cool off, accounting for 13 hits and 11 runs off three Yankee pitchers. Five of the Browns' hits went for extra bases, including two doubles by Milt Byrnes and another by Red Hayworth. Muncrief did surrender 10 hits in the contest, but allowed just one run past the second inning as the Browns cruised to an 11-3 victory. Combined with a Washington loss, St. Louis was back in second place.

Arriving in town just before the Washington series was Mike Chartak. Chartak, a first baseman-outfielder, quit his war plant job in Cleveland to return to playing baseball full-time. He supplied the Browns with a decent bat off the bench and some much needed power. (In 1943, his first full year with the club, Chartak hit .256 with 10 home runs in 108 games.)

Nicknamed the "Volga Batman" because of his Russian heritage (Chartak means "little devil" in Russian) and "Shotgun" because of his strong arm, Chartak developed his strength in his youth by swinging a coal pick. Chartak was born in Brooklyn but his family soon moved to Carbondale, Pennsylvania. He was not only a star athlete in high school, but also a miner of

"bootleg coal." At the age of 17, Chartak left the coal miner's life, signing with Wilkes-Barre of the New York-Penn league.

Just over a year later, in June 1935, the Yankees signed Chartak and assigned him to their minor league system. Like McQuinn with Gehrig, Chartak's path to the majors was blocked by the New York outfield trio of Joe DiMaggio, Charlie "King Kong" Keller and Tommy Henrich. Chartak stayed in the minors for five years, until he was given a brief look by the Yankees in 1940. Chartak played in 11 games, collecting just two hits in 15 at bats, a .133 average.

In 1941, New York manager Joe McCarthy gave Chartak an opportunity to win the first base job in spring training, vying for the position against rookie Johnny Sturm. In the end, McCarthy moved Joe Gordon from second base to first base, eventually moving him back to second after a month and inserting Sturm in his place. Chartak was sent back to the minors in Kansas City.

Chartak spent the entire 1941 season in the minors. He appeared in five games for the Yankees in 1942, without collecting a hit, prior to being sold to Washington for the waiver price. Chartak played in 24 games for the Senators, batting .217, before being traded to St. Louis on June 2nd along with Steve Sundra and Bill Trotter for Roy Cullenbine. The Browns along with Brooklyn had shown interest in the player when he was sold to Washington earlier in the season. With the Browns, Chartak played in 73 games, hit .249 and picked up the "Volga Batman" nickname.

Chartak didn't play in the Browns' Memorial Day doubleheader against Washington, St. Louis didn't need him. In the first game, St. Louis came back from a 3-0 deficit, scoring three times in both the fifth and the seventh innings. McQuinn tripled in the go-ahead run in the seventh, and then scored the eventual game-winning run on a sacrifice fly. Chet Laabs added his first homer of the season for good measure. George Caster relieved Nelson Potter in the eighth and got out of a bases-loaded, nobody-out jam surrendering just one run. Caster pitched a 1-2-3 ninth to lock down the 6-4 win.

Tex Shirley pitched seven innings in game two, giving up just six hits but walking seven. He started the seventh by walking Stan Spence and opening the at-bat against Bill Lefebvre with a ball. Sewell intervened at that point, replacing Shirley with Al Hollingsworth. A walk, an error and a sacrifice fly gave the Senators one run, but that's all Hollingsworth allowed as the Browns took the second game, 4-2, to sweep the doubleheader.

New York lost both games of its doubleheader to Detroit, meaning St. Louis, at 23-18, was just one-half game behind the first place Yankees. Meanwhile Washington slipped into a third-place tie with Philadelphia and Detroit, each club possessing a .500 winning percentage.

St. Louis hadn't been in first place since May 20th, its longest stretch of the season away from the top spot in the standings. That streak came to an end May 31st as St. Louis beat Washington for the third straight time while New York lost to Detroit 6-2.

The Browns win was no easy affair. They trailed 3-1 entering the home half of the ninth inning. But Washington starter Roger Wolff started the inning by walking Don Gutteridge and hitting Al Zarilla with a pitch. After McQuinn's sacrifice bunt moved the runners over, cleanup hitter Vern Stephens, who entered the game with just two RBI in his last 14 games, lofted a deep fly out to left field, allowing Gutteridge to score. With two out, Gene Moore laced a triple to the gap in left-center field scoring Zarilla and tying the game. Neither team scored in the tenth inning, and the Senators had no luck in the eleventh against Al Hollingsworth, who relieved starter Sig Jakucki in the ninth.

With one out in the bottom of the eleventh, McQuinn singled off reliever Alex Carrasquel. Stephens then walked to push the winning run to second base. Moore stepped up again, but in contrast to his wallop of two innings prior, he managed to squib a slow grounder towards the hole between first and second. Second baseman George Myatt made a nice stop on the ball, but hurried his throw to first. The ball sailed wide of the bag, enabling McQuinn to score the winning run.

It was ironic for Moore to deliver the two key blows against Washington. Just two-and-a-half months earlier, Senators owner Clark Griffith had reluctantly sent the player to St. Louis after Angelo Giuliani refused to report, deciding instead to retire after being traded to the Browns for catcher Rick Ferrell.

Despite being platooned, Moore was the Browns hottest hitter. In his last six games, Moore was 8-for-22 (.364) with four runs and seven RBI. He had driven in 11 runs in his last ten games. Moore led the team in the month of May with 14 RBI.

Not that Moore ever would brag about his feats. Moore's nickname was "Rowdy", which was just like calling a tall person "shorty." He wasn't vocal and didn't drink, usually hanging out with McQuinn in hotel lobbies, both players relaxing by smoking cigars and watching the traffic of people around them. The *Brooklyn Eagle* wrote of Moore in 1939, "The tradition is that Moore says 'hello' when he reports for spring training, 'goodbye' when he leaves for home in October, and nothing much in between."

Oddly enough, some of Moore's early career was spent with a wild and boisterous St. Louis Cardinals team often referred to as the "Gas House Gang." Moore, the son of one-time major league pitcher Gene "Blue Goose" Moore, began his career in Cincinnati, where he played four games for the Reds in 1931. From 1933 to 1935 with the Cardinals, Moore appeared in 23 games, batting .339 over the three seasons. He did not play in the 1934 World Series in which St. Louis defeated Detroit, four games to three.

Moore was picked up in the offseason by Brooklyn, but was traded to the Boston Braves, along with pitcher Johnny Babich, for pitcher Frank Frankenhouse on February 6, 1936. Moore enjoyed a couple of fine seasons with the Braves, batting .290 with 38 doubles, 12 triples and 13 home runs in 1936 and .283 with 16 homers in 1937. But following a 1938 campaign in which he hit .272 in 54 games he was dealt back to Brooklyn for the 1939 season. In 1940, after playing ten games with the Dodgers, he was sold back to Boston.

By the time he reached the Browns in March of 1944, Moore had played for 17 teams in nine leagues over his long career. *Current Biography* noted that Moore had "seen more towns than Rand McNally."

Moore also came to St. Louis at the tail end of his career. Two bad knees forced him to be rested often by Sewell and limited his effectiveness on defense. But, as evidenced by his recent play, Moore could still swing a potent bat.

Moore, however, wasn't in the lineup when St. Louis played the series finale against Washington on June 1st. Not that many people in town knew that. Despite a wartime promise that it wouldn't occur, St. Louis was hit with a city-wide transportation strike that affected streetcars and buses. Only 1,393 fans showed up, 782 of those paying customers. The *St. Louis Post-Dispatch* remarked that the "transportation strike held the crowd down so low that the game was in the nature of a private showing." The few fans that did show up witnessed one of the better hitting performances of the first half-century.

Stan Spence, normally an outfielder but who was playing first base in place of an injured Joe Kuhel, led a 20-hit Senators attack by ripping six hits in six at bats, to tie a then modern day record for hits in one game (Wilbert Robinson had seven hits in one game before the turn of the century), as Washington salvaged the fourth and final game of the series, 11-5. Spence, who hit his sixth home run, scored two runs and drove in five.

In the four-game series, Spence had 11 hits in 21 at bats, a .524 average. He arrived in St. Louis batting .238 on the year. Spence pounding Browns pitchers was nothing new. In 1943, during a season in which he batted .267 with 12 homers, Spence clubbed St. Louis hurlers at a .575 clip (23-for-40) with eight home runs, two-thirds of his season total.

Browns pitchers—in the final game Kramer, Weldon West, Shirley and Zoldak all took the hill—tried to pitch around Spence during the series, throwing him an assortment of pitches, but it was to no avail.

"He just wears us out," one Browns pitcher observed after the game. "We've thrown him everything, high balls, fast balls, curves, slow balls, knucklers and anything else that anybody could think of, but the result was always the same. He just naturally hit everything."

The Browns hung on to their half-game lead over the Yankees despite the loss. Coming in next to St. Louis was the Philadelphia Athletics. The A's weren't counted on to do much in the pennant race in '44, but they came into their four-game series with the Browns sporting a 19-19 record.

St. Louis managed just four hits in the opener, but they all came in the fourth inning. Strung together with an error by 21-year-old third baseman George Kell, the Browns managed to score three times in the inning. Browns starter Bob Muncrief scattered five singles in picking up the 3-0 shutout win, his first of the season and the second overall complete game blanking by a St. Louis starter.

Game two of the series was just the opposite of the first. The two teams combined for 34 hits—12 of them doubles—and 26 runs in a Browns 18-8 win. St. Louis pounded A's starter Jesse Flores, who entered the game with a 2-0 record and just 37 hits and eight walks allowed in 49 innings pitched, for eight runs on six hits and two walks in three innings. Browns hurler Nelson Potter, who owned the club's other complete game shutout, was touched for five runs on nine hits in 4 2/3 innings. Al Hollingsworth gave up three runs on eight hits in 4 1/3 innings but still picked up the win. Every position player who started in the game had at least one hit. The Browns were led by Frank Mancuso, who went 2-for-5 (including his first major league home run) with six runs batted in, and Mark Christman, who hit a grand slam.

The two teams finished the four-game set with a Sunday doubleheader. Denny Galehouse, part-time pitcher and full-time war plant worker, started the opener for the Browns so that he could catch a train back home. Undone by two errors by second baseman Don Gutteridge and one of his own, Galehouse pitched just six innings as the Browns lost 4-3. Amazingly, Muncrief, who pitched nine innings two days earlier, toiled the final three innings for St. Louis. The Browns won the second game by the same score when pitcher Jack Kramer, who relieved starter Sig Jakucki in the eighth inning, singled home Mark Christman with two outs in the tenth inning.

Now 47 games into their 154-game schedule, and off until June 8th, the Browns were on top of the American League by one-and-a-half games over New York. However, after starting the season with the record nine-game winning streak, St. Louis was just 18-20. New York may have been in second place, but the hottest team was Detroit. Just off a seven-game win streak, the Tigers vaulted into third place, one game behind New York and two-and-a-half behind St. Louis. Stephens led the A.L. with 30 RBI while Gutteridge topped the circuit with five triples and 11 steals.

As the Browns had three days off to rest, coincidentally the war in Europe heated up. On June 4th, the day of the Browns-A's doubleheader, the Allies took Rome. Two days later, the Allies launched their D-Day invasion onto the beaches of Normandy. The war often dominated newspaper headlines, but now banner headlines were occurring every day. June 6th: "ALLIES INVADE NORTHERN FRANCE: BEACHHEADS WON; GAINS INLAND"; June 7th: "ALL BEACHHEADS CLEARED OF ENEMY"; June 8th: "ALLIES DRIVE DEEPER PAST BAYEUX 1st phase ends; 2nd phase begins"; June 9th: "YANKS GAIN TOWARD CHERBOURG".

While most major league players enlisted into the armed forces weren't in combat, baseball didn't go unaffected. The only two games scheduled for June 6th, both National League contests, were postponed per a prior decision by baseball officials to not play whenever D-Day might occur. While they didn't have a game to be canceled, the Browns were affected on a much more personal level.

Elmer Wright, a one-time player in the Browns minor league system, was killed during the invasion of France. Three weeks after D-Day, on June 29th, George McQuinn was notified that his younger brother Kenneth, who was in the Navy, was missing in action in the "European sector," assumed to having occurred during the Normandy beachhead landings.

The Browns returned from their respite to play a four-game series against Cleveland before once again embarking on a road trip. In the first 47 games, St. Louis starters had pitched 21 complete games. Of those 21 games, the Browns won 17.

Jack Kramer went the distance against the Indians in the opener, but served up three doubles in the fifth which led to three runs. Kramer and the Browns lost, 4-3. The second game fared no better for St. Louis. Nelson Potter was cruising along with a 2-1 lead, but allowed a two-out, two-run single to Lou Boudreau in the seventh. Cleveland tacked one more on in the frame to win 4-2. St. Louis still maintained first place, though, as neither New York or Detroit could take advantage of the Browns' recent woes.

St. Louis was idle Saturday, June 10th, but it still made some noise. The Browns announced they re-signed pitcher Paul "Daffy" Dean, brother of one-time St. Louis Cardinals great and current St. Louis radio announcer Dizzy Dean. Paul Dean combined with his brother for a lethal 1-2 pitching combination on the "Gas House Gang" Cardinals teams in 1934-35. Paul Dean won 19 games in both seasons, also the first two years of his major league career. However, Paul Dean won just 12 games over the next six years. In February of 1943, the Browns bought Dean from Washington, for whom Daffy never even played a single game. He pitched in three games for St. Louis that season without recording a decision.

With pitching always at a premium, perhaps even more so because of the wartime conditions, the Browns decided to bring back Dean. They sent him to Little Rock to see if he had anything left in his arm. Dean never did pitch again in the majors, although ironically his brother, who retired after pitching in just one game in 1941, did. In 1947 after claiming during a broadcast he could do better than some of the Browns pitchers, Dean was called on his bluff. Dizzy Dean suited up for one game and tossed four scoreless innings.

Either one of the Dean brothers might have fared better than the three Browns pitchers that took the hill against the Indians in the first game of the Sunday doubleheader. Making his typical Sunday start, Galehouse was bounced after just 2 1/3 innings, giving up four runs on six hits. Al Hollingsworth did no better. He lasted 1 2/3 innings, allowing five runs on six hits and three walks. Sam Zoldak mopped up the final five innings. His line: five innings, seven hits, four runs, four walks and five strikeouts. The final score was 13-1 as Mel Harder improved to 6-1, shutting down St. Louis on five singles.

Bob Muncrief, recently returned from a short visit back home to Texas, took the mound in the second game against Steve Gromek. Gromek kept St. Louis off the scoreboard—Cleveland got one run in the sixth—but he loaded the bases with one out in the seventh. The Browns sent up Gene Moore to pinch hit for Frank Mancuso. Indians player-manager Lou Boudreau responded by lifting Gromek and replacing him with veteran reliever Joe Heving. Moore deposited Heving's first pitch onto the right-field pavilion roof for a grand slam. Muncrief gave up one more run, but finished with a 4-2 win and his fourth consecutive complete game victory.

The exciting blast by Moore was witnessed by just 10,199 fans. A decent mark for a Browns game, but comparably low to other Sunday doubleheaders around the majors. In the other cities where doubleheaders were played June 11th, Cincinnati drew 24,377, Chicago (AL) 23,461, Pittsburgh 23,016, Boston (AL) 22,662, New York (NL) 21,326, Brooklyn 20,302 and Philadelphia 18,691.

One of those in the stands, at least for game two, was Browns manager Luke Sewell, who viewed the end of the three-game losing streak from a seat next to Don Barnes located down the left field line. Sewell was thrown out of the game while exchanging lineup cards with the umpires before the start of the second contest.

Perhaps Sewell was pondering his roster dilemma while watching the contest. Major league rosters had been given a 60-day exemption—ending June 15th—for carrying more than the usual 25 players. As it stood, the Browns were carrying 27 players, including part-timers Galehouse and Chet Laabs. St. Louis had 10 pitchers, two catchers, six infielders and nine outfielders. Sewell already made it known that he wanted to have just seven outfielders on the roster.

Sewell made his first move June 12th, three days before the deadline. The Browns sold outfielder Hal Epps to Philadelphia. It didn't help Epps' cause that he could be inducted into the military at any time, having already passed his physical. In a separate move, but obviously part of the Epps deal, the A's assigned outfielder Bill Burgo, who hit .239 in 22 games with Philadelphia, to the Browns farm club in Toledo.

"The Reindeer," as Epps was sometimes called, played well in spring training but never got into a groove once the season started. Epps started all 12 games St. Louis played in April. While he did score 11 runs in that span, he hit just .182 (8-for-44). Epps' playing time decreased in May as Mike Kreevich's increased. He played in just eight games with four starts, collecting two hits in 18 at bats (.111). Epps played in just two games in June, appearing in both games of the June 4th

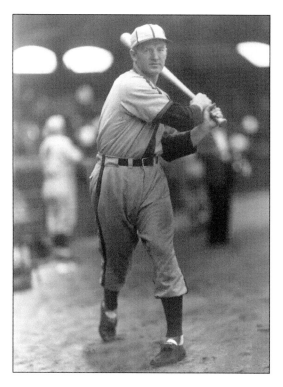

RED HAYWORTH. Catcher Red Hayworth, younger brother of longtime major league catcher Ray Hayworth, was stuck in the Yankees minor league system like many others before finally getting his chance with the Browns. (SM)

doubleheader against Philadelphia. His final numbers with St. Louis: 22 games, .172 batting average, 15 runs, three RBI, one double, one triple and two errors committed. One quirk about the move was that it helped clear up confusion among the fans as both Epps and Moore wore the uniform jersey number 15.

The first game for the Epps-less Browns was rained out, meaning St. Louis had just a two-game series with Chicago. The Browns took the first game, 5-3, thanks to a two out, two-run single by Mark Christman in the top of the ninth, capping a three-run rally. St. Louis made it two-for-two with a 16-hit, 10-3 walloping of the Chisox the next day.

The Browns entered Chicago with the worst batting average in the league, but busted out for 26 hits in the two contests versus the White Sox. Especially coming to life were the outfielders. Milt Byrnes, the only outfielder to start both games, went 5-for-9, while Al Zarilla collected four hits, Mike Kreevich three and Gene Moore one.

And then there was Frank Demaree. Demaree went hitless in three at-bats June 13th and didn't play June 14th. Before the team left for Detroit, Demaree was given his unconditional release, paring the Browns roster to the required 25 players. The additions of Chartak and Hafey plus the unexpected signing of Laabs had made Demaree expendable. In 16 games, all starts, Demaree batted .255 (13-for-51) with two doubles, four runs and six RBI, but he was just 1-for-9 (.111) in the three games he played in June.

Fresh off their two-game sweep of Chicago, the Browns continued to pile up hits on the road. In the first contest of a three-game series in Detroit, St. Louis tallied 14 runs and 14 hits off five Tiger pitchers. Bob Muncrief, meanwhile, pitched yet another complete game victory, holding Detroit to just one run.

The Browns winning streak hit five June 17th as Sig Jakucki shut out the Tigers. No Detroit runner got past second base. Mark Christman continued his hot streak, blasting a three-run homer. Christman had eight RBI over the past four games, giving him 33 on the season, good enough to tie him for second in the American League with ex-Brown Frankie Hayes.

But all was not perfect. Vern Stephens left the game on June 15th because of a sore elbow. Sewell had to use light-hitting Floyd Baker in his stead. Then, in the eighth inning of the Browns' 5-0 win over Detroit, Red Hayworth twisted his knee while heading for third base on a ground out to short by Jakucki and had to be carried off the field. With Joe Schultz sent back to Toledo, Frank Mancuso would have to be the sole catcher for the next week, a schedule that included two doubleheaders.

Hayworth and Mancuso actually had a lot in common. The two rookie backstops each had an older brother that was an accomplished major league catcher. And both Hayworth and Mancuso had trouble with popups.

FRANK MANCUSO. Catcher Frank Mancuso had a hard time catching pop flies thanks to a back injury he suffered during combat paratrooper training. Frank Mancuso is the younger brother of Gus Mancuso, who played on five World Series teams. (SM)

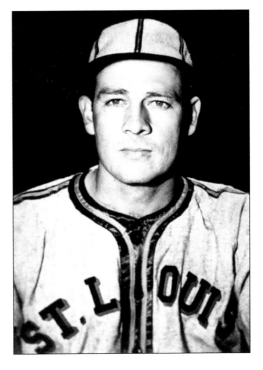

Ray Hayworth's career was all but over by the time his younger brother Myron, nicknamed "Red", made it to the major leagues. Ray, nine years the senior of Red, first played in the bigs in 1926 with Detroit. By 1939 he was on his way out, although he did suit up for one game in 1942 for, ironically enough, the Browns, collecting a pinch-hit single, and at the age of 40 played seven games for Brooklyn in 1944.

Red Hayworth perhaps could have joined his brother in the major leagues before 1944, but as was the case with McQuinn, Chartak and many other ballplayers, he was stuck in the New York Yankees minor league system. In Hayworth's case, the tandem of Hall of Famer Bill Dickey and capable backup Buddy Rosar clogged his path. Hayworth's break came when the Browns picked him up. He hit .278 in Toledo in 1943 and with Rick Ferrell and Frankie Hayes traded, Hayworth found himself splitting time as a starter at catcher with Mancuso.

Like Hayworth, Frank Mancuso was much younger than his brother. Gus Mancuso had 13 years on his younger sibling. Gus Mancuso broke into the majors in 1928 and played in five World Series with the St. Louis Cardinals and New York Giants. Ever since 1939 he'd bounced around the majors, but Gus did play in 78 games with the Giants in '44, hitting .251.

Frank Mancuso started playing semi-pro baseball as soon as he left Charles Milby High School in Houston in 1935. Soon thereafter, he ended up in the New York Giants organization, whose starting catcher at the time just happened to be Gus Mancuso. But like his older brother, who was traded to Chicago in December of 1938, Frank Mancuso didn't last much longer in the Giants system, instead landing himself with the Browns.

Mancuso worked his way up the Browns farm system, from Springfield, Illinois to St. Joseph, Missouri to San Antonio, Texas. And he hit everywhere he went. Mancuso's .270 average with San Antonio in 1942 was his lowest to that point as a professional.

But after that 1942 season didn't come a promotion to Toledo or even St. Louis, but a trip to the military. Mancuso volunteered himself for the paratroopers—partly because he'd earn another $100 a month—and that is where his next big break, almost literally, came.

Mancuso reached the rank of second lieutenant and was making his fifth practice jump, the required number before becoming a combat paratrooper, at Fort Benning, Georgia. As he jumped from 800 feet—a shorter distance than any of his first four leaps—Mancuso inexplicably dove head first instead of the correct way, feet first. Mancuso got his feet caught in the parachute lines—his legs were pulled when the chute opened, what Mancuso later comparing the feeling to being stricken by a truck—and he ended up in some trees before he could get himself loose.

Mancuso's legs healed during his subsequent stay at the hospital, but it was discovered that he was missing cartilage between two vertebrae in his back. From previous athletic play Mancuso knew that he had a bad back, but either the military didn't know about it or the condition worsened, because he was given an honorable discharge.

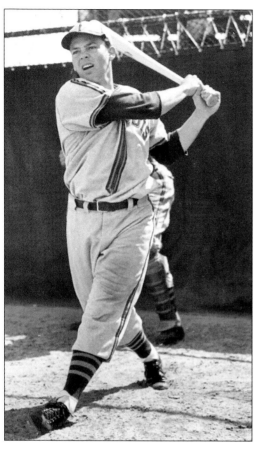

VERN STEPHENS. Vern Stephens was named the starting shortstop for the American League at the All-Star Game. Stephens was hitting .302 with a major league-best 52 RBI at the break. (SM)

Baseball commissioner Judge Kenesaw Mountain Landis officially reinstated Mancuso in February of '44. Mancuso finally made it to the majors when the Browns added him to their roster, but his back still caused him problems. It pained him to look skyward, a definite concern on pop flies. Mancuso would make 17 errors in 1944, a mark of futility for catchers that wasn't topped until 1974 when Thurman Munson committed 22 errors (Mickey Grasso of Washington also made 17 errors in 1950 and 1952). Hayworth had problems of his own. He would commit 13 errors in '44.

Recalled Don Gutteridge: "He [Mancuso] couldn't look up without fainting. If he looked up for a pop fly he'd black out. That's why he really couldn't catch pop flies. He said jokingly, 'Well, I run Christman and McQuinn.' Everytime there's a pop fly to him [Mancuso], they'd [Christman and McQuinn] just run like the devil to try and help him out. He couldn't look up very much. That's why he missed some foul balls. He was a good catcher, he could catch the ball, he just couldn't look up. Hayworth was just one of those fellows that had trouble judging the ball when it went up over his head."

Mancuso made an error in the first game of a doubleheader against Detroit on June 18th, but so did Kreevich, McQuinn and Gutteridge (twice). Combined with 11 hits and six walks allowed by Kramer and Caster, it led to a 7-3 Detroit win. Detroit's starter, Hal Newhouser, became the American League's first pitcher to win ten games.

A Gutteridge error in the ninth inning of game two set up a Rudy York two-run homer to give Detroit a 7-5 win. The doubleheader sweep by the Tigers pulled them to within one-half game of the first place Browns.

Following a day off, Stephens returned from his elbow injury for a doubleheader at home against Chicago. In the first game Muncrief again went nine innings, but the White Sox scored one run off Caster in the tenth to hand the Browns their third straight defeat. Sewell mixed things up in game two, starting Hollingsworth, who had yet to win in three previous starts and had been demoted to the bullpen. But Hollingsworth, the starter in the game in which the Browns opening nine-game winning streak came to a halt, put an end to St. Louis' modest three-game losing streak by tossing a five-hit shutout. Mancuso made two errors in the contest and Gutteridge one, giving each player four errors in the Browns' recent two doubleheaders.

St. Louis split the next two games with Chicago, but pasted White Sox pitching for 23 hits. The Browns recent hitting attack against Chicago meant St. Louis was no longer the worst hitting team in the league. Now batting .247, St. Louis passed Chicago, whose average dipped to .244. The Browns still had no .300 hitters, Kreevich topping the club with a .298 clip after going 1-for-3 against the White Sox.

Next up for the Browns was a four-game series with Detroit. The Tigers came into St. Louis now one-and-a-half games behind the first place Browns. In the first game of the series, a night game played June 23rd, Sig Jakucki repeated his performance of six days earlier, again shutting out Detroit 5-0. The Tigers didn't have much luck in the second game either, managing just six hits off Muncrief, who tossed his eighth complete game en route to his sixth straight win. Stephens, his elbow obviously back to normal, rapped four hits and drove in a run, putting him one ahead of Stan Spence for the American League lead in RBI, 41 to 40.

Nelson Potter was cruising along with a one-hitter in the first game of a Sunday doubleheader before Detroit busted through with four runs on five straight hits in the eighth, giving the Tigers a 4-2 lead. But George McQuinn hit a two-out, two-run home run in the ninth to tie the game and Gene Moore scored on Milt Byrnes' double in the tenth to give the Browns another victory over Detroit. Hollingsworth completed the four game sweep by pitching 7 2/3 strong innings in a 5-2 win in game two, his first-ever win against Detroit. Jakucki pitched the final 1 1/3 innings to extend his scoreless inning streak to 19 1/3 innings.

The four-game sweep cemented the Browns position in first place before heading to New York for a three-game series with the slumping Yankees beginning June 28th. St. Louis had been in first place this late in the season just twice before—in 1908 and 1922.

Yet the Browns fans still weren't coming out to the ballpark. The team drew approximately 145,000 in its first 35 games (28 home dates), which was about 25,000 more than in the previous season at the same point for an eventual sixth-place ballclub, but it still lagged behind every other team in the league. The last place Philadelphia Athletics had drawn 330,000 fans, nearly two-and-a-half times more than the first place Browns. the *St. Louis Star-Times* ran an informal survey to see why fans weren't attending Browns games. Among the reasons given: escalating prices, specifically for hot dogs (15 cents), the pass gate (50 cents, up from 25 cents the previous year) and scorecards (10 cents, up from 5 cents); the quality of play; the Browns themselves, who had a dearth of "color and pep"; gas rationing; competition with the Cardinals who shared Sportsman's Park; and living distance from the stadium.

The Cardinals outdrew the Browns for night games, with an average of 14,291 compared to 7,254, doubleheaders, 12,613 to 11,301, and even day games, 1,823 to 1,219.

The Browns were doing better on the road, though. While averaging just over 5,000 fans at home, St. Louis was a pretty good draw now that they were in first, playing in front of an average of nearly 13,500 fans in opposing stadiums. Case in point was New York, where St. Louis had already set a crowd record at Yankee Stadium for the '44 season. The opener—a day game of course in New York—still drew 11,360 fans, including 9,142 paying customers.

Bob Muncrief had won six straight decisions dating back to his 3-2 win over Boston on May 25th, including his first-ever win over New York just four days later. But Muncrief couldn't make it two in a row over the Yankees. New York pounded him for seven runs in four innings, including a two-run inside-the-park home run by Stuffy Stirnweiss, to take the opener, 7-2.

Jakucki extended his scoreless inning streak to 23 innings before finally surrendering a run in the ninth inning of game two. Unfortunately for Jakucki, that was all New York needed, the Yankees winning 1-0 as the Browns offense mustered just two hits off Monk Dubiel. Jakucki, who entered the contest 5-0 as a starter, came close to notching his third straight shutout. However, he surrendered a ninth inning leadoff single to Bud Methany, who had robbed McQuinn of a two-run homer in the eighth with a fine catch, and was then advanced to second on a sacrifice bunt by Hershel Martin. After Johnny Lindell flied to Milt Byrnes in center for the second out, Sewell elected to intentionally walk power hitter Nick Etten. Jakucki got Rollie Hemsley to swing and miss at two curveballs, but on an 0-2 pitch the Yankee catcher singled to right center field to score Methany and give the Yankees the win.

The victory was the Yankees' sixth straight. New York had lost 13 of 15 games prior to the winning streak, falling as far as seventh place in the eight-team league, but now were back to within two-and-a-half games of the first place Browns.

The Browns salvaged a win in New York when Al Hollingsworth finished off the three-game series with his second shutout of the season. Hollingsworth scattered seven hits in picking up his fifth straight win. He got all the offense needed when Stephens poked a two-run homer into the left-field seats, his league-tying eighth of the season, in the first inning. The blast extended Stephens' hitting streak to 15 games. He hit .389 in June with four homers and 22 RBI in 22 games.

THROUGH JUNE THE STANDINGS STOOD:

Team	W	L	GB
St. Louis	39	29	
Boston	36	31	2.5
New York	33	30	3.5
Chicago	30	30	5
Washington	32	34	6
Detroit	31	36	7.5
Cleveland	31	36	7.5
Philadelphia	30	36	8

From New York, St. Louis traveled to Boston to take on the second place Red Sox. Boston was 17-2 at home in Fenway Park, but the Browns took the opener of the three-game series, 9-1, as Nelson Potter pitched a complete game to raise his record to 8-5.

The largest crowd to date in Boston, 32,436, showed up for the Sunday July 2nd doubleheader. Much to the Browns' chagrin, the Red Sox faithful went home happy. In the opener, St. Louis managed just six singles off Boston starter Tex Hughson, none by Stephens whose hit streak ended at 16 games. Jack Kramer stymied Red Sox hitters as well, limiting them to five hits. But Boston scored off Kramer in the sixth inning when Red Hayworth dropped a throw from Mike Kreevich as he tried to tag out one-time Browns minor leaguer Jim Bucher following a single to center. Bucher played in Toledo in 1943 but was drafted by the military. However, a week before he was to report for duty he received notice that because of his age (33) he wasn't to be inducted after all. The Browns sent him to Toledo and dealt him to Boston when the Red Sox were in search of a third baseman after Jim Tabor was injured around Memorial Day. Bucher's run held up as Boston won 1-0 to make Hughson the first 12-game winner in the A.L.

St. Louis scored three times in the first two innings of the second game and took a 3-1 lead into the ninth. Tex Shirley shut down Boston on three hits in the contest, but surrendered a one-out double to "Indian Bob" Johnson. Browns manager Luke Sewell took Shirley out of the game and, with reliever George Caster out with a cold, called upon Bob Muncrief, who had been the club's top pitcher in recent weeks.

Muncrief got Bobby Doerr to ground out for the second out. But Lou Finney, who returned to the Red Sox two weeks earlier and was playing in just his second game in two years, blooped a double to left then scored the tying run on a single by Hal Wagner. Finney came through again in the eleventh, sending a two-out grounder between Gutteridge's legs and into right field, scoring Doerr from second with the winning run.

The Browns switched gears, leaving the second place Red Sox for a four-game series in Philadelphia against the last place Athletics. The series opened with a traditional July 4th doubleheader. Jakucki continued his impressive pitching by tossing his third shutout in four starts, the Browns winning 4-0. Jakucki had now given up just one run in his last 32 innings pitched.

Hollingsworth entered his start in game two almost as hot as Jakucki, having won his last five decisions. But the A's tagged him for five runs and eight hits, including Frankie Hayes' ninth homer of the season. The Browns meanwhile could do nothing with Philly starter Luke Hamlin, who they "vowed and declared they would kill . . . the next time he pitched against him" and the Athletics managed to split the doubleheader, winning 8-3.

Boston split their doubleheader as well and remained one-and-a-half games behind St. Louis. Following the Browns' doubleheader, Nelson Potter reflected on the state of the American

League pennant race: "It'll be a tight race right down to the finish, but if we can stay on top, or even close to it, we'll win the pennant in September right in St. Louis."

Caster returned from his cold July 5th and was immediately pressed into service. He was inserted to the seventh inning of a 2-2 tie—Potter had pitched the first six innings—and held the A's scoreless through the eighth. In the top of the ninth, Sewell was stuck with a sticky situation. Gene Moore led off the inning with a single, advancing to second on a Milt Byrnes sacrifice bunt, with Byrnes also safe at first when second baseman Irv Hall dropped the throw while covering first. Mark Christman bunted the two runners over, giving the Browns two men in scoring position with just one out.

Sewell sent Al Zarilla to pinch hit for Hayworth, but venerable Athletics manager Connie Mack ordered his pitcher, Russ Christopher, to intentionally walk the batter to load the bases. That brought up Caster, a .180 hitter over his previous nine major league seasons and hitless in five at-bats so far in the current campaign. Regardless of his lack of hitting prowess, Sewell left Caster in to bat. The pitcher made the move look good, delivering a two run-single over a drawn-in Philadelphia infield. Armed with a 4-2 lead, Caster made things interesting in the bottom of the ninth, putting two runners on with two outs before he retired Bill "Fibber" McGhee on a force out to end the game.

Sewell ran Muncrief out to the mound the next day to take on Woody Wheaton, making his first (and only) major league start. Wheaton, who also played the outfield, had led the International League in pitching and was second in hitting while playing for Lancaster in 1943.

Vern Stephens greeted Wheaton by clubbing a 2-2 pitch into the left field upper deck. The three-run homer was all Muncrief needed as he tossed his second shutout and the team's seventh whitewashing in its last 32 games.

As the team headed towards Washington, Sewell declared Mike Kreevich would be the team's starting center fielder for the rest of the season, no matter how he was hitting. The manager noted Kreevich's defensive play for his reasoning. Sewell also pointed out Chet Laabs, who went 2-for-3 in the latest game against the A's. "Laabs is finding his batting eye and should be a big help from now on," Sewell observed.

The All-Star Game players were named as well and three Browns players were selected (fan voting didn't begin until 1947) for the 12th mid-summer classic: Stephens, McQuinn and Muncrief.

If the Brown players had a say-so, they surely would have recommended Washington's Stan Spence be put on the team. Spence ripped St. Louis again in the first of the final four-game series before the All-Star break. Spence went 4-for-5 with a double, a triple and four RBI off Jack Kramer and Sam Zoldak as Washington won the opener 7-0 behind the six-hit pitching of Milo Candini. Kramer, who started the season 5-0, fell to 8-9 while Kreevich, the newly anointed center fielder, had to miss the game after pulling a muscle in his leg.

St. Louis finished out the series taking two of the final three games, with each team tossing a shutout in separate games in the July 9th doubleheader. Tex Shirley racked up his second complete game and first career shutout.

St. Louis ranked seventh in the league in hitting and was tied for last in fielding, yet claimed a two-and-a-half game lead over Boston.

The standings at the All-Star break:

Team	W	L	GB
St. Louis	45	34	
Boston	42	36	2.5
New York	39	35	3.5
Washington	38	38	6
Chicago	34	37	7
Cleveland	37	41	7.5
Detroit	36	42	8.5
Philadelphia	35	42	9

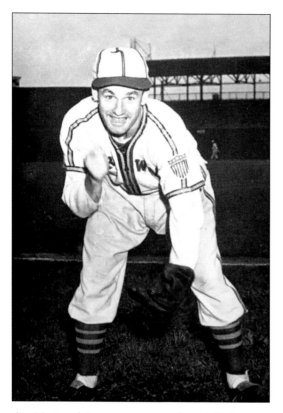

FLOYD BAKER. Light-hitting infielder Floyd Baker was used sparingly. He would receive some of his playing time filling in at shortstop when Vern Stephens was injured. (SM)

Both Stephens and McQuinn were announced as starters for the All-Star Game for the American League with Muncrief available for relief duty. Stephens was the most deserving Brown to be an All-Star. He was hitting .302, ninth in the league, with a major league best 52 RBI as well as 50 runs scored. McQuinn was batting .265 with 50 runs while Muncrief posted an 8-4 record.

While the St. Louis trio was headed for the All-Star Game, the rest of the Browns weren't given time off. The remaining Browns played a contest against their Toledo farm club. The Browns lost 6-4 as Jack Kramer continued his funk. St. Louis didn't score until the final inning when they pieced together five hits along with an error.

Played in Pittsburgh, the 1944 All-Star Game was the most one-sided game in the short 12-year history of the contest, the National League winning 7-1. All three Browns played, with Stephens and McQuinn going the full nine innings. Stephens went 1-for-4 with a strikeout and one putout defensively; McQuinn was 1-for-4 with a strikeout and made five putouts plus a key error when he dropped a throw from Bobby Doerr during a four-run fifth inning; Muncrief was the third pitcher used by manager Joe McCarthy and he pitched 1 1/3 scoreless innings, giving up one hit while striking out one. Each member of the All-Star squads were given $50 in war bonds. The $100,999.39 in receipts from the game went towards buying baseball equipment for the armed forces.

The All-Star Game wasn't the only news July 11th. Nationally, President Franklin Delano Roosevelt announced he was going to run for an unprecedented fourth term. On the baseball front, major league officials, obviously pleased with the increase in attendance for night games, announced teams could change their schedules and play as many contests under the lights as they wanted. The only exceptions were Sunday games, which had to be played during the day. Also, the home team must obtain approval from the visiting team to switch from a day to a night game. The Browns immediately declared the rest of their games scheduled from Monday through Friday would be played at night, pending the approval of the opposing club.

Before playing any games under the lights at Sportsman's Park, St. Louis had to travel to Cleveland for an extended six-game series which included two doubleheaders. The two clubs split their July 13th doubleheader, with Sig Jakucki getting bombed in the first game and Nelson Potter pitching all 10 innings in a 4-1 game two win. Fortunately for St. Louis they lost no ground on its hold on first place as Boston and New York also split their doubleheader.

St. Louis and Cleveland had a 14-inning affair July 14th, with both starting pitchers, Bob Muncrief and Steve Gromek, amazingly pitching the entire game. Gromek provided his own game-winning hit, singling with one out in the 14th to score Ray Mack. St. Louis blew a chance to win the game much earlier in the contest when the Browns took a 2-1 lead in the seventh and still had the bases loaded. After Don Gutteridge lofted a short fly out to right field, Chet

Laabs faked going towards home. However, Red Hayworth tagged from second base and headed to third, resulting in Laabs being caught off third base and tagged out in a rundown to kill a potential rally. Ex-Brown Roy Cullenbine then tied the game in the bottom of the inning by blasting his 11th home run of the season over the screen in right field.

Meanwhile, New York swept a doubleheader from Boston, moving the Yankees to just one-and-a-half games behind St. Louis. There was even worse news for the Browns. After the latest Browns loss it was revealed that Stephens had suffered a reoccurrence of his sore elbow and would be lost for about a week.

Floyd Baker was inserted in Stephens' place and was placed in the leadoff spot. He went 0-for-5, not that it mattered much as St. Louis was pounded 13-2. The Yankees also lost, but announced that 33-year-old shortstop Frank Crosetti was going to return to the team.

Prior to the season Crosetti declared he was going to sit out. He had been working at a California Shipyard instead of playing baseball. Crosetti was the Yankees starting shortstop from 1932 to 1940 and a valuable backup the previous three seasons. Crosetti, who had played in seven World Series, added experience to the shortstop position that had been manned by rookie Mike Milosevich. Crosetti was expected to arrive on July 18th, coincidentally the first game of the upcoming Browns-Yankees series.

St. Louis concluded its 20-game road trip with another doubleheader against the Indians. Played in front of 32,553 fans, it was the largest crowd of the season in Cleveland. That gave St. Louis the honor of playing in front of the largest crowd in four different cities: Cleveland, New York, Washington and Boston. In what the *St. Louis Post-Dispatch* called "a wild, woozy affair, easily one of the worst major league games of the season," the Browns scored the game-winning run on a McQuinn RBI single in the top of the twelfth. St. Louis had led 7-4 after seven innings, but George Caster, who pitched seven innings in relief, allowed two Indians to score in the eighth and another in the ninth. In an era when most contests were played in less than two hours, the opening game went three hours and 15 minutes, thanks in part to 15 walks by 3 Browns' pitchers.

The second game also went twelve innings and Don Gutteridge, who scored the eventual game-winning run in the opener, repeated the trick by tripling to lead off the top of the twelfth and scoring on a sacrifice fly by Milt Byrnes.

St. Louis, a team Cleveland papers referred to as "the sliding Browns" before the doubleheader, could have easily lost both games but escaped with two wins and now led New York by two full games. The two wins meant St. Louis salvaged a split of its six game series with Cleveland and finished its road trip with a 10-10 record.

Wrote Kyle Crichton of *Colliers* magazine: "If they win [the pennant], historians may find the turning point came in a Sunday doubleheader at Cleveland July 16th, when the Browns took two twelve-inning games at a time when they were staggering around like wine-struck paisanos."

St. Louis headed home for a long homestand, starting with a four-game series against New York. Denny Galehouse, who had been pitching inconsistently as a part-time weekend and holiday pitcher, joined the team on the train ride from Cleveland to St. Louis as he had decided to quit his war plant job in Akron and join the Browns full-time.

The anticipation of the Yankees invading St. Louis was high, but *St. Louis Post-Dispatch* sports editor and columnist John E. Wray was looking forward more to a possible pennant deciding series with the Yankees in St. Louis scheduled for the final weekend of the season. "If that should prove to be the real crucial clutch of the race," Wray wrote, "you won't be able to get into Sportsman's Park short of stick of dynamite."

Sportsman's Park wasn't sold out for the first game of the series, but 19,003 fans, 16,824 paying customers, showed up to witness Bob Muncrief pitch what the *Post-Dispatch* called "one of the best games of his career." In his first start since pitching in the All-Star Game, Muncrief tossed his third shutout of the season. He allowed only six singles with just one Yankee baserunner reaching third base. Muncrief was backed by a rare show of Browns power. Milt Byrnes and Gene Moore both placed homers onto the stadium's right-field pavilion roof while Chet Laabs clubbed a 400-foot blast.

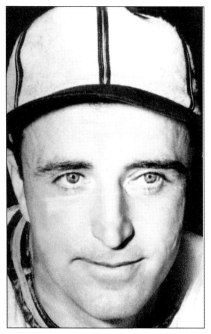

DENNY GALEHOUSE. Pitcher Denny Galehouse, who had been a part-time and holiday pitcher, quit his war plant job in mid-July and joined the Browns on a full-time basis. (NBH)

The Browns led 5-2 in the second game of the series when New York busted loose for four runs in the sixth to win 6-5. Johnny Lindell hit a three-run homer and Mike Milosevich, playing because Frank Crosetti was not yet in shape to play, drove in the eventual game-winning run when he fought off an inside pitch and blooped a single into center, scoring Nick Etten.

Over 16,000 fans gathered in Sportsman's Park on Thursday, July 20th. Little did they know that they would witness a baseball first on the same day Adolf Hitler survived a bomb planted by his former chief of general staff. Nelson Potter took the hill for the Browns that day against Hank Borowy. Potter had really come into his own ever since joining St. Louis the previous season. But pitching in the majors hadn't always been so kind to Potter.

Potter was born in Mt. Morris, Illinois, where he was known as "Clint" or "Popcorn", and still resided there during the off-season with his wife and two children. He played baseball at Mt. Morris College and from there was signed by the Chicago White Sox. However, the White Sox dropped Potter after he hurt his arm while playing for their farm club in Waterloo, Iowa. The St. Louis Cardinals picked him up and sent him to Lincoln of the Nebraska State League. With Lincoln in 1934, Potter led the league with a 1.71 ERA and also pitched a no-hitter. Potter advanced through the Cardinals chain to Houston and finally to the big leagues, pitching one perfect inning for St. Louis in 1936.

Potter continued to bounce around the Cardinals' system, going from Toronto to Columbus, Ohio, before being bought by the Philadelphia Athletics. Potter made it to the A's in 1938, but was hit hard. In 35 games, which included nine starts, Potter sported a 2-12 record with a 6.47 ERA. He also walked six more batters than he struck out. He appeared in 41 games with 25 starts in '39, but fared little better than his rookie campaign, posting an 8-12 record but a 6.60 ERA with 88 walks and just 60 strikeouts. The following season saw Potter improve slightly to a 9-14 record and 4.44 ERA.

Potter pitched in 10 games for the A's in 1941 before being sold to the Boston Red Sox on June 30th. He pitched 10 more times for Boston, ending the year with a combined 3-1 record and 7.06 ERA. He gave up 56 hits and 32 walks in 43 1/3 innings while striking out just 13. After the season Potter decided to have his right knee, which had been bothering him for 10 years, checked out. He had surgery in 1938 in Philadelphia to correct the problem, but when he had the knee looked at again, it turned out doctors removed the wrong cartilage in the first operation.

With his knee problem fixed, Potter's control sharpened dramatically. In 1942, pitching for Louisville, which had acquired Potter from Boston for cash, Potter went 18-8 with a 2.60 ERA and just 50 walks in 211 innings. Feeling healthy for the first time in his career, Potter was taken in the minor league draft by the Browns. But his reputation still wasn't very good. Of his performance before the Browns picked him up Kyle Crichton wrote: "Nelson Potter had been pounded lustily all over the American League while working for Philadelphia and Boston."

But Potter not only had a healed knee, he also had a knew weapon. Already possessing a good screwball, Potter unveiled a new pitch in 1943 - a slider.

"I picked up that slider real quick and it just happened to fit in nice, and it was easy for me to throw," Potter told a reporter many years later. "The batters started leaning out over the plate

for the screwball, now I could move the slider in on their fists. It made a tremendous difference. There were just a few pitchers using the slider then."

After St. Louis traded away Bobo Newsom, manager Luke Sewell inserted Potter into the starting rotation. In 33 games with 13 starts, of which eight he tossed a complete game, Potter finished with a 10-5 record and 2.78 ERA.

A throat ailment and a case of the flu sidelined Potter for all of spring training in '44 yet he won his first two games, pitching a complete game in both victories which prompted Sewell to comment, "He's making a bum out of all my theories."

With Steve Sundra off to the military and Denny Galehouse able to pitch only weekends, Potter, along with Jack Kramer and Sig Jakucki, helped stabilize the Browns pitching staff. Coming into the game against New York, Potter was 9-5 with wins in his last four decisions.

As on the day before, the July 20th game was played at night. The weather was a bit cool and the air dry. The conditions made it tougher for a pitcher to grasp the ball, thus New York starter Borowy took to wetting his fingers before taking his grip. A pitcher moistening his fingers was considered illegal—spitballs were outlawed in the majors in 1920—so Sewell went out to complain to home plate umpire Cal Hubbard about Borowy's actions.

Potter had a strange habit of wetting two fingers on his right hand then drying them off either on his shirt or with the resin bag. His behavior had already caused managers Joe Cronin of Boston and Connie Mack of Philadelphia to complain to umpires during the season. Potter was even accused of throwing spitballs, a charge Denny Galehouse says occurred often. "Potter of course was accused of cheating so much," Galehouse recalled. "He threw a sinker and a screwball and had a pretty good slider, a sinker-slider. And he was accused of wetting them every once in a while to get them to break a little more."

With Borowy told to stop wetting his hands, Yankees third base coach Art Fletcher wanted to make sure Potter received the same warning. Potter continued his habit, although at the time he claimed he was just blowing on his hands. Hubbard said he was moistening his fingers ("Which I was but he couldn't prove it," Potter once remarked) and warned Potter and Sewell in the fourth inning that if the Browns pitcher did it again he'd be tossed out of the game.

Sewell went to talk to Potter and, according to Hubbard, on his first pitch after the manager left the mound Potter made a deliberate motion with his fingers to his mouth. To Hubbard, who claimed to have warned Potter "five or six times" already, that was the breaking point. Hubbard called time out and gave Potter the heave-ho, the first time in 14 years the pitcher said he had been ejected.

The fans at Sportsman's Park were not happy with Hubbard's decision, to say the least. They littered the outfield with bottles and straw hats while some even tried to storm the field but were held back by the police. Some towels even made it onto the field by way of the Browns dugout. Before play could restart, the grounds crew had to rid the field of the garbage. There was so much debris, they had to use bushel baskets to speed up the process.

Hubbard said he never accused Potter of throwing an illegal pitch, although he knew Potter was one that was often accused of such tactics. On July 22nd, American League President Wil Harridge still handed Potter the automatic ten-day suspension given for throwing an illegal pitch, making Potter the first pitcher to ever be suspended by Major League Baseball for that reason. No pitcher would be suspended for cheating again until Rick Honeycutt in 1980.

Browns President Don Barnes immediately asked for an appeal hearing, to include Potter, Sewell and the umpiring crew, but it was denied the next day by Harridge.

For his part, Potter, in separate interviews in 1965 and 1982, denied ever throwing an illegal pitch. "The truth is, I have never thrown a spitball in my life," Potter claimed.

Said Galehouse, a teammate of Potter's both in St. Louis and later with Boston, of the accusations: "He never admitted it, let's put it that way."

Angered by Harridge's decision, Barnes announced he'd still pay Potter's salary, as nothing in the terms of the suspension mentioned anything about holding back the player's salary.

Potter returned to his family in Mt. Morris for a brief vacation. In later years, Potter confirmed the rumors that nine months later he and his wife had a baby boy. "And one thing you can be sure of," Potter said, "I didn't name him Cal Hubbard Potter."

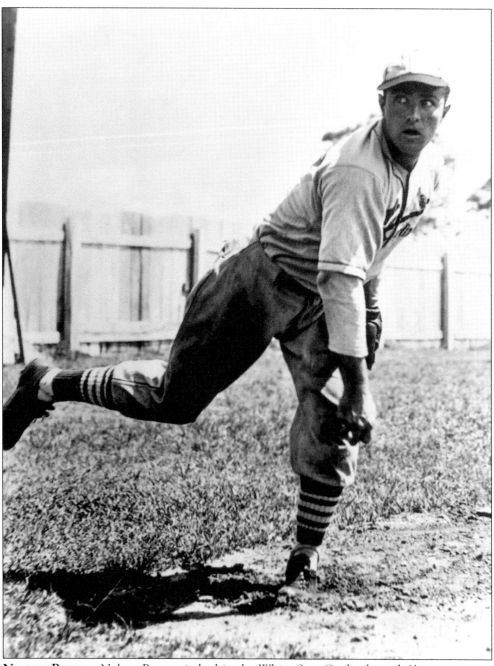

NELSON POTTER. Nelson Potter pitched in the White Sox, Cardinals, and A's organizations before landing with the Browns. Thanks in part to using a new pitch, a slider, Potter found success with the Browns in 1943. But it was with a spitball in which Potter gained some notoriety in 1944, becoming the first pitcher suspended for throwing an illegal pitch. (SM)

Seven

Fifth Inning
A Hot Scrabeenie and the Unhappy Brown

Despite the brouhaha involving Nelson Potter, there was still the matter of a game to be completed. The headlines the next day went to Potter and his unique ejection, but Mike Chartak proved to be the hero.

When the first two batters in the seventh inning reached base, manager Luke Sewell pulled his starting second baseman, Don Gutteridge, and inserted Chartak as a pinch hitter. The move didn't go over well with the Brownie faithful. The *St. Louis Post-Dispatch* reported, "As Mike has not had much luck in his pinch-hitting roles this season there were groans among the fans."

Chartak had pinch hit six times so far in 1944 and had yet to reach base. He didn't prove to be a prodigious substitute in 1943 either, collecting just three hits in 18 at-bats, a .167 average.

But the "Volga Batman" came through this time, depositing a 2-and-1 pitch from Hank Borowy onto the roof of the right-field pavilion for his first home run of the season. The blow gave St. Louis a 4-2 lead, which was extended to 6-2 when George McQuinn ripped a two-run homer just two batters later. The day ended with a 7-3 Browns victory.

The bliss was shortlived, however, as St. Louis dropped the next day's game to New York, 8-2. The loss prevented the Browns from winning the four-game series. Instead the two ballclubs each won two games, meaning St. Louis still held a two-game advantage over New York.

Boston invaded Sportsman's Park next. The Red Sox were in second place for the first half of the month, but slipped behind the Yankees into third. Since July 16th, Boston had matched St. Louis win for win and loss for loss, remaining four games behind the first place Browns the entire week.

Vern Stephens, who had been out with a sore elbow, returned to the Browns' starting lineup. He was limited to two pinch-hit appearances in the seven games since suffering the injury July 14th. Stephens showed no ill effects. His RBI single in the first inning off Mike Ryba, a reliever making his first start of the season, put St. Louis on top, 1-0.

After Boston tied the game in the second, the Red Sox put together a four-run third inning, scoring by way of four hits, a walk and an error by right fielder Gene Moore, which doomed the Browns. The Red Sox took the series opener, 8-4. Jack Kramer took the loss, dropping to 9-10.

The first game of the Boston series was played at night, drawing 8,942 paying customers. The three night games against the Yankees in the precious series attracted a total of 43,073 cash patrons, an average of 14,357 per game. (The lone day game against New York drew a paying crowd of 4,298.) Thus it came as no surprise when the Browns announced their new playing times for the remaining schedule. Of the last 37 home games, 19 would now be played at night. St. Louis also had five doubleheaders, three Sunday single games and five weekday daytime games scheduled. (The Browns needed permission from the visiting team to change its single games to nighttime contests. New York, which had proven to be against the idea of playing under lights, rejected the Browns in their proposal to change the September 28 to October 1 season-ending, four-game series against the Yankees from day to night games.)

Things didn't go well for the Browns—and especially pitcher Bob Muncrief—in the first game of the Boston doubleheader July 23rd. Muncrief allowed seven runs in the second inning as the

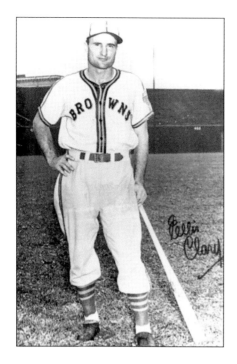

ELLIS CLARY. Utility man Ellis Clary was the "manager" of the scrabeenies—the name the team's backup players gave themselves. (AC)

Red Sox routed St. Louis, 12-1. Reliever Weldon "Lefty" West fared a little better than Muncrief, but still allowed 11 hits and five runs in his seven inning stint. Red Sox hurler Tex Hughson, whose wife gave birth earlier in the day, improved his record to 15-4.

With his team getting blown out and another game yet to play that day, Browns manager Luke Sewell put in substitutes for some of his starters relatively early in the contest. Second baseman Don Gutteridge was replaced by Ellis Clary; first baseman George McQuinn left in favor of Mike Chartak, while right fielder Gene Moore was spelled by Al Zarilla. Clary, Chartak and Zarilla, as well as Tom Hafey and Floyd Baker, normally didn't see much playing time. "If somebody don't get hurt, the utility men don't get much playing," explained Clary.

The group of backups even had a nickname for themselves—scrabeenies—with Clary, who in June played in just three games accumulating only three at-bats, serving as "manager" of the squad. Clary and Chartak didn't take advantage of their rare moments on the field in the loss to the Red Sox. Clary went 0-for-1 and committed an error while Chartak was 0-for-2. But Zarilla caused Sewell to sit up and take notice, banging out two singles in his two plate appearances. When Sewell penciled in his lineup card for the second game, Zarilla was listed batting sixth as the starting left fielder.

As happened often over the years with the Browns, Zarilla found his way to St. Louis after another club had given up on him. Zarilla's rights were originally owned by the Chicago Cubs. In 1938, his first year of professional baseball, the 18-year-old Zarilla batted .328 for Batesville of the North-East Arkansas League, a Class D minor league. But along his way up the Cubs minor league chain, Zarilla broke his ankle while sliding into a base. The Cubs then lost interest in Zarilla, the injury a catalyst for his leaving the Chicago farm system.

The native of Los Angeles soon found himself property of the Browns playing for Springfield (Ill.). Zarilla worked his way up, next playing for San Antonio of the Texas League and then, despite batting .200, onto the last stop before making the big club, Toledo.

Zarilla tore apart American Association pitchers in 1943, hitting .373 in 57 games. The Browns, always desperate for a little punch in their lineup, called Zarilla up to St. Louis on June 28, 1943. He didn't fare quite as well in the majors as he did in the minors, however. Zarilla played in 70 games his rookie year, batting .254 with seven doubles, one triple and two home runs.

But Zarilla did make history in 1943. With St. Louis on an Eastern road trip in September, Zarilla's draft board in California informed the ballplayer that he had to choose between a war plant job or baseball. If Zarilla chose baseball, the board said, he would be classified 1-A, making him available to be drafted immediately. Thus, Zarilla became the first player to be told it was going to be either employment in a war plant job or the Army.

The broken ankle Zarilla sustained early in his career didn't mend correctly. Because of that, Zarilla bounced between 4-F and 1-A status. He did get a job during the offseason at the Western Pipe & Steel Co. in the ventilation department, but inevitably decided to return to the Browns during spring training.

It didn't take long for the military to call. On April 8th, Zarilla was given his pre-induction examination. He was called back again May 9th and cleared for the Navy. But every time Zarilla was made 1-A, shortly thereafter he was reclassified 4-F. Four times Zarilla had been classified 1-A and four times 4-F. As August neared, despite his two previous induction exams earlier in the year, Zarilla was 4-F.

When he wasn't going in for military exams, Zarilla saw most of his time on the bench. He played in just three games in April, managing just one hit in eight at-bats. Zarilla saw more action in May and June, but still started just 18 of the team's 56 games during that span.

He found ways to keep busy, though. Before games Zarilla, strictly an outfielder, took grounders at third base just in case he was needed in an emergency situation. Zarilla also threw some batting practice in order to help conserve the arms of the other pitchers.

Playing on the first letter of his last name, Zarilla was given the nickname of "Zeke" by teammate Vern Stephens. Zeke rhymed with sneak, and Stephens claimed Zarilla was sneaky fast. Stephens often referred to Zarilla as "Sneaky Zeke." Zarilla had managed to sneak his way into the lineup and he was not about to leave quietly.

In the second game of the doubleheader against Boston, Zarilla took quick advantage of only his second start of the month. In his first at-bat, which came in the bottom of the second inning, Zarilla cracked his second home run of the season, a two-run shot off Red Sox starter Joe Bowman that made it to the roof of the right-field pavilion. The homer gave St. Louis the lead, 2-1, and they went on to win 9-3.

Zarilla added a single and a double to finish with a 3-for-4 performance. He drove in four runs in the contest. Stephens drove in four runs of his own with a grand slam in the fourth, his 10th round-tripper of the season.

For the series finale, Zarilla once again batted sixth and played left field and he again went 3-for-4 with a homer to the roof of the right-field pavilion, this time a solo shot in the second. Then "Sneaky Zeke," on back-to-back plays in the seventh inning, arrived ahead of throws intended to force him out following bunts. Zarilla scored the first of three runs that inning as St. Louis held on to beat the Red Sox, 6-5, and split the four-game series with Boston.

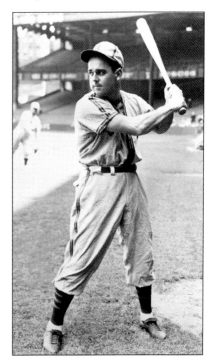

In the three games since being inserted by Sewell during the Boston blowout, Zarilla was 9-for-12, a .750 average, with a double, a triple, two home runs, three runs, six RBI, two walks and a hit by pitch. Next up for the Browns in their homestand was the last place Philadelphia Athletics. The new opposition didn't affect Zarilla any.

The 25-year-old outfielder pounded out three hits in four at-bats, including a double, scoring once while driving in two in a St. Louis 9-1 win as Bob Muncrief continued his mastery over the A's. Muncrief extended his scoreless inning streak against Philadelphia to 24 innings before ex-Brown Frankie Hayes homered off of him in the fourth. The win upped Muncrief's record to 10-6, making him the pitcher with the most victories on the club.

The victory, combined with a New York loss, put St. Louis three-and-a-half games on top of the second place Yankees, the Browns' largest lead in a month.

Every team in the league hosted a game where the net

AL ZARILLA. "Sneaky Zeke," Al Zarilla, little-used from May–June took advantage of being placed in the starting lineup in July. He raised his batting average nearly 100 points during an 11-game hitting streak. (SM)

TOM TURNER, RED HAYWORTH, FRANK MANCUSO. Tom Turner (*left*) was added to the Browns' catching regiment at the trading deadline, joining Red Hayworth and Frank Mancuso. (SM)

proceeds went towards the National War Relief and Service Fund, inc. The Browns' turn came in the second contest of the St. Louis-Philadelphia series July 26th. There were no free passes issued for this game, everyone had to pay their way into the stadium—including team management, media members, umpires and players!

The Browns centered their pregame ceremonies around the A's venerable manager Connie Mack. The 81-year-old Mack was celebrating the 50th anniversary of his first managing in the major leagues. Mack, already elected to the Hall of Fame in 1937, had been the skipper of Philadelphia (and owner) since 1901, winning eight American League pennants and five World Series.

In addition to honoring Mack, several bands played during the one-and-a-half hour ceremony including The Shady Valley Folks, The Ozark Ramblers, the Coast Guard band and Irish tenor Peter Higgins.

Fans flocked to Sportsman's Park to help contribute to the fund. The crowd of 24,631 was the greatest for a Browns home game since the team's first-ever night contest in 1940 and it also was just 151 less than what the Cardinals attracted for their War Relief game. It was later announced by the chairman of the benefit game committee, Oscar Zahner, that $25,000 was raised that night (the Cardinals took in $25,832 in net proceeds), an impressive figure considering the Browns 1943 War Relief contest mustered just $5,000.

As for the game itself, Zarilla didn't figure in the scoring in the 4-2 St. Louis triumph, but he still continued his hot streak. He rapped out two hits, including another double, in four at-bats. Red Hayworth provided the big blow. The Browns trailed 2-1 in the fourth inning, but following two walks, Hayworth knocked a three-run homer to give the Browns the lead for good. It would be Hayworth's first and only major league home run. Jack Kramer pitched a complete game to tie Muncrief for the team lead in wins, evening his record at 10-10.

St. Louis lost 7-5 to Philadelphia on July 27th, but had a prime opportunity to tie or take the lead in the eighth inning. The Browns loaded the bases with one out in the frame. Vern Stephens hit a sacrifice fly to cut the lead to two runs. Bobo Newsom, the well-traveled A's reliever and former Brown then walked Gene Moore, refilling the diamond with St. Louis runners. Up stepped "Sneaky Zeke," the hottest Brown of them all. But Newsom struck out Zarilla to end the threat and the inning.

According to one account, the next day a young boy met Zarilla, the hottest hitter in baseball (he was 15-for-his-last-24, a .625 average). After being introduced to the ballplayer,

the child said to Zarilla, "Oh, you're the fellow that struck out last night with the bases loaded." It was possibly just a fictional account by a reporter (nothing new; remember the "Say it ain't so Joe" incident with 1919 "Black Sox" outfielder Joe Jackson), but it shows that even in 1944 a player was only as good as his last at-bat.

With the help of an umpire, Zarilla turned an out into a home run in the series finale versus the A's on July 28th. The Browns trailed 4-2 in the sixth inning. Gene Moore led off with a single and Zarilla followed by lining out to right field. However, umpire Bill McGowan intervened, saying he called time out before Philadelphia starter Don Black had pitched the ball because Moore had been tying his shoe.

Given new life, two pitches later Zarilla sent a Black offering to his favorite spot—the roof of the right-field pavilion—to tie the game. Zarilla had three hits in the game, including one in a four-run seventh inning that pushed St. Louis ahead after they had allowed the A's to score once in the top half of the frame.

Muncrief, who pitched a complete game Tuesday, just three days earlier, pitched the final two innings to earn the win. The performance didn't excite four-year-old Bob Muncrief Jr., however. The younger Muncrief, at the game with friends of the family because the pitcher's wife was in the hospital, was asleep during his dad's entire relief stint. In 32 innings against Philadelphia, Muncrief had allowed just one run.

Washington was due up next for St. Louis but Saturday's game was postponed until Monday, due to wind and rain.

Despite his recent relief victory, Muncrief started the first game of the Sunday doubleheader against Washington's Mickey Haefner. Neither pitcher allowed a run through nine innings. Haefner provided the game's first run with a two-strike double in the tenth that scored pinch runner Jake Evans. Evans came in for ex-Brown Rick Ferrell, who doubled after Chet Laabs misplayed his fly ball to open the inning.

Haefner retired the first two batters in the bottom of the tenth, including Zarilla, who managed a single earlier in the contest to keep his hitting streak alive at nine games. But Frank Mancuso, a necessary starter because Hayworth, the only other catcher on the squad, had left for High Point, N.C. to be with his sick mother, kept the Browns hopes alive by singling. Haefner then walked Tom Hafey, who was pinch hitting for Muncrief.

Don Gutteridge, who hadn't knocked in a run in 20 games, a span of 21 days, stepped in. After fouling off two pitches, Gutteridge drilled a pitch off the wall in right field, scoring Mancuso and pinch runner Tex Shirley. "Winning one like that certainly makes us feel good," remarked manager Luke Sewell. "They are the kinds of games a club must take if it wants to win a pennant."

St. Louis made it a doubleheader sweep, winning 7-3 in the second game. Save Mancuso, every Brown player—even starter Denny Galehouse—had at least one hit. Zarilla again led the way, going 2-for-4 with a double, a run scored and two RBI. The sweep enlarged St. Louis' lead to four-and-a-half games over second place Boston, the largest bulge of the season. New York was five games out while Cleveland, the only other team with a record above .500, was in fourth, six-and-one-half games behind the Browns.

Still, not much respect was coming the Browns' way. A cartoon emanating from New York pictured St. Louis club management as a hillbilly hunter, labeling the man "poor white trash," while his sleepy-eyed listless hound, signifying the Browns, flopped on the ground refusing to pursue the A.L. pennant rabbit which was hiding behind the hunter. the *Boston Globe* tore into the club, the manager and even the city. *St. Louis Post-Dispatch* sports editor and columnist John Wray reasoned the paper was critical because "the 'begging' Browns are running ahead of the 4 million dollar Red Sox."

St. Louis finished the month the way it started it—with a win. The Browns edged Washington 3-2 on July 31st, handing the Senators their 10th straight loss. The Browns hit two solo homers—Vern Stephens clubbed his 11th and George McQuinn his seventh—but it was Gutteridge's single in the eighth which scored Mancuso that was the difference.

MILT BYRNES, VERN STEPHENS, AL ZARILLA. Milt Byrnes, Vern Stephens, and Al Zarilla get a good laugh looking at the damage they've inflicted on one of their bats. All three would hit in the .290s in 1944. (SM)

Jack Kramer pitched the complete game for the win, but it was the sight of another Browns starter that took the notice. Nelson Potter, his suspension over, had returned the day before from his home in Mt. Morris, and he tossed some warmup pitches in the bullpen. Potter's return just fueled the optimism, especially with St. Louis carrying its largest lead of the season.

WITH JULY CLOSING AND JUST 54 GAMES LEFT TO PLAY
HERE'S HOW THE STANDINGS LOOKED:

Team	W	L	GB
St. Louis	58	42	
Boston	52	45	4.5
New York	50	45	5.5
Cleveland	50	49	7.5
Detroit	48	50	9
Chicago	46	48	9
Philadelphia	43	55	14
Washington	42	55	14.5

Still, the Browns braintrust felt they needed to make a move. With Hayworth temporarily excused from the club, Mancuso was the only catcher on the team. Both players had been banged up through a variety of injuries throughout the season. With Sewell not trusting Joe Schultz, who was in Toledo, the team acquired catcher Tom Turner from the Chicago White Sox for cash July 31st, the day of the trading deadline. Turner was 29-for-109 (.229) with two homers and 13 RBI for Chicago in 39 games. He did hit one of his home runs against St. Louis, damaging the Sportsman's Park scoreboard in the process. Sewell labeled it, "Turner's dent."

However, Turner wasn't known for his hitting prowess. Serving as a backup catcher for Chicago since 1940, his best season came in 1942 when he had career highs of a .242 batting average, three home runs and 21 RBI. Turner was a decent defensive catcher whose biggest weapon may have been his mouth. He was a noted bench jockey, someone who incessantly yells at and insults opposing players in hopes of rattling them.

Turner had a couple of things in common with some of the Browns players. He had played in the Cardinal organization—playing for their minor league teams in Carythersville, Columbus

(Ga.) and Houston before being purchased by Chicago in 1940—and he was 4-F. Turner had been turned away from the military in the off-season because of high blood pressure.

To make room for Turner, the Browns sold Tom Hafey to Washington for the waiver price of $7,500. Washington originally offered $5,000 and a player for Hafey to which St. Louis countered with a straight cash asking price of $10,000 before settling for less. Since being signed May 22nd, Hafey had appeared in just eight games. He collected five hits in 14 at-bats (.357 average) with two doubles, a run and two RBI.

Despite his lack of playing time there was some disappointment by his teammates in the loss of Hafey, according to the *St. Louis Post-Dispatch*, which reported "there is a feeling among the players that if he [Hafey] could get into the lineup regularly he would prove to be a pretty good hitter."

Turner didn't play August 1st in the series finale against Washington—the Browns 101st game of the season. With St. Louis staring at three days off, Mancuso instead got his sixth straight start. The Browns extended Washington's losing streak to 11 games—two shy of the worst stretch in the 47-year history of the franchise—by pounding out 13 hits in an 11-6 win. The Senators didn't help their cause by committing five errors.

Two players didn't rack up any hits for St. Louis—Gene Moore and Al Zarilla. The latter saw his hitting streak end at 11 games. During that hot streak, Zarilla went 22-for-38, a .579 average, with seven runs and 14 RBI. He clocked five doubles, a triple and three home runs. Hitting just .217 before his batting tear, Zarilla's batting average now stood at .313. Needless to say, Zarilla had gone from a backup role to being firmly implanted in the starting lineup.

While things were going well for Zarilla, another former "scrabeenie" wasn't as pleased. Tom Hafey was refusing to report to Washington.

Tom Hafey came from good baseball lineage. Both he and his brother, Bud, played for the Missions of the Pacific Coast League and later in the majors. Hafey's cousin was Chick Hafey, an outfielder who played 13 years in the majors from 1924-37 mainly for the Cardinals. Chick Hafey compiled a .317 lifetime batting average and .526 slugging percentage and was elected to the Hall of Fame in 1971.

Daniel "Bud"Hafey played for four teams in three years, batting .213 in 123 games as a backup outfielder from 1935-36 and 1939. Tom Hafey joined his brother in the majors in 1939, playing in 70 games at third base for the New York Giants while batting .242 with 10 doubles, one triple and six home runs.

In 1940, Hafey was given the opportunity to win the Giants third base job. Not only did Hafey lose out to Burgess Whitehead, who played second base the previous season for the club, but he was also farmed out to the minor leagues.

Hafey never made it back to the Giants. Things didn't go well for him in the minors. While in Toronto, after struggling at the plate, Hafey, whose nickname was "The Arm" because of his strong throwing ability from third to first, was converted to pitcher.

The experiment didn't last long, however. The Giants eventually gave up on Hafey and the Browns signed him and sent him to their farm club in San Antonio. During the 1943 season, according to Hafey, the Browns needed players in St. Louis and also at their American Association team in Toledo. However, Hafey wasn't promoted, instead remaining at San Antonio— until he decided to leave on his own. "In the middle of the year they needed somebody up in St. Louis and

TOM HAFEY. The Browns sold Tom Hafey to Washington at the trading deadline. However, Hafey didn't want to go to Washington. When his request for a bonus was denied, he refused to report. (SM)

Toledo but they made me stay where I was so I just got mad, came home and was going to join the fire department," recalled Hafey.

Hafey remained in California in 1944 working in a shipyard. Because of a double hernia, Hafey was classified 4-F, which is the reason Bill DeWitt, the Browns Vice-President, called him in mid-season to re-join the team.

There was another problem besides Hafey's steadfast refusal to go to Washington, which he explained was for both personal and monetary reasons. He was summoned to Jefferson Barracks in Missouri for a military examination. He failed the exam, thus being designated with a 4-F draft classification. But Washington owner Clark Griffith claimed when Hafey was claimed on waivers by the Senators he was classified 1-A. Griffith didn't want to pay St. Louis, saying the team misrepresented his draft status.

The Browns refused to take Hafey back claiming a deal had been consummated with the Senators. They brought up Griffith's own words when Angelo Guiliani refused to report to the Browns after being traded to St. Louis from Washington in March: "In these times, everyone must take their chances."

Griffith appealed to baseball commissioner Judge Kenesaw Mountain Landis asking to be alleviated of paying the Browns $7,500. Regardless, Hafey had no intention of making the move to Washington, especially when his request for money—one newspaper report had Hafey asking for a $1,000 bonus—was denied. Explained Hafey: "I just didn't want to go to Washington. It was during the war, if you remember, and what happened, they had quite a few of the Cuban and Puerto Rican players over there. I talked to [Gene] Moore, one of our outfielders who came from Washington. He said, 'You tell them you want an extra $5,000 and you'll go over there.' Which I did. And they said no way. And then at the same time I got a notice from the draft board in California [which said] you've had it, come back to California. So that was the end of my time with the Browns."

Hafey, who had his train fare taken care of by the Browns when he was summoned by the team earlier in the season, had to arrange and pay for his own transportation back to Berkeley, California, while the powers that be decided exactly to which team he belonged.

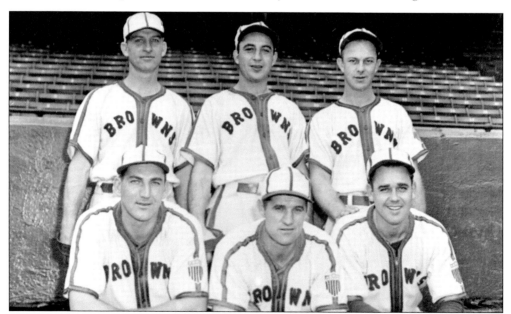

BROWNS OUTFIELDERS. With Tom Hafey gone, the Browns outfield consisted of: (*top row, left to right*) Gene Moore, Milt Byrnes, and Chet Laabs; (*bottom row, left to right*) Mike Chartak, Mike Kreevich, and Al Zarilla. (SM)

Eight

Sixth Inning
If We Ever Win One, We'll Clinch It

With the Browns holding their most dominant lead of the season—they were five-and-one-half games ahead of Boston as they headed to Kansas City for an exhibition game against the minor league Blues on August 3rd—one paper found a reason for the team's success. *The Sporting News* ran a cartoon that cast manager Luke Sewell as a snake charmer with the Browns levitating over a rope. A side view depicted a Browns player on the edge of a board being held up by a four man "pyramid" (two players on the bottom, one on top of those two who was holding another). The pyramid of players was labeled "infield." The cartoon's title, "Browns magic."

While the three outfield spots had been in a state of flux all season—Milt Byrnes, Frank Demaree, Hal Epps, Mike Kreevich, Chet Laabs, Gene Moore and Al Zarilla all had held significant starting time at some point—the infield was basically set. Injuries did force each of them out of the lineup for brief stretches, but Sewell plugged in George McQuinn at first base, Don Gutteridge at second base, Vern Stephens at shortstop and Mark Christman at third base in the lineup for the majority of the year. The four formed a decent fielding infield, with the corner infielders McQuinn and Christman shining. They all also did damage at the plate.

With 101 games gone by, McQuinn was hitting 267 with 63 runs and 49 RBI; Gutteridge was at .251 with 61 runs, 21 RBI and a team-high 13 steals; Stephens was at the top of many league offensive categories, batting .301 with 61 runs, 69 RBI and 11 homers, while Christman was hitting .285 with 40 runs and 57 RBI.

The biggest surprise of the bunch was Christman. McQuinn and Gutteridge were veterans of the major leagues and both had been starters for years. Stephens was three years removed from the minors, but had been a starter and big run producer in his first two seasons. Christman, though, had been nothing more than a utility player and minor leaguer up to this point in his career.

--Marquette Joseph Christman was born October 21, 1913 just outside of St. Louis, in Maplewood, Missouri. Like most St. Louis baseball playing youths, Christman's dream was to play for the hometown Cardinals, not the Browns. In 1932, while still a senior at Maplewood High, Christman got a chance to make his dream a reality. He attended a Cardinals tryout in St. Louis and was subsequently invited to a later tryout in Springfield, Missouri. However, Christman didn't make the cut.

But Christman's professional aspirations weren't to be denied for long. A Detroit "bird dog" scout, Jim Feeney, saw Christman play in an amateur game at University City. In 1933, Christman inked a contract with the Tigers minor league affiliate in Beaumont, Texas.

Christman, whose brother Paul was an All-American football player at the University of Missouri, started in the low levels of the Tigers system. He began with the Alexandria (La.) club of the East Galine League in 1934. The next season he played for Henderson of the West Dixie League, hit .284 and was named Most Valuable Player. That earned Christman a promotion to Beaumont where he played for the next two seasons. Never known as a speedster in the majors, Christman nevertheless stole 47 bases while in Beaumont in 1937.

MARK CHRISTMAN. Despite the 1944 Browns being labeled as having an "All 4-F infield," third baseman Mark Christman was classified 1-A, not 4-F. Christman was a great fielder who also turned into a clutch hitter with the Browns. (SM)

Twenty-four years old and with four years of minor league experience, Christman finally made it to Detroit in 1938. Splitting his time between third base and shortstop, Christman played in 95 games, batting .248 with six doubles, four triples, one homer, five steals, 35 runs and 44 RBI.

During spring training in 1939, Christman proclaimed that he had the potential to be a .300 hitter. But it turned out he wouldn't be able to meet that goal with Detroit. During the offseason the Tigers acquired third baseman Pinky Higgins from Boston. In his six plus seasons with Philadelphia and Boston, Higgins had a .305 batting average. He knocked in over 100 runs in each of his two years in Boston and drove in over 90 three times with the A's. At shortstop Detroit had Billy Rogell, the starter for the previous seven seasons, plus 24-year-old-rookie Frank Croucher. There was little space for Christman.

Christman played in only six games in a month's time and was ultimately traded to the Browns on May 13, 1939, one of 10 players involved in the deal. Along with Christman, St. Louis received pitchers George Gill, Bob Harris, Vern Kennedy and Roxie Lawson and outfielder Chet Laabs. The Tigers acquired pitchers Bobo Newsom and Jim Walkup, infielder Red Kress and outfielder Beau Bell. The deal turned out to be a steal for the Browns.

Four of the six players St. Louis received directly or indirectly were part of the '44 club while the Tigers didn't have much to show for the deal shortly after making it. Christman and Laabs were still with the Browns five years later in 1944, while Kennedy was traded in 1941 for Rick Ferrell, who was eventually traded for Gene Moore. Harris won 23 games for St. Louis from 1941-42 before being dealt for Frankie Hayes, who the Browns traded to Philadelphia receiving Sam Zoldak as part of the exchange. Gill lasted just the 1939 season with the Browns, posting an abysmal 1-12 record, and Lawson pitched only two years before both faded into obscurity, never again appearing in the majors.

Walkup pitched in just seven games for Detroit in 1939, his last season in the majors. Newsom won 37 games for Detroit from 1939-40, but lost 20 in 1941 and was sold to Washington for $40,000 in the offseason.

Kress played only 84 games in two years before retiring, although he did return in 1946 to pitch in one game for the New York Giants. Bell, who hit .344 for St. Louis in 1936 and .340 in 1937 with league highs of 218 hits and 51 doubles, played in just 54 games batting .239 for Detroit in '39 and was traded for outfielder Bruce Campbell in January of 1940.

While Christman did play in 79 games for the Browns following the trade, playing mostly at third base, hitting just .216, his impact with St. Louis was still a couple of seasons away. He was named captain of the Browns in '39 despite being acquired a month into the season, and spent the next three seasons playing exclusively for St. Louis' minor league team in Toledo. With the Mudhens, Christman played third base, shortstop and second base, although when Vern Stephens was promoted to St. Louis in 1942, Christman became the everyday shortstop.

In 1943, nearing his 30th birthday, Christman returned to the major leagues. However, with Don Gutteridge at second, Stephens at short and Harlond Clift at third, much like his time in Detroit, Christman couldn't find a starting job. His big break finally came towards the close of the season. Clift was a durable, fairly good fielding third baseman who hit for average, had some power and consistently drew over 100 walks a year. However, he had been with the Browns since 1934 and had grown accustomed to losing. Clift had the defeatist mentality that Luke Sewell was trying to abolish. So on August 18, 1943, the Browns traded Clift to Washington for infielder Ellis Clary, Ox Miller, a 28-year-old rookie reliever who appeared in just three games for the Senators, and cash.

Ostensibly, Clary was to become the Browns new starting third baseman. He had played 76 games for the Senators in 1942, primarily at second base, hitting .275. Clary was moved to third by Washington in '43 and hit .256 in 73 games prior to being traded to St. Louis. With Clary still on his way to St. Louis, Sewell started Christman at third. In his first start August 18th, Christman stroked a double, scored a run and drove in another. *The Sporting News* reported that Christman also played "a whale of a game in the field." This was nothing new. "Mark Christman was one of the greatest third basemen, fielding third basemen, I had ever seen," said Babe Martin, Christman's one-time teammate and contemporary.

While few questioned Christman's glove, he now started showing what he could do with the bat. Christman started again August 19th. In a 3-0 win over Philadelphia he blasted two triples. The starting job was no longer Clary's; Christman owned it now. He finished the season appearing in 98 games, playing 37 in the field at third, 24 at short, 20 at first and 14 at second, and hitting .271 with 11 doubles, five triples, two home runs, 31 runs and 35 RBI. Despite playing four positions, Christman committed a total of only three errors on the season.

Christman took on a job at the Central Fire Truck Co. in St. Louis in the offseason, thus maintaining his 2-B draft classification. But that meant he could only play part-time for the Browns, even though he was being penciled in as the starter. Christman eventually returned to the Browns full-time, and was reclassified 1-A. But being 30 years old and with two children, his chances of being drafted were greatly decreased.

With Clary starting at third during spring training in '44, reporters noted that with McQuinn, Gutteridge, Stephens and Clary, the Browns had an "all 4-F infield," a comment with which Christman took exception. "What's with all this talk about the Browns having an all 4-F infield," he objected. "I'm not." Unfortunately, the tag stuck and decades later the '44 Browns are often referred to—incorrectly—as the club with the all 4-F infield.

Christman changed his offensive style since coming up with Detroit six years earlier. As a rookie, the right-handed Christman was an opposite field hitter, meaning the majority of the balls he hit went towards right field. By 1944, Christman was a pull hitter, knocking the ball towards left field.

Whatever his secret, Christman was already enjoying his finest season in the majors and it was only August. He entered the season a .249 career hitter, but was hitting 36 points higher than that after the team's game August 1st. Christman was also driving in runs with great proficiency. He had but 99 RBI in 892 AB in his first three seasons, or one RBI per 9.01 AB. His 57 RBI already was a personal best. Christman was knocking in one run every 6.16 AB, a rate second on the club only to Stephens who was batting 16 points higher with distinctly more power.

The Sporting News wrote that Christman "Today is considered one of the best fielding third baseman in either league, and a tough, dangerous hitter in the clutch."

In first place, the Browns could have used a three-day rest. However, over the winter the club signed a contract to play the Kansas City Blues of the American Association in an exhibition game. The game was a boon to the last place Blues ("resounding last place" according to the *St. Louis Post-Dispatch*) who drew a season high attendance of 5,965. Kansas City even beat St. Louis 9-8, the Blues scoring six runs in the seventh and eighth innings off Al Hollingsworth and the Browns backups. The Browns did bang out 14 hits, led by Gene Moore who went 4-for-5 with two triples and three RBI.

With their exhibition folly behind them, the Browns prepared to face Cleveland for a three-game series, their final home games before a long road trip. The Indians, nine games behind St. Louis and looking to make a move towards the top, made what they thought was a key move, flying in Ray Mack, their starting second baseman from 1940-43 but now a part-time weekend player, from his war plant job.

Cleveland's ploy backfired. Mack made three errors—and could have picked up a fourth on a ball he bobbled but was scored as a single—leading to five unearned runs in a St. Louis 9-6 win. In the second inning, Mack botched back-to-back double play grounders. The first miscue, on a Frank Mancuso bouncer, filled the bases. The second, on a ball hit by Bob Muncrief, allowed two runs to score. Mack's fielding didn't get much better in the Cleveland-St. Louis series-ending doubleheader, making three errors in the two games to push his three-game total to six.

Also committing an error in the first game was St. Louis catcher Tom Turner, who was making his first start as a Brown. Turner dropped a pop fly off the bat of Mickey Rocco. With all the troubles Frank Mancuso and Red Hayworth had during the season with pop flies the play didn't go unnoticed, according to the *St. Louis Post-Dispatch*, "causing fans to chuckle, 'He belongs, all right.'" Turner's gaffe put Rocco on base and he eventually scored to cut the Browns lead to 9-6. Cleveland put two more runners on, but Al Zarilla made a "circus catch" on catcher Norm Schlueter's fly ball to end the contest.

Nelson Potter started the second game, his first appearance since the completion of his 10-game suspension. Ironically, Cal Hubbard, the home plate umpire that ejected Potter for going to his mouth and which subsequently led to the pitcher's suspension, was the third base umpire. There was no controversy this time for Potter, as the pitcher didn't wet his fingers as he had in the past, instead brushing them off on his left arm.

Potter wasn't sharp after his long layoff, giving up 10 hits and four runs in 7 2/3 innings. But St. Louis scored six runs in the sixth, keyed by a two-run single by Stephens, who now led the American League with 73 RBI, and a three-run double by Mancuso. The Browns ended with a 6-4 win—George Caster pitching out of jams in the eighth and ninth—to complete the three-game sweep as well as a very successful homestand. St. Louis went 14-5 during its recent stretch at Sportsman's Park, padding four-and-a-half games to its lead.

The news for second place Boston wasn't as good. Red Sox ace starter Tex Hughson, who sported a 17-4 record, was summoned by the military. He had just one more start before entering the Navy. In addition, second baseman Bobby Doerr, the club's leading hitter, had his draft status changed from 4-F to 1-A, and had already passed his induction exam.

As the Browns boarded on a train August 8th, preparing themselves for two big four-game series at New York and Boston, they made club history. August 8th marked the Browns 70th consecutive day atop the standings breaking the record of 69 days in first place set by the 1922 squad, although, as the *St. Louis Post-Dispatch* reported, "the Browns' 1922 stay in first place was not on consecutive days."

St. Louis opened its series in New York in exciting fashion. Nick Etten gave New York a 2-1 lead in the fourth when he hit his 12th homer of the season off Browns starter Bob Muncrief. The score stood until the eighth when George McQuinn tied the game with a two-out single that scored pinch runner Tex Shirley. In the ninth inning, Al Zarilla pounced on a Hank Borowy pitch and delivered it into the right-field seats for a solo homer, his fifth of the season.

Sig Jakucki pitched the final two innings to earn the victory in the 3-2 win, St. Louis' ninth consecutive triumph, tying the team's longest skein since the Browns opened the season 9-0.

Denny Galehouse helped make it 10 in a row. The St. Louis starter won his fifth straight decision, blanking the Yankees in a 3-0 Browns win. Galehouse gave up just six singles while not walking any as he allowed just one New York baserunner to reach second base.

Working on just a one-day rest following his two-inning relief stint, Jakucki got rocked by New York as the Browns' winning streak came to a halt. Jakucki gave up six runs on 10 hits—including homers by Rollie Hemsley and Russ Derry—as the Yankees won 6-1.

The Browns may have lost but their stock was turning out to be a winner. Since selling stock in the club at an initial cost of $5 per share in 1936, the price of shares in the Browns had sunk to as low as $1.75. It began the season selling at $2.25 a share, but in some transactions Browns stock was now selling for $5.25 a share.

St. Louis returned to its winning ways August 12th, beating the Yankees 8-3, giving the Browns their first four-game series victory over New York since the 1940 season. George McQuinn led the way, powering two two-run homers, his seventh and eighth blasts on the year. McQuinn added another RBI in a four-run seventh inning. Sewell's club headed to Boston carrying a 65-43 record (.602 winning percentage). The Red Sox were now six-and-one-half games behind the Browns. New York fell to fourth place, nine-and-one-half games out, with Detroit, eight games behind, in third place.

The Browns opened their series with Boston with a Sunday doubleheader. In the opener, McQuinn continued his home run tear by knocking a solo shot while Stephens hit two balls over the famed Green Monster (named because of its color and unusually high 37-foot wall) in left field. The Browns led 6-5 heading into the ninth, but reliever George Caster, who entered the game in the seventh for Muncrief, served up a two-out home run to Leon Culberson, just the second homer (and final) for Boston's leadoff center fielder on the season. The game went into extra innings and remained tied at 6-6 until the 13th when with one out and with Caster still on the hill, Bobby Doerr hit his 15th homer of the year to end the affair.

St. Louis also lost catcher Tom Turner early in the game when he chipped a bone on his finger on a Doerr foul tip. He was expected to miss 10 days. The contest took three hours and 15 minutes to play, an unusually long time for games of that era. Most games took around two hours to play, two-and-a-half hours for extended extra-inning contests.

In 1944, the state of Massachusetts had a law on the books that stated no game which starts after 4:30 p.m. on a Sunday could start a new inning after 6:15 p.m. Because of the length of the first game of the doubleheader, the second game, which didn't begin until 5 p.m., was in jeopardy. A baseball game isn't considered official until four and one-half innings have been played, or if the home team is losing, five innings.

The two teams managed to just squeak the second game in. St. Louis scored five times in the fourth—highlighted by a two-run triple by Christman—to take a 6-0 lead. Boston didn't score in the bottom of the fourth and time permitted the fifth inning to be played. St. Louis didn't score in its half, while Boston managed to push across one run. But with the game an hour and 17 minutes old, meaning it was past 6:15 p.m., the sixth inning could not be played. The game was called and with five innings completed, the Browns were the victors. Nelson Potter pitched the five-inning complete game to pick up his 11th victory, surpassing his career high of 10 wins in a season which was set the previous year.

The Browns fell 5-1 to the Red Sox on August 14th, losing to a pitcher they prevented Boston from trading to the National League. Earlier in the season, Boston intended to trade Emmett O'Neill to an unspecified National League team for a reported $15,000. In order for Boston to swing the deal, they had to pass O'Neill through waivers and hope nobody claimed him. If unclaimed, O'Neill could pass freely to the other league.

The ploy almost worked. Every team passed on the pitcher except for the Browns, who were enamored with anyone who could throw as hard as O'Neill. While O'Neill threw hard, he had little control where the ball went. In his career, which spanned 1943-1946, O'Neill walked 260 batters, an average 6.57 base on balls per nine innings, an atrocious ratio. Because of his propensity for walks, Boston player-manager Joe Cronin was always hesitant to start O'Neill, hence the effort

to deal the pitcher. But O'Neill was on a hot streak. He did walk four Browns and throw a wild pitch, but he allowed just four singles and one run en route to his fourth straight win. Browns starter Denny Galehouse saw his five-game winning streak come to an end.

Sig Jakucki, who got pounded on one day's rest by New York, didn't fare any better with a four-day reprieve against Boston. Jakucki put St. Louis in an early hole in the final game of the series. Boston tagged him for six hits in 1 1/3 innings before Luke Sewell pulled him out. Boston scored once in the first and already had three runners cross the plate in the second and had runners on first and third with one out.

Sewell brought in Tex Shirley to replace Jakucki. While the pitcher was warming up, infielder McQuinn, Gutteridge and Stephens got together around second base. Umpire Bill McGowan wandered over and joined the discussion. According to the *St. Louis Post-Dispatch*, the umpire and players had the following exchange:

McGowan: "Now don't get panicky; you're doing all right, even if you do lose three out of four here."

McQuinn: "Lose three out of four? We'll not lose this ball game."

The first batter Shirley faced was Pete Fox who lined out to Gene Moore in right field. Moore was able to double up Catfish Metkovich off first base, but not before Leon Culberson scored to make it 5-0 Boston.

While Jakucki was getting rocked, Boston starter Yank Terry cruised along. He retired the first 13 batters of the game before Moore singled with one out in the fifth. Terry's shutout was broken two batters later, Mark Christman doubled off the Green Monster in left scoring Moore. Things fell apart for Terry in the sixth. Milt Byrnes, pinch hitting for Shirley, walked. He moved to third on a Gutteridge double. Terry settled down getting Mike Kreevich on an infield popup, but he then walked McQuinn to load the bases for Stephens.

With Red Barrett warming up in the bullpen and ready to go, Cronin nevertheless stuck with Terry; his faith didn't pay off. Stephens, who hit a grand slam off Boston's Joe Bowman on July 23rd, duplicated the feat against Terry, knocking the pitcher's first pitch out of the ballpark, tying the game 5-5. Cronin then took out Terry and inserted Barrett, but he wasn't the answer either. Moore singled, took second on a wild pitch then scored what proved to be the winning run on a Zarilla double. George Caster pitched the final four innings and allowed just one hit.

Interestingly, the official scorer credited Caster with the win and not Shirley. When the starting pitcher gets knocked out before five innings, the scorer can deem whomever he feels is deserving the winner. Shirley did pitch 3 2/3 hitless and scoreless innings, but in this case the scorer felt Caster was under greater duress because he was pitching with a one-run lead, where the Browns were down by five, then four, runs when Shirley was on the mound. The ramifications of not being given the win was not lost on Shirley. "That victory will be important to me next spring when new salaries are discussed," Shirley noted.

Since July 2nd, when the Browns wrapped up losing two of three games to the Red Sox, the club was 26-12. Seeing his team split the four-game series with Boston, thus keeping the lead at six-and-one-half games, was not all that displeasing to manager Luke Sewell. "We're playing tag now and they'll have to catch us," Sewell said as the team traveled onto Philadelphia.

Sewell had reason to speak with confidence. After taking three of four games from New York and splitting with Boston, the two closest teams to St. Louis when the team left on its road trip, the Browns now had four-game tangles with the two worst teams in the league, Philadelphia and Washington.

The Browns were their own worst enemy in the opening game against the A's on August 16th. In the bottom of the first inning Irv Hall singled. Ford Garrison bunted, but pitcher Jack Kramer's throw hit Garrison in the back, allowing Hall to go to third where he eventually scored on a sacrifice fly by Frankie Hayes. Now up 2-0 in the fourth, Philadelphia's George Kell singled then attempted to steal second base. Don Gutteridge dropped the throw (but wasn't given an error) and Kell subsequently scored on an single by pitcher Russ Christopher.

St. Louis did get two runs back in the fifth on a two-run homer by Milt Byrnes, but in the bottom of the inning Al Zarilla misjudged a Hal Epps fly ball, the former Brown, nicknamed "Reindeer,"

turning it into a triple. Kramer then helped him home by throwing a wild pitch. St. Louis couldn't score again off Christopher, who picked up his fifth straight win in pitching the complete game.

Nelson Potter got the start the next day because Bob Muncrief was experiencing pains in his arm. Potter pitched well, allowing just two runs in eight innings, but tired under the hot playing conditions. George Caster gave up three runs in the ninth but it didn't matter as St. Louis rapped 15 hits and scored 10 runs. Stephens clubbed his 15th homer, tying him with Boston's Bobby Doerr for the league lead.

The Browns now led Boston by seven full games, their largest lead of the season. Meanwhile, the St. Louis Cardinals were running away with the National League. The Cardinals had an 81-23 record (.743 winning pct.) and were 17.5 games ahead of second place Pittsburgh. Both St. Louis teams were receiving about 100 World Series ticket applications a day.

The Browns pounced on Don Black in the third game, taking a 4-0 lead heading to the bottom of the fifth. Tex Shirley, operating on two days' rest, held Philadelphia to just one hit through four innings, but he ran out of gas in the fifth. Shirley was tagged for two doubles, two singles and two walks before finally being pulled by Sewell, leaving with the score 4-3 in favor of St. Louis. Rookie Sam Zoldak replaced Shirley and promptly gave up a two-run single to Ford Garrison, giving the A's the lead and providing the eventual 5-4 final score. The Browns couldn't score off reliever Joe Berry over the final four innings.

For the second consecutive series the Browns were faced with trying to salvage a split. Things looked good early as St. Louis led 3-0, Milt Byrnes collecting a pair of RBI singles while Bob Muncrief was keeping the A's off the scoreboard. But Muncrief tired significantly in the seventh. Pinch hitter Larry Rosenthal cracked an RBI double and Garrison a two-run single to tie the game.

Relievers George Caster and Russ Christopher, who tossed the complete game win against the Browns three days earlier, each didn't allow the opposition to score and the game eventually headed into extra innings. In the bottom of the twelfth, Bobby Estalella tripled off Caster, who was working his fifth inning, to start the inning. Caster intentionally walked both Frankie Hayes and Dick Siebert to load the bases. Bill McGhee popped out to Christman, but 21-year-old rookie George Kell pasted a Caster pitch over the heads of the outfielders in left center, scoring Estalella with the winning run. The seventh place A's took three out of four games from St. Louis, the first time in a month and a half the Browns lost a series. They had won five series and split five in that span.

St. Louis looked to right the ship in Washington against the last place Senators. Since leaving St. Louis riding an 11-game losing streak, Washington had fared only slightly better, winning just six of its next 17 games. The two teams started their four-game set with a Sunday doubleheader. The Browns opened up a 2-0 lead on the Senators' Dutch Leonard in the first game, but following a Mike Chartak leadoff double in the fourth inning, the Washington starter mowed down the final 18 St. Louis hitters. Washington meanwhile scored four times off Denny Galehouse, St. Louis nemesis Stan Spence driving in two runs.

While Washington won a tight 4-2 game in the opener, there wasn't much doubt in the second game of the twinbill. The Senators pounded three St. Louis pitchers—Jack Kramer, Weldon West and Sam Zoldak—for 17 hits and 12 runs as Washington routed St. Louis 12-1. The Browns scored their only run in the eighth inning; by that time Washington already had 10 runs. Early Wynn, who hadn't beaten St. Louis in four previous starts, won his final game before he entered the Navy.

The two defeats meant the Browns had lost four games in a row, their longest losing streak of the season. To make matters worse, both Boston and Detroit swept their doubleheaders. St. Louis now led the Red Sox by three-and-one-half games and the Tigers by five games. New York, which was swept by Detroit, stood six-and-one-half games back. With the losing streak and the narrowing of the team's first-place lead the naysayers now had reasons to come down on the Browns, but such talk didn't effect the players, at least publicly. "They'll not get me down," said Mark Christman. "They'll have to take this right out of my teeth before they'll take this pennant away from me."

Sig Jakucki, who in his last three starts was roughed up for 22 hits and 15 runs in just 11 innings, took the hill August 21st against Washington's Milton Haefner, one of four knuckleball pitchers on the Senators staff. Jakucki gave up two runs in the second then served up a solo homer to second baseman Freddie Vaughan, who was playing in just his third major league game. But Jakucki settled down after that, retiring the next 17 batters. The game went into extra innings tied 3-3 and both pitchers remained on the mound. Then in the top of the twelfth, after Frank Mancuso collected his third hit of the game, Don Gutteridge blasted a Haefner offering deep into right-center field. Mancuso scored and Gutteridge wasn't too far behind him completing an inside-the-park homer, his first home run of any kind in '44. "(Gutteridge) ran so fast he almost caught up with Frank at home plate," reported the *St. Louis Post Dispatch*.

Gutteridge hustling was no accident. He was called a "pepperpot" by his teammates because of his playing style. Gutteridge shied away from such characterizations. "Well, I've been called a pepperpot and all that," he said in an interview in 1994. "I don't know, I liked to play. I loved to play. I loved to play and loved to go to the ballpark and get in the uniform and perform."

As often happens, luck and circumstance put Gutteridge on the track to the major leagues. His father worked for the Kansas City Southern Railroad—Gutteridge also worked there as a brakeman during the 1943 offseason—and they had a baseball team. Throughout his school days, all Gutteridge wanted to do was play baseball. His father got him onto the railroad team and a scout saw him play one day. By 1936, Gutteridge was playing for the St. Louis Cardinals.

With the Cardinals, Gutteridge was a third baseman. He played in just 23 games in '36, but hit .319 with a .538 slugging percentage. The next season Gutteridge was the starter. He played in 119 games and hit .271 with 26 doubles, 10 triples, seven homers and 12 stolen bases.

The Cardinals traded their starting shortstop, Leo Durocher, to Brooklyn in the offseason meaning Gutteridge spent the 1938 season splitting his time between third and short. He played in 142 games, hitting .255 with 21 doubles, 15 triples, which was second in the National League behind teammate Johnny Mize, a career-high nine homers and 14 steals. However, Gutteridge committed 45 errors, 17 at third base in 73 games and 28 at short in 68 games.

St. Louis moved second baseman Jimmy Brown to shortstop in '39 and kept Gutteridge at third. Gutteridge played in 148 games and hit .269 with 27 doubles, four triples and seven homers, but his steals slid from 14 to five.

In 1940, though, Gutteridge played in just 69 games—almost half of those coming as a pinch hitter or pinch runner. Gutteridge was ready to retire until a Cardinals teammate, who retired following the '40 season, gave him a call. "I was going to give up and then Pepper Martin got me to go to Sacramento with him, 'cause he was a friend of mine, Pepper Martin was," Gutteridge recalled. "So he's going out there to manage in Sacramento. I says, 'Well I'll go out there with you for one year and then if I don't go back to the major leagues I'm going to quit.' He said, 'OK, if you'll give me one year I'll be happy.' That's because Pepper and me were buddies. So I went out there and had a good year and the Browns bought me then."

Gutteridge hit .309 for Sacramento in 1941—a team which also included future Brown Al Hollingsworth—and also stole 46 bases and scored 113 runs. Gutteridge was still technically property of the Cardinals, but they didn't want him. In January of 1942 the Cardinals decided they'd let the Browns bring Gutteridge to spring training and if they liked what they saw they could have him for $7,500.

"A couple of the Browns players were called into the service and so they needed players," explained Gutteridge. "And so of course the Cardinals and Browns had offices together in St. Louis. I guess they walked across the hall and they said, well if you want the Gutter you can have him for a little bit of nothing because he was going to quit anyway. Anything they can get out of him is better than nothing. So I guess that's why I ended up with the Browns."

There was still one problem. Luke Sewell wanted Gutteridge to be the team's second baseman. In his five years with the Cardinals, Gutteridge had played only third base and shortstop. Besides, Bill DeWitt warned Sewell that Branch Rickey, the Cardinals pariah of baseball talent, said Gutteridge couldn't play second base. However of the two Browns second

basemen in 1941, one, Johnny Lucadello, was off to the military and the other, Don Heffner, Sewell wasn't enamored with. So Gutteridge got some on-the-job training.

Gutteridge watched other second basemen from around the league and talked to stalwarts like New York's Joe Gordon and Boston's Bobby Doerr. If he had any questions, Gutteridge was ordered to talk only to Sewell, the manager fearful of anybody else tinkering with him.

One thing the Browns knew for sure was that Gutteridge wouldn't be drafted. He tried to enter the military twice but was classified 4-F both times. Gutteridge had albumin in his urine, bad knees and chips in his ankle. "If you had a chipped bone then they wouldn't take you in the Army, afraid you'd break down marching or some shit," said Ellis Clary, Gutteridge's teammate from 1943-45. "But Gutteridge could outrun a scalded dog and he had one of them things in his ankle, and hell, I think it made him faster. He could fly."

Gutteridge played in 147 games for the Browns in 1942—all but two of those at second base. He hit .255 with 27 doubles, 11 triples, one homer, 16 steals—a personal best at that point in his career—and a career high 90 runs. He committed 23 errors, which was about the average for starting second basemen in the American League that season.

Gutteridge trotted out to second base 132 times in 1943. His statistics weren't eye-catching—.273 batting average, 35 doubles, six triples, one homer, ten steals, 77 runs—but enough was thought of Gutteridge that he received 13 votes for A.L. Most Valuable Player, good enough for 18th place. He was still learning his new position, however. Despite missing 20 games, Gutteridge led A.L. second basemen in errors with 29. He may have not put up flashy numbers, but no one could ever accuse Gutteridge of not giving it his all. Teammate George McQuinn once said of Gutteridge, "He couldn't do much except win you ballgames."

Gutteridge's inside-the-park homer against Washington proved to be a game-winner. Jakucki held the Senators in the bottom of the twelfth to finish up his elongated complete game. Gutteridge's blow was indeed fortuitous as both Boston and Detroit lost. The Tigers were in third place, six games back of St. Louis, but the club's fans were getting excited about the upcoming series against the Browns, which began August 25th. There was such demand for tickets that three ticket windows had to be opened at Briggs Stadium in Detroit.

On August 22nd, the Allies liberated Paris from Nazi occupation, ending four years and 74 days of imprisonment. Yet fighting continued back in the United States, and in Washington, D.C., no less.

Nelson Potter and ex-Brown Johnny Niggeling were engaged in a scoreless duel for six innings. Then in the bottom of the seventh, Washington broke loose for three runs. Freddie Vaughan led off by beating out a bunt. He was sacrificed to second by Gil Torres and was moved to third on a single to left by Rick Ferrell. John Sullivan followed with another single to left, scoring Vaughan and sending Ferrell to second. Niggeling then joined the act, sending yet another single to left. Ferrell scored on the play and when Al Zarilla's throw from the outfield sailed wide of the plate and past the catcher, Sullivan also crossed the plate and Niggeling moved up to second base.

George Case was up next and he tried to move Niggeling to third by way of a sacrifice bunt. Case pushed the bunt up the first base line but foul. Potter, while retrieving the ball, had a few words for Case. According to the St. *Louis Post-Dispatch*, Potter "asked him [Case] if he didn't have nerve enough to swing."

Case took exception to Potter's inflammatory words, punching Potter in the nose, the pitcher responding by slugging Case in the jaw. Both benches emptied and a lengthy brawl ensued. After umpires Cal Hubbard, Charley Berry and Red Jones finally untangled all the players, they ejected Potter, Case and Washington backup first baseman Ed "Babe" Butka. Potter, who ended up with a "slightly bruised nose and a scratch near his right eye," was also eventually fined $100 for the incident.

The fight was a good way for St. Louis to get rid of some of its frustrations. The Browns ended up losing to Washington 3-0, meaning they had lost six of eight games to the two worst teams in the league.

GEORGE MCQUINN. George McQuinn knocked three homers in two days in mid-August. But even when his bat was cold, McQuinn was worth having in the lineup because of his glove. (SM)

Sewell, disgusted by his club's lack of hitting, scheduled a prolonged batting practice for the next day, one of two off days the Browns had before starting the crucial series in Detroit. In the past eight games, McQuinn was 3-for-22 (.136), Christman 5-for-33 (.152), Stephens 5-for-31 (.161), Gutteridge 6-for-28 (.214) and Moore 4-for-17 (.235).

The Browns got some more bad news before heading to Detroit. All-Star pitcher Bob Muncrief's arm wasn't bouncing back and it was diagnosed that he had a sore arm. Team doctors didn't know when Muncrief could pitch again.

Denny Galehouse matched up against Dizzy Trout in front of over 12,000 fans in Detroit in the opening game between the Browns and Tigers. In the third inning, Tigers shortstop Joe Hoover led off against Galehouse and singled. Hoover then stole second, thanks in part to Vern Stephens dropping the throw from Frank Mancuso. He moved to third on a ground out by Trout and remained there when Doc Cramer flew out to shallow left field.

Galehouse then walked Eddie Mayo. With Pinky Higgins, the third-place hitter in the lineup, at bat, the Tigers executed a delayed double steal, meaning Hoover didn't break for home until after the Browns threw down to second base. McQuinn, who ended up with the ball on the play, threw home but it was too late to nab Hoover. That was the only run of the game. Trout allowed just four singles, walked three and struck out five in shutting out the Browns.

The second game of the series also produced a shutout. But it wasn't Browns starter Sig Jakucki, who hadn't allowed a run against the Tigers in 19 1/3 innings, who didn't allow the opposition to score. Instead it was the Browns who again were blanked—for the third straight game—this time by Stubby Overmire, 5-0. It didn't take long for Detroit to ruin Jakucki's scoreless streak. Rudy York hit a solo homer off Jakucki in the second then connected again in the third, this time a two-run shot.

The Browns hadn't scored in 27 innings so Luke Sewell took some advice from umpire Bill McGowan on how to construct his lineup. McGowan told Sewell he should put Mark Christman third in the order and Milt Byrnes seventh. Usually, Sewell had Christman batting seventh and Byrnes second. For the first game of the Sunday doubleheader against Detroit, Sewell did move Christman to the third spot in the order, moving George McQuinn to sixth, while he batted Byrnes eighth.

The strategy worked for a while as St. Louis scored the first three runs of the game off Detroit starter Hal Newhouser, who already had 20 wins on the season. The Browns pitched Bob Muncrief, sore arm and all, and he held the Tigers scoreless until Dick Wakefield homered off him in the fifth.

Then in the sixth, Byrnes and Christman both would make fielding gaffes. With one out in the inning, Eddie Mayo and Pinky Higgins hit back-to-back singles off Muncrief. Rudy York then doubled, scoring Mayo to cut the St. Louis lead to 3-2, with Higgins going to third. Sewell then replaced Muncrief with George Caster, who intentionally walked Wakefield to fill

the bases. Jimmy Outlaw stepped up and hit a grounder to Christman "who, to the amazement of everyone, nonchalantly tossed Outlaw out at first, Higgins scoring the tying run." Later, Christman explained that because of a bad hop he fielded the grounder off-balance. He figured there was no chance for a double play and a play at the plate on Higgins was no sure out, so he chose to take the safe out instead.

Paul Richards then hit a fly to left field which Byrnes got a late jump on. Richards ended up with a two-run double, giving Detroit a 5-3 lead, a score that stood the rest of the way. The Browns did collect 13 hits off Newhouser, but the Tigers pitcher didn't walk anybody and struck out eight to improve to 21-9. Continuing his practice of using any pitcher as a starter or out of the bullpen, Sewell brought in Jack Kramer for the final two innings.

Sewell didn't need any bullpen help in the second game. He also juggled his lineup again, moving Christman back to seventh and inserting Al Zarilla for Byrnes and placing him third in the order. The Browns, who had scored just 14 runs in their last eight games, erupted for 17 hits and 17 runs against five Detroit hurlers. A season high crowd at Briggs Stadium of 51,376 witnessed the Browns biggest hitting attack since a 17-hit performance in an 18-8 win over Philadelphia on June 3rd. Every starter but Gutteridge had at least one hit and each scored at least one run, except for Stephens, who did have three RBI. McQuinn rapped out four hits while Mike Kreevich and Stephens had three. Christman blasted his sixth homer of the season.

But all was not well with St. Louis. Muncrief complained of soreness following his start, his fifth consecutive start without earning a win, and was sent home to rest his ailing arm. Sewell, desperate for a veteran pitcher, reached out and signed 38-year-old former major leaguer Willis Hudlin. Hudlin not only was pitching for Little Rock in the Southern Association, but he was also part owner of the club.

Hudlin began his professional career with Waco in 1924. He then pitched for Cleveland from 1926-39, winning at least 12 games nine times including five straight seasons from 1927-32. He finished his career in 1940 with four teams, Cleveland, Washington, the Browns and New York Yankees, compiling composite totals of a 3-5 record with a 6.98 ERA.

The addition of Hudlin and the recent decision by Commissioner Landis to put Tom Hafey back on the Browns meant St. Louis had 27 players on its roster, two over the limit. Hafey eventually was released to Oakland of the Pacific Coast League. To make room for Hudlin, the team farmed out Weldon "Lefty" West also to Oakland. Although West's initial reaction was to refuse to report, the rookie eventually accepted the demotion. West wasn't a stabilizing

LUKE SEWELL. Luke Sewell tried almost anything to correct the Browns' struggles, whether it was taking lineup advice from an umpire or signing retired pitcher Willis Hudlin. (NBH)

factor in the bullpen and Sewell didn't use him often. He had pitched in just 11 games, recording no decisions with a 6.29 ERA and 34 hits and 19 walks allowed in 24 1/3 innings with just 11 strikeouts. Sewell had used West just once in August, on the 20th in a 12-1 loss in the second game of a doubleheader to Washington. West pitched three innings in that contest allowing five runs on seven hits and two walks while striking out three.

St. Louis finished its road trip by splitting two games with Cleveland. They won the first 8-3 as Denny Galehouse pitched a complete game but lost the second 12-7 when Cleveland scored eight runs (seven unearned) in the eighth inning. The Browns won just nine of the 22 games they played on the road and had three teams nipping at their heels. New York now was in second place, three-and-one-half games back, while Boston and Detroit were tied, lurking four games behind. Commented coach Zack Taylor on St. Louis' struggles to lock up the pennant, "If we ever win one, we'll clinch it."

The good news for the Browns was that they played 23 of their last 28 games at home, including the final 16. The bad news was that Detroit, the hottest team in the league and one of their pennant pursuers, was coming to town for a four-game series.

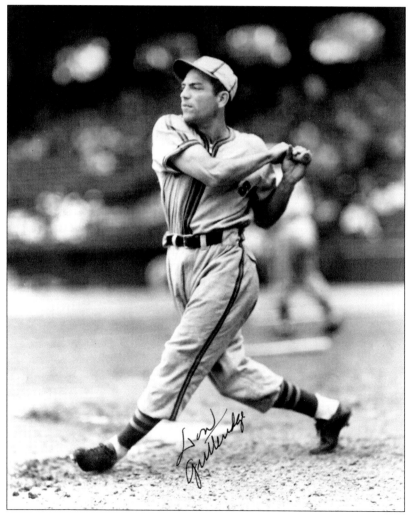

DON GUTTERIDGE. "He couldn't do much except win you ballgames." Speedy Don Gutteridge never played second base before coming over to the Browns in 1941. He was immediately made their starter and even garnered MVP votes in 1943. (SM)

Nine

Seventh Inning
Fighting For a Pennant

The Detroit Tigers got a boost to their offense when the Navy decided there was no longer such a big necessity for pilots. Because of the new policy, Dick Wakefield was released from his military commitment in July. He had been stationed at the Iowa pre-flight school. Wakefield was Detroit's "bonus baby," signing with the team for a then-astonishing $51,000. After a brief seven-game trial in 1941, Wakefield rejoined the Tigers in 1943 and was the American League's top rookie hitter. Playing left field, he batted .316 while leading the circuit in hits (200) and doubles (38). But the Navy called in the offseason.

Despite 33-year-old power hitting first baseman Hank Greenberg in the military, Detroit still had sluggers Rudy York and now Wakefield, plus the best one-two pitching punch in the A.L. in the form of Hal Newhouser, the eventual league Most Valuable Player in both 1944 and 1945, and Dizzy Trout. Newhouser and Trout as well as another top starter, Stubby Overmire, were all classified 4-F.

When Wakefield rejoined Detroit on July 13th, the Tigers were mired in seventh place with a record of 37-42 (.468). Since that time, Detroit was playing the best baseball in the league, putting together a 29-16 record (.644). For comparison, St. Louis was 25-20 (.556) in that span. With St. Louis hosting Detroit for a four-game series, a sweep by the hard-charging Tigers would create at least tie for first place, worse if the second place Yankees also kept winning.

Perhaps the pressure of the pennant race was getting to St. Louis. The Browns made a couple of fielding blunders in the first game of the series to help Detroit score the game's first runs then later tie the contest. With one out and two men on in the seventh, Vern Stephens dropped a relay throw from Don Gutteridge on a potential double play grounder hit by Overmire. Instead of possibly getting out of the inning, the bases were now loaded. The next batter, Doc Cramer, singled to center off St. Louis starter Sig Jakucki to drive in two runs.

The Browns took a 3-2 lead in the bottom of the inning, highlighted by a two-run single by Gutteridge, but St. Louis helped the Tigers tie the game in the eighth. St. Louis manager Luke Sewell elected to put Willis Hudlin on the mound in the eighth inning. Hudlin, making his first appearance in the majors in four years, promptly served up a leadoff double to York, who then moved to third on a Wakefield ground out. The next batter, Jimmy Outlaw, grounded to Don Gutteridge. York raced home and Gutteridge threw to the plate to try and nail the runner. York didn't have a chance to score, so he turned back towards third and got himself in a rundown. Catcher Frank Mancuso threw the ball to third baseman Mark Christman, but his throw skipped off York's back, the errant toss allowing York to score the tying run.

Detroit didn't need the help of St. Louis fielders in the ninth as Pinky Higgins delivered a two-out single to score Cramer with the eventual winning run. Hudlin took the loss while Trout, who pitched 2 2/3 innings of scoreless relief, raised his record to 23-9.

An interesting side note from the game: in the second inning Outlaw was hit by a Jakucki pitch. Outlaw wasn't sure if he could continue playing. The Browns, though, allowed York, who batted two places up in the order from Outlaw, to pinch run while Outlaw tested his injury in the dugout. Outlaw returned to the game. While the Browns may have been gracious to

the Tigers in that instance, their niceties didn't help them in the standings any. Not only did Detroit nip St. Louis, but New York also swept a doubleheader against Washington. That meant the Yankees were just two games in back of St. Louis while Detroit was three games behind. Boston, the only other team in the league within 10 games of the top spot, was three-and-one-half games behind the Browns.

Perhaps because the Cardinals were running away with the National League pennant—they were 91-30 (.752), 20 games ahead of Pittsburgh—bookmakers started posting odds who would take the A.L. flag. St. Louis was the front runner at 2.5 to 1. Following them were New York at 3-1, Detroit at 4-1 and Boston at 6-1.

The odds changed following the games of September 1st. St. Louis starter Nelson Potter was pulled before retiring a batter in the third, leaving with the Browns down 5-0, a Wakefield two-run homer, his eighth, finally chasing him. York added his 16th homer in the fourth off Al Hollingsworth to put the lead to 6-0, more than enough support for Tigers starter Hal Newhouser. Newhouser went the distance in picking up his 22nd win in the 6-3 Detroit win.

The only high note for the Browns was that they turned a triple play on a ground ball off the bat of York. That didn't temper the fact that with the win by Detroit and a victory by Boston (New York lost), three teams were now within two-and-one-half games of the lead. Still, the Browns, the only team in the 16-team major leagues never to have been to a World Series and who were just 4-12 in their last 16 games, were the sentimental favorites.

Even a Hall of Fame pitcher, who never played in the American League, was pulling for the Browns. "If they do what I and the whole country want them to; they'll finish on top," said Grover Cleveland Alexander, who was living at the Broadview Hotel in East St. Louis.

For a while, things looked better for the Browns in the third game of the series. St. Louis trailed 2-1 in the seventh, but with two outs Al Zarilla clubbed his sixth home run to tie the game. Stephens then singled, prompting Detroit manager Steve O'Neill to bring in Roy Henshaw to relieve starter Ruffus Gentry. However, Henshaw walked George McQuinn and Milt Byrnes to load the bases. Out came O'Neill again and Henshaw left in favor of Johnny Gorsica. Mark Christman hit a chopper back to the mound, the ball deflecting off Gorsica's mitt to Higgins at third. Higgins threw onto first, but Christman beat the relay for a infield single, Stephens scoring to give St. Louis a 3-2 edge.

The lead was temporary, though. Browns starter Denny Galehouse had allowed just six baserunners—two hits and four walks—in seven innings. But Galehouse started the eighth inning by walking pinch hitter Chuck Hostetler and giving up a single to Doc Cramer. Eddie Mayo pushed the runners up a base with a ground out and Galehouse intentionally walked Pinky Higgins to fill the bases. Galehouse did settle down to strike out Rudy York, but Dick Wakefield blistered a grounder which took a high hop off the glove of Don Gutteridge and into the outfield, two runners scoring and Wakefield ending up on second with a double.

Detroit added two more runs off George Caster in the ninth to make the score 6-3. St. Louis, though, started its half of the ninth with back-to-back singles by Zarilla and Stephens off Walter "Boom-Boom" Beck. O'Neill replaced Beck with Overmire and despite having pitched over six innings two days earlier, the pitcher retired all three batters he faced without allowing the Browns to score a run.

New York and Boston also won, prompting J. Roy Stockton of the *St. Louis Post-Dispatch* to write that the 1944 pennant chase is the "hottest race in American League history."

St. Louis had now lost four games in a row - and saw its lead dwindle to just one game - tying its longest losing streak of the season. The frustration was teeming over. After Sewell and Jakucki were both tossed out of the game in the sixth inning by umpire George Pipgras, a former major league pitcher who toiled with the Yankees from 1923-33 and the Red Sox from 1933-35, Sewell yelled out to the ump: "Still working for the Yankees, eh Pipgras?"

With both Detroit and New York just one game back, St. Louis had a chance to drop out of first place for the first time since regaining the top spot July 1st. The Tigers were going for the four-game sweep and they jumped on Browns starter Jack Kramer in the first for a run,

Doc Cramer scoring on an infield bounce out by York. But this time St. Louis answered quickly. In the three previous games, the Browns never held a lead until the seventh inning. In the finale, however, Zarilla clubbed a two-run double in the first off Trout, looking for his 24th win, to give the Browns a 2-1 lead. That was enough for Kramer who didn't allow a run the rest of the way upping his record to 13-12, St. Louis winning 4-1.

Even if Detroit had won they wouldn't have been in first place. New York swept a doubleheader, pulling them within one-half game of the Browns. Both St. Louis and New York played doubleheaders on Labor Day, September 4th. The Browns played Cleveland and the Yankees went against Philadelphia.

St. Louis had a good chance to sweep the two games from the Indians. The Browns led 3-0 after four innings in the opener, but Cleveland chased St. Louis starter Jakucki with a four-run fifth, highlighted by a three-run homer by ex-Brown Roy Cullenbine, his 16th of the season. The Browns trailed 6-3 in the eighth when Cleveland starter Mel Harder walked the bases loaded then allowed a single up the middle by Vern Stephens which knocked in one run. Indians player-manager Lou Boudreau sent in reliever Joe Heving to face George McQuinn. A base hit could tie the game, but Heving got McQuinn to ground into a force out to end the threat. Heving allowed a single in the ninth inning, but the Browns couldn't score, losing 6-4. St. Louis also temporarily lost sparkplug center fielder Mike Kreevich as he was knocked out of the game when he crashed into the right-field wall during the contest.

Stephens provided all the offense the Browns and Nelson Potter needed in the second game, blasting a two out, two-run homer, his 17th, in the first. Potter pitched a complete game as St. Louis won 5-1. The news wasn't so good for 40-year-old steamfitter Claude Bond. Upon witnessing Red Hayworth ejected by Pipgras for arguing balls and strikes, Bond threw a soda bottle onto the field, "out of sheer exuberance" he later explained, the missile flying near the vicinity of first base umpire Ernie Stewart. Bond eventually was fined $25 plus court costs.

The Browns didn't lose any money, but they did lose first place. Unfortunately for St. Louis, New York swept its doubleheader against Philadelphia, not allowing the A's to score a single run in the two games. The Browns were now one-half game behind the first place Yankees.

The four remaining contenders had between 21 and 24 games left to play. Because of wartime travel restrictions, clubs had extended home stands. The advantage among the contenders went to St. Louis and Detroit, both of whom had the majority of their remaining games at home. Fourth place Boston not only had to play mainly on the road, but they also lost second baseman Bobby Doerr and his A.L. leading .325 batting average. Doerr left the team September 4th, 15 days before his induction into the Army. Doerr was inducted even though he experienced a punctured ear drum when he was six.

THE STANDINGS AND SITUATION FOR THE FOUR TEAMS ALIVE IN THE PENNANT CHASE AS OF SEPTEMBER 4TH:

Team	W	L	GB	Games left	Home	Away
New York	74	59		21	2	19
St. Louis	73	59	.5	22	17	5
Detroit	70	60	2.5	24	18	6
Boston	71	62	3	21	4	17

With two days off, St. Louis no longer in first place and heading for its final road trip of the season, reports were surfacing that there were rifts on the Browns, an accusation manager Luke Sewell dismissed. "Oh that isn't so," Sewell said. "There are no cliques on this club. This club is hustling, they're trying . . . If they're doing any fighting it's a case of fighting to win."

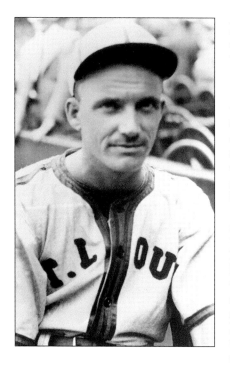

BOB MUNCRIEF. Bob Muncrief developed a sore arm causing manager Luke Sewell not to entrust the ball to the pitcher much in September. (SM)

Case in point for the team's combativeness came in the first game of the Browns' five-game series in Chicago. The White Sox scored twice in the first off Denny Galehouse, thanks to two Don Gutteridge errors, and two more times in the fourth. St. Louis couldn't pierce Chicago starter Orval Grove for any runs until the seventh, when Gutteridge tripled home Sam Zoldak then scored on a sacrifice fly by Al Zarilla.

The score stood 4-2 when St. Louis batted in the ninth. Grove retired Gutteridge to begin the frame, but then gave up back-to-back singles to Milt Byrnes and Zarilla, prompting Chicago manager Jimmy Dykes to bring in reliever Gordon Maltzberger. Vern Stephens worked Maltzberger to a 3-2 count before finally drawing a walk to load the bases. Mike Chartak, subbing at first for a tired and underweight George McQuinn, jumped on Maltzberger's first pitch, lacing a two-run single to tie the game. Gene Moore then flied out to center, Stephens scoring the go-ahead run.

Tex Shirley kept Chicago off the board in the final inning, St. Louis prevailing 5-4. Shirley and rookie Sam Zoldak pitched the final five innings, allowing just two hits and one walk while holding the White Sox scoreless. The win pushed St. Louis into a first place tie with idle New York. Detroit, which won twice while both St. Louis and New York had off days, won its third straight to move within one game of first.

Bob Muncrief tested his sore arm September 4th in a St. Louis 6-4 loss in the first game of a doubleheader, pitching a perfect ninth inning. Still, the arm wasn't 100 percent healthy. Given a start against Chicago, Muncrief surrendered five runs on seven hits, including four doubles plus a homer by opposing pitcher Bill Dietrich, in six innings. While Muncrief didn't pitch well, it wasn't bad enough for him to take the loss. That responsibility befell Al Hollingsworth who allowed two runs in each of the seventh and eighth innings. The 9-5 loss dropped the Browns out of first place—again—as New York beat Boston 7-6 in 12 innings.

Jack Kramer did nearly everything possible to try and win the third game of the series between St. Louis and Chicago. The contest went 14 innings and both he and White Sox starter Eddie Lopat pitched the entire game. Kramer even supplied the Browns' only run, tying the game 1-1 with a solo homer in the eighth, his second home run of the season, a Ruthian swat that was called "one of the longest of Comiskey Park this season."

Chicago finally won the game in the bottom of the 14th when umpire James Boyer ruled that Milt Byrnes didn't snare Thurman Tucker's bloop hit to right but instead caught the ball after it bounced once. The base hit ruling allowed LeRoy Schalk to score from third giving the White Sox the 2-1 victory. The loss stung not only because New York fell to Boston 7-1, but also because Detroit clobbered Cleveland 15-6, propelling the Tigers into second place past the Browns.

St. Louis finished out its final road games by splitting a doubleheader with Chicago on September 10th. Nelson Potter pitched a complete game in the Browns 6-2 win in the opener while pitcher Orval Grove tripled off Denny Galehouse, the fourth Brown pitcher, to score Skeeter Webb with the winning run in the 11th inning of a 3-2 White Sox victory in the second game.

New York, Detroit and Boston also split doubleheaders, leaving the standings at the status quo for a while. Because of a quirk in the schedule, most of the American League weren't due to play again until Friday, September 15th. The only game scheduled before then was a

Wednesday night game between New York and Philadelphia. The league was compensating for makeup dates due to rainouts, but because of nice weather throughout the summer those open dates weren't needed.

The Browns, among others, could use the break. McQuinn was declared fit to return to the starting lineup. He had missed five straight starts, replaced at first base by Mike Chartak, who went 6-for-22 (.273) with three runs and four RBI during that span. McQuinn had been hitless in his previous 17 at-bats before being sat down by manager Luke Sewell. The news wasn't as good for a pair of St. Louis pitchers. Sewell wasn't sold on Muncrief's status for the stretch run. "(Muncrief's) a question mark," Sewell remarked. "(He) looked good for a few innings against Chicago then his arm seemed to tighten up."

Meanwhile, Galehouse received notice that he was to report to Camp Blanding in Florida for his pre-induction draft examination September 18th. Galehouse, though, requested that the proper documents be transferred to St. Louis, which caused a delay in the exam date.

While the Yankees took time to announce they were accepting World Series ticket requests on a conditional basis, the Browns had "horseshoes and other good luck tokens cluttering up the clubhouse."

St. Louis didn't need luck in beating Chicago in the first game of a 16-game season-ending homestand. However, a little knowledge of the rule book helped. The White Sox appeared to score the game's first run in the top of the first inning when Ed Carnett singled in Wally Moses with two outs. But following the hit, Luke Sewell declared to home plate umpire Joe Rue that Chicago had batted out of turn, as Guy Curtright was listed as the hitter due up according to the lineup card presented by White Sox manager Jimmy Dykes. Carnett's hit was nullified, St. Louis escaping the inning unscathed. The Browns quickly took advantage of the Chicago gaffe, scoring twice in the first inning. That was good enough for Denny Galehouse who cruised to a 5-1 win.

The win pushed St. Louis back into second place, one-half game behind New York, which was idle, and tied with Detroit, which split a doubleheader with Cleveland. Still, St. Louis had led Boston by six-and-one-half games August 15th, but were just 9-17 (.346) since.

The seven game drop in the standings raised the eyes of at least one person, sports commentator Bill Stern of the NBC "red" network. On his radio show, Stern said that St. Louis was mixed up with "one of the biggest baseball scandals since the Black Sox episode of 1919." Stern didn't get into specifics, but said that all pertinent details would be forthcoming in the latest issue of a racing magazine out of Chicago later in the week.

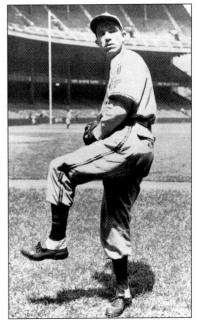

Stern did say there was no proof offered in the report, but it is implied that league officials preferred to have the American League pennant winner represented in a larger stadium than Sportsman's Park and have exerted their influence in getting the Browns to drop games in order to see that come to fruition. Stern said that the article acts on the premise that "fans are demanding a full and acceptable explanation of the Browns' collapse. They want to know why a club that took command of the A.L. from the outset suddenly dropped itself out of the race entirely and with no reason apparent or unapparent."

Two days later, Stern recanted, saying that his radio report was not his own opinion, but rather he was merely citing an article which ran in the magazine *Collyer's Eye*. The broadcaster further said that after doing his own research, he believed the charges levied by *Collyer's Eye* to be false. Stern's confession didn't ease the negative feelings among the players, however. Shortly after

TEX SHIRLEY. Tex Shirley was wild on and off the field. He always wore a cap or Texas-style cowboy hat to hide the fact he was bald. (NBH)

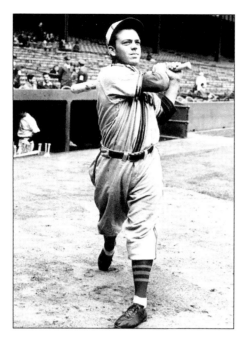

VERN STEPHENS. With a batting stance similar to that of Joe DiMaggio, shortstop Vern Stephens quickly established himself as an elite hitter in the majors, not to mention the AL's top shortstop. (NBH)

Stern's accusations of the Browns, the *St. Louis Post-Dispatch* reported that "the radio broadcaster who talked about the Browns scandal may have a hard time finding ballplayers for guest stars for a long, long time . . . several major figures have declined recently."

St. Louis did its best to dismiss the charges with actions instead of words. The Browns' game against the White Sox on September 16th started about five minutes late when umpire Bill Summers asked St. Louis starting pitcher Jack Kramer to change his undershirt. Kramer's undergarment had black sleeves, similar to what the Chicago players wore. Summer was worried American League President Wil Harridge would object, so he ordered Kramer to put on the same type of colored shirt that his teammates wore.

Kramer was not affected by the pregame changing. He allowed just one hit—a Schalk single to center field in the fourth—and didn't walk a single batter. The only other Chicago batter to reach base was Ralph Hodgin, whose grounder forced Schalk out at second base. Meanwhile, St. Louis hitters mashed out 14 hits off Eddie Lopat and Jake Wade—four of those came off the bat of Mike Kreevich, who was now 10-for-23 (.435) in the five games since he returned to the starting lineup following his crashing into the outfield wall on September 4th—to win 9-0. Don Gutteridge even hit his second home run of the season, but the first to make it over the fences.

Combined with a 6-3 New York loss to Philadelphia (Detroit was idle), St. Louis moved back into first place, one-half game up on both the Tigers and Yankees. Boston stood three games out. New York had owned first place for a span of 12 days. The St. Louis stranglehold on first didn't last long. The largest crowd to date at Sportsman's Park for a Browns game, 26,009 (22,094 paid), saw St. Louis split a Sunday doubleheader with Chicago.

Nelson Potter pitched another fine game in the opener, limiting the White Sox to one run on six hits as St. Louis won 5-1. Gutteridge and Stephens homered for the Browns. It marked Gutteridge's second home run in as many games and Stephens' second in three days, giving him a team-high 19 on the season. Stephens was in just his third full season in the majors and he didn't turn 24 years old until October 23rd, but he was already the lynchpin of the Browns lineup. Though he wasn't always that way.

Growing up, Stephens was deemed too small to make his high school team at first, weighing in at only 100 pounds. But Stephens, who grew up in Long Beach, California, was able to build muscle mass through constant weightlifting and swimming. Living in a warm climate, Stephens honed his athletic skills by playing baseball and basketball on a year-round basis.

Stephens didn't just make the high school baseball team, he became a star player. At the age of 16, he was the leader and shortstop of his American Legion team. One year later he signed on with the Browns, receiving a whopping $500 bonus.

Stephens went to Long Beach Junior College for one and a half years, but baseball was his true calling. In 1938, he played for the Browns' minor league team in Johnstown. It didn't take long for "Junior," so dubbed because he was named after his father, to show what kind of hitter he was. In 1939, Stephens led the Kitty League with a .361 batting average. He also slugged

44 doubles and had 123 RBI. St. Louis moved Stephens to San Antonio of the Texas League in 1940. He didn't disappoint, leading the circuit with 97 RBI. Stephens played most of 1941 with Toledo of the American Association, but he did sneak into three games for the Browns late that season as well, collecting one hit in his two plate appearances. He also committed one error in his two fielding chances.

While no one questioned Stephens' hitting prowess, his fielding was always considered a little suspect. But it wasn't for a lack of trying to improve. "He and I got together a lot and talked about where I wanted him to throw the ball," recalled Don Gutteridge, Stephens' second base partner from 1942-45. "I always like to take the ball on the inside of second base and he'd always try to get me the ball there. I guess we fielded 1,000 balls a day—now it seems like 1,000 balls a day. He worked and I worked.

"He was a good hitter and a pretty good fielder on everything except a ball hit straight at him," remembered Denny Galehouse. "And more infielders have told me that's the toughest ball to field because you can't judge the hops as well."

Stephens was the choice for shortstop in 1942. He enjoyed a solid rookie campaign, batting .294 with 26 doubles, six triples, 14 home runs, 84 runs and 92 RBI. His average and RBI output were both second best on the team.

"Buster," as Stephens was sometimes called because of his power, did not suffer a sophomore slump. He was selected to the 1943 All-Star Game after he hit .308 with 17 doubles and seven homers with 44 runs and 45 RBI through the midway point of the season. Stephens, who had a batting stance similar to Joe DiMaggio, didn't stop his production in the second half of the season. He finished the year batting .289 with 22 homers, the third-highest total in the American League, and 91 RBI, which was fourth best. Stephens even garnered 49 points in the Most Valuable Player voting, good for ninth place.

Of course, the question of the military often came up with the youthful Stephens. He was summoned to Jefferson Barracks in Missouri for a physical exam in the summer of '43, but was rejected because of a broken kneecap suffered earlier in his career and then reinjured while with the Browns. As often happened, Stephens was called in for another exam, this time in his hometown of Long Beach. On December 30th, 1943, Stephens, who also had allergies, was reclassified 1-A and even was served his induction papers. But because of his trick knee, the label didn't last long. Stephens was soon back to 4-F and back on the Browns roster.

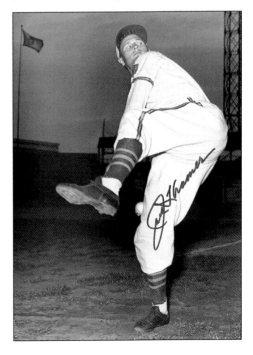

It was a good thing for St. Louis because the Browns needed his bat. Stephens already had over 100 RBI, the last time a Brown would ever eclipse that total. "He'd look bad at the plate on a curveball or a certain pitch and then they'd throw the next one the same way and he'd hit it out of the park. He was just that way," recollected Galehouse.

"Stephens was the offensive leader, goddamn he was a hell of a hitter, and he could hit the ball plum out of sight," said Ellis Clary.

Stephens became so highly regarded by 1944 that no other shortstop was even placed on the American League All-Star team that year. "No doubt Stephens is top man in the position in the league," said Cleveland player-manager Lou

JACK KAMER. Jack Kramer pitched like an ace down the stretch for the Browns going 5–1 while completing all six of his starts. (SM)

Boudreau, the Indians starting shortstop since 1940 who led the league in '44 with a .327 average and 45 doubles.

If Stephens did have one foible, though, it was his propensity for enjoying the night life. The Browns tried to room him with Gutteridge, a noted non-drinker, hoping his lifestyle would rub off on Stephens. "Yes, he was very much a ladies' man," remembered Gutteridge. "And I roomed with Vern for a little while. Of course I never did drink or anything so they said why don't you room with Vern Stephens and maybe you can straighten him out a little bit. Well, I could never straighten him out because he was never in his room."

"As a matter of fact, Gutteridge is like a preacher," Clary recalled. "[Manager Luke Sewell] put him in with Gutteridge one year and I said, hell, Gutteridge couldn't do nothing with him. He got Gutteridge to drinking. That was a joke. Of course, Gutteridge never took a drink in his life, never did. But you couldn't do that with [Stephens]. Hell, you'd have to tie a rope around him. He did what he wanted to do, just like they do today.

"He stayed up all night, fooling around. I roomed with him one year and I know. He messed around all night. Women calling his room all (the time). He was a good looking bastard and the women loved him and he tried to accommodate them all. Well, I just told them that he wasn't there. He went by three names—Junior, Vern and Stevie. Hell, there'd be flock of women calling all the time. I'd say, hell, he ain't here. And they'd say the hell he ain't there. And I said, well come on up and look. But he wasn't there. He stayed out half the damn night, all night. It didn't bother him because he was 21. You can do anything when you're 21."

One account has it that the Browns finally convinced Stephens to stop his all-night partying, but Stephens responded by going into a slump. The team left him alone after that. If that was the case, then Stephens must have been having a good time when Chicago was in town because he drove in another run in the second game of the Browns twinbill with the White Sox, giving him seven RBI in his last six games. But it wasn't nearly enough as the Chicago pounded the Browns for seven runs in the final three innings to win 8-2.

Chicago scored one of its runs when pitcher Joe Haynes stole home. It marked the first time a pitcher swiped home in the American League since August 15th, 1923 when Washington's George Mogridge performed the feat versus Chicago and it was only the 17th time overall in the circuit's history (it happened just two more times before the advent of the designated hitter in 1973). Ironically, of those 17 times, seven occurred against the Browns.

While the Browns split their doubleheader with Chicago, Detroit swept its against Cleveland while New York lost both of its games to Philadelphia. For the first time on the season, the Tigers were atop the American League. With every team in the league off September 18th, here is how the top of the standings looked:

Team	W	L	GB
Detroit	78	62	
St. Louis	78	63	.5
New York	76	64	2
Boston	74	66	4

Last place Washington came into town next to face St. Louis in a three-game series. In a preseason poll, the Senators were picked to finish second by the baseball writers, mainly because of their pitching staff, which featured four knuckleball pitchers.

One of those hurlers was Johnny Niggeling, a former Brown. Niggeling didn't break into the majors until he was 35 years old, pitching two innings for the Boston Braves in 1938. He hurled in 10 games for Cincinnati in 1939 and was sold to St. Louis in January of 1940 for the waiver price. Niggeling moved into the Browns rotation, starting 20 games in '40, posting a 7-11 record with a 4.45 ERA. He went 7-9 with a 3.80 ERA in 1941 and improved to 15-11 with a 2.66 ERA in 1942. Niggeling was 6-8 in 20 games in 1943 before being included in the Harlond Clift

TOM TURNER. Catcher Tom Turner instigated a nasty fight with Washington's Roberto Ortiz, which would result in both players being out for the season. (SM)

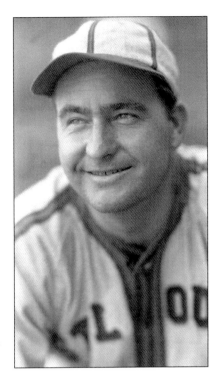

trade to Washington. Many fans were upset because they felt Niggeling was a solid starter.

Now 41 years old, Niggeling, called "old nuts and bolts," needed plenty of rest between appearances. Prior to his start against St. Louis on September 19th, his last pitching performance had come 15 days earlier. Niggeling showed no rust from the long layoff.

Niggeling's knuckler was working; he didn't allow a run through nine innings. But neither did Browns starter Denny Galehouse. The breakthrough didn't come until the top of the 11th, when Washington scored six times, all with two men out. Niggeling, who allowed just four hits while walking three and striking out 11 in 10 innings, gave way to fellow knuckleballer Roger Wolff in the bottom of the 11th and he completed the Senators shutout.

Meanwhile, Detroit helped its own cause by topping New York 4-1. Boston, just one-and-a-half games out on September 2nd, fell to five games back by losing for the sixth time in its last 10 outings.

St. Louis bounced back to beat Washington the next day 5-2, with Jack Kramer winning his 15th game. Again, Detroit beat New York while Boston also lost. With just 11 days left in the season the St. Louis Cardinals clinched the National League pennant while it now looked like it was turning into just a two-team race in the American League:

Team	W	L	GB
Detroit	80	63	
St. Louis	79	64	1.5
New York	76	66	4
Boston	74	68	6

Tensions between the Senators and Browns had been raised ever since Nelson Potter and George Case mixed it up at Washington on August 22nd. Nearly a month later, both teams were still combative. In the first game of the series, Roger Wolff hit Vern Stephens with a pitch. Browns manager Luke Sewell took exception, waving a bat in the direction of the pitcher. Sewell had to be forcibly held back by the umpires in order that he wouldn't charge the mound and start a fight with Wolff.

On September 21st, the final game of the year between the two clubs, the umpires weren't around yet to hold anybody back. Browns catcher Tom Turner was apparently looking for a fight. George McQuinn later admitted that upon his arrival to the stadium, Turner, a noted bench jockey, claimed he was going to instigate something with Washington's Roberto Ortiz. McQuinn also said by the time Turner arrived, the backup catcher had already drank a few beers.

Washington had a number of Cuban players on its team, including Ortiz. Turner supposedly taunted the Senators during batting practice by calling them (Washington manager Ossie) Bluege's Cuban Giants, a reference to a Negro League team with the same nickname. One account had Turner chiding 5-foot-10, 155-pound catcher Mike Guerra with the 6-foot-4, 200-pound Ortiz intervening on his behalf.

Regardless of how it all started, Ortiz ended up grabbing a bat and headed towards Turner. Turner told Ortiz to drop the bat and he'd fight him and that's exactly what happened with the two ballplayers lining up in boxing formations in the middle of the field. Red Smith wrote that "Turner fought from a weaving crouch, Ortiz 'the Corbett Standup Stance'."

Because it was batting practice, the umpires were still tucked away in their quarters. The players circled the two combatants as they went after each other. Ortiz began by trying to kick Turner in the groin. As Smith wrote, "Roberto tried a field goal placement. The kick was partially blocked and the crowd booed." Hearing the commotion, the umpires raced out onto the field. However, the umps were still wearing their street clothes. Ellis Clary thought fans had rushed onto the field to join the fracas so he tackled what he thought was an oncoming fan, but was in actuality umpire Al Weafer. After Clary realized what he had done, he let Weafer go and the umpires broke up the brawl.

Clary recalled the entire incident: "Yeah, during batting practice we had a third-string catcher named Tom Turner that was abusing them damn Cubans that was on the Washington club. And it made it very awkward on me because I had been with the Washington club and played with all those guys in Washington and down in Cuba. And it put me in an awkward situation, I didn't have nothing against those guys.

"But Tommy Dick Turner lived down in Texas and he hated a Mexican as far as he could see one. And he compared the Cubans to the Mexicans because they spoke Spanish. And ol' Bob Ortiz decided to come over and see about what the hell's he talking about and called his hand.

"And he had a bat in his hand and Turner told him, you throw the bat down and so and so. He threw it down and Turner started up the steps of the dugout and when he got about to the top step, Bob Ortiz kicked him like a football right upside the head.

"Ortiz was a huge monkey you know, he was a big guy. And Ortiz was a friend of mine, I didn't have nothing against him. And hell, there I am on one team with a teammate cussing out my former teammates. Calling them every damn thing you ever heard of. And they had a hell of a fight. And Bob Ortiz broke his hand, very visibly, a big knot on the back of his hand.

"And Al Weafer, the umpire, who was sitting in the stands watching batting practice, he ran out there to break it up. I thought he was a fan, I grabbed him and threw him down. By the time he hit the ground I recognized him and I grabbed him and picked him up. He made a report on it, but there was nothing done about it because he explained in the report that I thought he was a damn fan running out.

"He came out to break up that fight, which was his job you know. It was a hell of a fight, they was killing each other. Because there was nobody out there that was going to stop it like they do today. Shit, let 'em fight. We was enjoying a good fight. They were poleaxing each other. It should've been stopped but it wouldn't have been stopped if he (Weafer) hadn't run out there."

Few repercussions actually stemmed from the fight. One was that Ortiz broke his hand and was out for the remainder of the season. That actually hurt the Browns because Washington faced front running Detroit in the final series of the year. Ortiz's absence only hurt the Senators chances of beating the Tigers. The other was the ending of a longtime friendship between Washington manager Ossie Bluege and St. Louis skipper Luke Sewell. The two were teammates and roommates when Sewell played for Washington from 1933-34. But with all the incidents between the two clubs over the past couple of years, this appeared to be the final straw in the breaking of their friendship.

Ortiz, who collected two hits in the previous day's game, was obviously not in the lineup for Washington and neither was Turner for St. Louis. It was reported that Turner had no marks on his body following the fight, but the Browns later announced that Turner would not play the rest of the season.

The Browns transposed their aggression onto Washington pitchers Dutch Leonard, Roger Wolff and Vern Curtis, who they banged around for 15 hits in a 9-4 win. Nelson Potter pitched his fourth consecutive complete game victory, a string which began September 4th. New York, meanwhile, beat Detroit and Hal Newhouser 5-4 in ten innings, meaning St. Louis was back to within one-half game of first place.

Philadelphia invaded St. Louis next while Detroit hosted fourth place Boston. Bob Muncrief started for the Browns and he was knocked around some by the A's, surrendering seven hits in four innings. But Muncrief allowed just one run in that span. He left in the seventh with a 4-2 lead and that's how the score stood as Sig Jakucki pitched three perfect innings to close the door. But St. Louis still lost ground on the Tigers, who swept a doubleheader from Boston. With nine games remaining, the Red Sox were now eight games out of first place. New York beat the Indians in Cleveland, but still dropped to three-and-one-half games off the pace.

The playing surface at Sportsman's Park wasn't the best because there was a game, whether being hosted by the Browns or Cardinals, being played nearly every day. Even more damage was done on Saturday, September 23rd when Missouri and Arkansas played a college football game prior to the A's-Browns night baseball game.

The weather—unseasonably chilly—was fitted more for the gridiron contest. Despite being in contention for their first American League pennant, the Browns, who had recently been regularly drawing more than 7,000 fans for their night games, had just 3,764 paying customers show up at Sportsman's Park. Those who didn't show up missed St. Louis winning its fourth game in a row, 3-1 over Philadelphia. Denny Galehouse pitched a complete game, getting out of a two-out, two-on situation in the ninth by inducing pinch hitter Larry Rosenthal to ground out to Don Gutteridge. Again, the Browns remained in second place one game out as Detroit beat Boston, eliminating the Red Sox, who lost 12 of their last 16 games, from the pennant chase. New York also won again, beating Cleveland 7-2, to stay three-and-one-half games back.

With the Browns farm team in Toledo eliminated from the American Association playoffs sooner than expected, St. Louis recalled three players to bolster the team for the stretch run. Joining the team were pitcher Earl Jones, who had a 10-6 record for the Mudhens while striking out eight batters per nine innings; infielder Len Schulte, who hit .296 with 96 RBI, and outfielder Babe Martin, the American Association MVP. Martin hit .350 with 27 doubles, 10 triples, 14 homers, 84 runs and 72 RBI. The Browns actually wanted Martin earlier in the season but his teammates in Toledo, sensing the loss of possible playoff money, threatened to go on strike if Martin left.

Philadelphia starter Jesse Flores stymied the Browns bats the next day in the series finale. St. Louis managed just four hits through eight innings, trailing 2-0 heading into the bottom of the ninth. Flores retired leadoff hitter Chet Laabs on a foul out then gave up a single to Vern Stephens but got Milt Byrnes to bounce into a force out. George McQuinn hit a long drive to right field but it curved foul. He eventually walked. Connie Mack let Flores try and finish his shutout bid, but Mark Christman spoiled it, doubling to left center, scoring both Byrnes and pinch runner Tex Shirley to tie the game. When Ed Busch's relay throw home went wide of the plate, Christman advanced to third.

That was enough for Mack, who summoned Joe Berry from the bullpen to face Floyd Baker. Baker lofted a routine fly ball to center field where Bobby Estalella camped under it. What happened next, as reported by the *St. Louis Post-Dispatch*: "Estalella reached it, got both hands on it, then the ball bounced out of his glove and Christman cantered home with the winning run." Realizing the significance of his blunder, Estalella left the field with tears streaming from his eyes.

The Browns on the other hand were all smiles, what with the victory and the fading Red Sox on tap next. Boston, fresh off being swept in a four-game series in Detroit and losers of eight straight, visited St. Louis for three games, the second-to-last series of the season.

Nelson Potter continued his and the Browns' hot streak, shutting out Boston 3-0, allowing just two singles. Chet Laabs, who the Browns were counting on to provide some power, hit just his third homer of the season in the first inning. Babe Martin played in his first major league game and, batting fifth, he collected a double and an RBI single in three at-bats. The victory extended the Browns winning streak to six games and, for the first time in 10 days, St. Louis was back in first place. The Browns were tied with Detroit, which lost 2-1 to Philadelphia, each team with 84-64 records with six games left. New York, at 81-67 and three games back, was still clinging on as well.

St. Louis played its last scheduled night game—the Yankees were still steadfast in their refusal to change their final four-game series from day to night—September 26th. The advantage of playing at night was that the Browns already knew if Detroit, which played most of its games during the day, had already won or lost. So St. Louis went into its game against Boston with the knowledge that Detroit had bested Philadelphia behind the pitching of Dizzy Trout.

St. Louis scratched a run across in the first inning when Chet Laabs scored from second base on a grounder to first by Milt Byrnes. Byrnes beat first baseman Catfish Metkovich's toss to pitcher Mike Ryba for a hit and Laabs, running with the crack of the bat, beat Ryba's throw to the plate. The run held up. Laabs' score proved to be the only time a player crossed home plate in the game. Sig Jakucki beat Boston for the fourth time on the season in tossing his fourth shutout of the season, limiting the Red Sox to five hits.

The final game of the Boston-St. Louis series was scheduled to begin at 2:30 p.m. Rain forced the start to be pushed back an hour. That made for a tight schedule for Boston, as its train to Chicago left at 5 p.m. When it was clear that the contest could not be played until nighttime, Boston manager Joe Cronin agreed to make alternate travel plans for his club to play St. Louis at 8:15 p.m. By that time, Detroit had already beaten Philadelphia, giving the Tigers a one-half game lead over the Browns, pending the result in St. Louis. "I want to give the Browns every chance to play this game which is very important to them," expressed Cronin during the rain delay. "Therefore, I am willing to do anything I can to get this game in."

St. Louis manager Luke Sewell figured a rainout was just as bad as a loss, his team falling behind Detroit either way. So the two teams suited up under the lights in front of a crowd of less than 5,000. They did impose an 11:20 p.m. curfew, ending the game no matter what was happening at that time. It was also agreed upon that no inning would start after 11:05 p.m.

For the pivotal contest, Sewell had Denny Galehouse start while Cronin threw out George "Pinky" Woods, who had won just three games on the season and hadn't started a game for Boston since September 2nd.

Galehouse struck out three batters in the first, but he allowed a leadoff single by Lou Finney who moved to second on a passed ball and to third following a wild pickoff throw by catcher Red Hayworth. One batter later, Tom McBride singled in Finney to give Boston a 1-0 lead.

Although Woods was a little wild, St. Louis couldn't hit him. Sewell, sensing the importance of the game, sent in left-handers Floyd Baker and Al Zarilla to pinch hit for Don Gutteridge and Chet Laabs against right-hander Woods after just one time through the lineup. It didn't help. Baker finished 0-for-4; Zarilla 0-for-2.

With rain starting to fall the previous inning, Sewell continued his pinch-hitting frenzy in the fifth. Still losing 1-0, Mark Christman drew a one-out walk from Woods, one of seven bases on balls the Red Sox pitcher issued in the game. Sewell sent Gene Moore to bat for Hayworth and he singled, Christman going to third. Mike Chartak hit for Galehouse—who allowed just the one run while striking out seven in his five innings of work—but he fouled out to third baseman Jim Tabor. Woods then got Baker to ground out to second to end the scoring threat.

George Caster took the mound for St. Louis in the sixth inning but Sewell's ace reliever allowed two runs, pumping the Boston lead to 3-0. The Browns didn't get another good scoring bid until the eighth inning when they loaded the bases without hitting the ball out of the infield. Mike Kreevich beat out a ball hit to Tabor, Zarilla drew a base on balls while second baseman Jim Bucher muffed a toss from Skeeter Newsome on a Stephens grounder. Woods got Milt Byrnes to fly out to Finney in right field, but too shallow for Kreevich to score. George McQuinn lined a shot to Finney, this time deep enough to get the run in. Woods then walked Christman to reload the bases. With the potential leading run, Frank Mancuso, at the plate, Cronin summoned Red Barrett from the bullpen. Barrett got Mancuso to fly out to end the inning.

Tex Shirley, who started pitching for the Browns in the eighth, helped Boston to one more run in the ninth inning. After Newsome singled, Shirley threw a wild pitch to advance the runner to second. Barrett then bunted. In his haste to gun Newsome down at third, Shirley threw the ball over Christman's head allowing the runner to score, giving

Boston a 4-1 lead. The *St. Louis Post-Dispatch* once wrote that "wildness is Shirley's greatest fault." Although, one could hardly blame Shirley for not concentrating enough on the mound against the Red Sox—his wife of just over a year, since July 1943, filed for divorce earlier that day.

Shirley probably wasn't the model husband. He was a hard drinker with a mean temper—and he was vain. Even though he was just 26 years old, Shirley had little hair on his head. He always wore a Texas-style cowboy hat in public to hide that fact. "Yeah, he was real bald," recalled Galehouse. "He always kept his (baseball) cap on, too."

Shirley had little major league experience before coming to the Browns, pitching in 18 games for the Philadelphia A's from 1941-42, compiling an 0-2 record with a 4.81 ERA and 28 walks and 11 strikeouts in 43 innings. Shirley pitched for the New York Giants farm team in Jersey City then went 7-11 for Springfield (Mass.) of the Eastern League in 1943 before being acquired by St. Louis. The Browns knew the military, which rejected him seven times because of a hernia, wasn't going to take Shirley.

Despite coming up from Springfield, "a mighty lofty jump," wrote Kyle Chrichton of *Colliers*, Shirley had a major league attitude. One time when Sewell came from the dugout to take Shirley out of the game, instead of the pitcher handing the ball to his manager as is customary, Shirley hurled it into the stands. Shirley, who had a lack of control when pitching as well, was fined by Sewell. One paper ran a headline the next day which read: "Shirley's best pitch of the season costs him $50."

Shirley got out of the rest of the ninth inning without allowing Boston to score. St. Louis trailed 4-1 and had 15 minutes to mount a rally before reaching the designated stopping time. Sewell again went to the bench, sending up Babe Martin to hit for Shirley. Martin was the Browns sixth pinch hitter of the game (No. 5, Len Schulte, had walked for Caster in the seventh). The rookie reached on an infield single. The next batter, Baker, lofted a high, short fly ball to left field. It fell, but Martin, thinking the ball was going to be caught, stayed too close to first base and was forced out at second. After Kreevich struck out, Barrett walked Zarilla, bringing up Stephens. A home run from the St. Louis hitter would tie the game. However, Stephens hit into a fielder's choice, third to second (although Sewell argued Zarilla was safe at second) to end the game and put the Browns one full game in back of Detroit with four games left.

Detroit surely had the advantage in the final four games. The Tigers hosted Washington, dead last in the American League, while St. Louis faced New York, a team they had lost ten times to on the season while winning eight. Not to mention that the Yankees were still mathematically alive in the pennant race, three games behind Detroit.

The beginning of the two climatic series had to wait one day as it rained in both St. Louis and Detroit on September 28th, causing postponements of both openers, doubleheaders to be played the next day instead. If the Browns were to take the pennant, it was not going to be an easy road. "What I thought was the next best ballclub (after the Browns) was the Yankees," asserted Gutteridge.

New York manager Joe McCarthy wasn't about to let St. Louis knock the Yankees out of the pennant race, throwing his two best starters, Ernie "Tiny" Bonham and Hank Borowy in the twinbill. Sewell countered with Jack Kramer and Nelson Potter.

St. Louis may have been battling for the pennant, but its fans stayed away from the ballpark thanks to chilly and soggy weather. Just 6,172 braved the elements to cheer on the Browns, gunning for their first-ever American League championship.

The Yankees got on the board first in the opener. A two-out single by Johnny Lindell scored Stuffy Stirnweiss. New York, still ahead 1-0, rallied again in the third. Bonham led off with an infield single and went to third on a double by Stirnweiss. Kramer bared down and got Bud Methany to foul out to Mark Christman then got Herschel Martin to look at strike three. With cleanup hitter Lindell up, Kramer threw a wild pitch. Bonham raced down from third to try and score but the ball hadn't gone that far away from catcher Red Hayworth who threw to Kramer at the plate in time to tag out Bonham.

The momentum of the play carried over into the bottom of the inning. Kramer led off by doubling over the head of Lindell, the center fielder playing shallow with the pitcher at bat. Don Gutteridge then laid down a perfect bunt past the left side of the pitcher's mound, reaching safely at first while Kramer moved to third. Mike Kreevich and Chet Laabs followed with singles, Kramer scoring on the first hit and Gutteridge the second, giving St. Louis a 2-1 lead.

Hayworth again robbed New York of a scoring chance, this time in the sixth throwing out Stirnweiss, who ended up leading the major leagues in steals with 55, trying to swipe third base. New York followed the out with two singles, making the failed steal attempt even more painful. Kramer shut down New York after that and George McQuinn supplied his eleventh homer, a two-run shot in the eighth, to put the final score at 4-1. Combined with Detroit beating Washington 5-2 behind the pitching of Rufe Gentry and Johnny Gorsica meant New York was officially eliminated from the race. The American League pennant, up for grabs among four teams at the beginning of the month, was now between just Detroit and St. Louis.

The Browns turned the tables on the Yankees in the second game by scoring in the first inning. Don Gutteridge led off with a double, moved to third on a wild pitch, then scored on a ground out to short by Mike Kreevich. Just two batters into their lineup and the Browns had a 1-0 lead. St. Louis managed just one hit off Borowy the rest of the way —a one-out single by Stephens in the seventh—but they didn't need any more. Potter shut down New York and was helped out by some good defense to preserve a 1-0 shutout.

"There were a couple of men on and two out [in the eighth]," Potter recalled years later. "Big Lindell was with the Yankees then, and he hit one to left center that was hit good. I turned around, and little old Mike Kreevich was already on his way. He pulled it down just at the last minute. Beautiful catch. In the ninth they had the tying run on second and Paul Waner was the pinch hitter. He hit a kind of a little nubber. It looked like it might be a base hit, over Gutteridge's head. And Gutteridge just backpedaled and made a jump at the last minute and it stuck in the web. That ended the ballgame."

Waner was a Hall of Famer on his way out who could still hit. In 1943, at the age of 36, Waner hit .311 in 82 games for Brooklyn. He played in 83 games for the Dodgers in 1944 hitting .287 before being released August 30th. The Yankees picked him up hoping his veteran bat would help them in their chase for the pennant, but Waner played in just nine games, batting .143. By the time the final weekend of the regular season rolled around, Waner had already accumulated all 3,152 of his career hits, sixth most in major league history at the time of his retirement. He would pinch hit once more during the series and appeared in just one game in 1945, walking in his only trip to the plate. Waner was primarily a pinch hitter for New York, but once a fan bellowed out, "Hey, Paul, how come you're in the outfield for the Yankees?" to which Waner yelled back, "Because Joe DiMaggio's in the Army."

Pitching in perhaps the biggest game of his career to that point, Denny Galehouse was masterful in the third game of the series. Not one Yankee reached third base as St. Louis won 2-0. Again the Browns scored one run in the first while Gene Moore supplied the other score with a solo homer in the sixth, but the pitching was the story for the Browns.

Galehouse allowed just five singles while walking two and striking out three. He was just continuing the hot trend of the Browns pitching staff. The Yankees hadn't scored since the first inning of the first game of the series, a streak of 26 innings. It was also the team's fourth shutout in six games. In Detroit, Hal Newhouser also continued his year-long pitching dominance, winning for the 29th time as the Tigers upended the A's 7-3.

With just one game left in the season, both St. Louis and Detroit had identical records. For his club's biggest game of the year, Tigers manager Steve O'Neill planned to start Dizzy Trout, winner of 27 games including seven by shutout, on just one day's rest. In St. Louis, for not only the biggest game of the season but also the most important contest in franchise history, Browns manager Luke Sewell selected as his starting pitcher the team's most notorious boozer, Sig Jakucki.

TEN

Eighth Inning
One Last Game

Somebody else said it would be better for the Browns to win their first pennant in some other year, a non-war year . . . But it would be just as sweet to the Browns in a war year as to the Tigers or Yankees.
J. Roy Stockton of the *St. Louis Post-Dispatch*
prior to the final regular-season game.

Browns manager Luke Sewell basically used a four-man starting pitching rotation throughout September. Nelson Potter, Denny Galehouse and Jack Kramer were the three constants while Bob Muncrief and Sig Jakucki shared the fourth spot. Sewell didn't have many choices for his starting pitcher for the season finale October 1st. Galehouse pitched the day before while Potter and Kramer each pitched in the doubleheader two days prior. The St. Louis skipper wasn't confident in using Muncrief because of the pitcher's arm troubles. Inconsistent pitchers Al Hollingsworth and Tex Shirley hadn't started since July 21st and August 18th, respectively.

Sewell could have mirrored the decision of Detroit manager Steve O'Neill and used one of his top flight starters, Potter or Kramer, on just one day's rest, but he chose to save them for a possible one-game playoff scheduled to be played in Detroit the next day if the two teams finished the season tied for first. Instead, Sewell opted for Jakucki, a bewildering move to some even years later.

Recounting the final game of the 1944 season in a 1951 *Sport* magazine article, Bob Burnes wrote that the decision to start Jakucki "was a surprise, and almost a desperate choice by Sewell, although he had every man on staff in the bullpen."

Jakucki had been a capable starter so far for the Browns in 1944, winning 12 games and losing nine in his previous 34 games, 23 of those starts (of which he completed 11). His teammates, though, weren't as concerned about how Jakucki was going to pitch in the pivotal contest as with what he was going to do the night before the game. With the American League pennant on the line, several Browns players went to Jakucki and pleaded with him to not take even so much as a sip of alcohol the night before the game. With Jakucki, that wasn't such an easy request.

There were several hard partiers on the Browns, including pitchers Bob Muncrief, Tex Shirley and Sam Zoldak. But Sigmund Jakucki outdid them all. He had a penchant for alcohol and the places that served it. "I wouldn't say (Jakucki was) an alcoholic, but he drank a lot," recalled Denny Galehouse. "He was the bar fly."

Jakucki also didn't shy away from fights, especially with a few drinks in him. "I don't know how you classify people like him. He was kind of a tough guy, I guess," said Jimmy Outlaw, who played in the major leagues from 1937-49 and in the minors around the same time as Jakucki. "He always had trouble in the Texas League, they told me. He was ready to fight at any time."

"He was a mean son of a bitch, a big, strong bastard that would turn over a juke joint every night if he could, you know," remembered Ellis Clary. "And he got into all kind of crap. He got beat up, but in the process he wounded a few people along the way. He's a tough son of a bitch, but he was a mean monkey. But you couldn't help but like him if he was on your side. He was a fun guy, but gee, at night he'd get a few belts and turn over a joint somewhere. No matter where he was, he'd get in trouble."

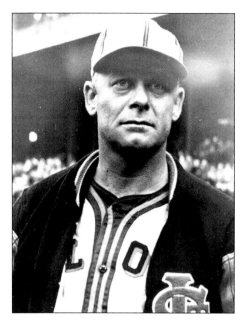

SIG JAKUCKI. Sig Jakucki was very confident of himself, saying he'd win 12–15 games for the Browns despite coming into 1944 with no major league victories. His teammates weren't concerned with his bravado, they just didn't want him to take a drink before the season finale in which he was to pitch. (NBH)

One of Clary's favorite stories about Jakucki involves a time the pitcher went drinking at a bar across from the New Yorker hotel in New York City. Jakucki placed himself at a familiar spot—a stool by the bar—and soon got into an argument with a gentleman seated next to him. Turns out, Jakucki's quarreling partner was a member of the New York underworld. In the midst of the argument, the man pulled out a gun and stuck it into Jakucki's ribs. Unfazed, Jakucki grabbed the weapon and clubbed "the hood," as Clary referred to him, over the head, knocking him unconscious in the process. Jakucki threw the gun down on the floor next to the prone figure, and walked out of the bar, presumably onto his next escapade.

"They tell me he (Jakucki) busted that guy's head, knocked him cold, left him laying there on his back and threw the guy's gun down," said Clary. "He grabbed that gun and stuck it into ol' Jack's ribs. Shit, he didn't know who he was dealing with. He was into something every night. Jakucki, goddamn, he was like Al Capone rolling around at night."

New York wasn't the only town Jakucki partied in, having been all over the country even before his time with the Browns. Jakucki was born in Camden, N.J. on August 20, 1909. In 1927, he decided to join the Army, going to nearby Philadelphia to set up his entrance exam. Jakucki was inducted and eventually sent to Honolulu, Hawaii, where he played baseball for the Army base team. He was such a standout that, according to one account, a local promoter convinced the military to sell him their release of Jakucki, who was serving in his second term. The Army granted Jakucki an early medical discharge.

So in 1931, Jakucki became the star shortstop, outfielder and sometimes pitcher for the Honolulu Braves. Jakucki got his first taste of the majors pitching for the Braves against a touring team of big league All-Stars, which included one of Jakucki's idols, Al Simmons, as well as Lou Gehrig, Frankie Frisch, Mickey Cochrane, Lefty O'Doul and Lefty Grove.

Jakucki became not only a phenomenal hitter in Honolulu, but also a fan favorite. By 1934, local rooters started pushing Jakucki towards the major leagues. They presented Jakucki as a power-hitting outfielder and sent him to the San Francisco Seals. But the Seals determined he couldn't crack their tough outfield, which included a young Joe DiMaggio.

Jakucki's next stop was across the bay where he was signed by another Pacific Coast League club, the Oakland Oaks. Jakucki soon found out that playing in a top minor league wasn't the same as playing in Hawaii. He lasted until May before Oakland released him.

Upon his release, the Galveston Sand Crabs of the Texas League decided to take a chance on Jakucki. With Jakucki not making it as a hitter, Galveston manager Bill Webb convinced Jakucki that if he not only wanted to make the majors but also continue playing professionally, he should convert himself into a pitcher full-time. Realizing that if he couldn't crack the PCL as an outfielder then there was no chance of a future for him in the major leagues, Jakucki took Webb's suggestion. In 1934, he sported a 10-7 record for the Sand Crabs. In 1935, he pitched in 51 games, most in the league, and had a 15-14 record, which included a no-hitter.

The next season Jakucki demonstrated some of his famed temper. While playing a game

in Houston in June, the pitcher went into the stands to fight a spectator. The incident drew him a suspension. The time off didn't affect his pitching ability as Jakucki threw a seven inning no-hitter (in doubleheaders in the minors each game's length is shortened to seven innings) July 16th. It wasn't much longer after that pitching performance that the St. Louis Browns bought Jakucki from Galveston.

The Browns had all sorts of pitching problems in 1936. St. Louis ended with a major league worst 6.24 ERA while striking out just 399 batters, the lowest total in either league. Jakucki didn't help matters any. Appearing in seven games, with two starts, Jakucki went 0-2 with an 8.71 ERA. He allowed 32 hits in 20 2/3 innings while walking 12 and striking out nine. Jakucki, the one-time star outfielder/shortstop in Honolulu, was also hitless in six at-bats.

The Browns brought Jakucki to spring training in 1937. He made the team but never appeared in a game, eventually being sent back to Galveston. Jakucki also pitched for New Orleans in 1937 before finally leaving professional baseball altogether.

Jakucki bounced around Texas and Kansas playing in semi-pro leagues. Eventually, Jakucki landed in Houston where he was employed in a shipyard, which also had a baseball team that he played for, then back to Galveston where he said he was a contractor, but in reality dealt mostly with painting and putting up wallpaper.

During World War II, the majority of major league ballplayers that were in the military didn't serve overseas. Those still stateside were recruited to play for their camp team. One such team featured Washington Senators pitcher Sid Hudson. Hudson won 17 games as a 23-year-old rookie for Washington in 1940 and won 40 games in his first three seasons before entering the Army.

Jakucki was recruited to pitch against the Hudson-led Army camp team in early 1944 and performed so well that officials from the Browns and New York Giants contacted him shortly thereafter. The Browns won Jakucki's services, for the cost of, as Vice President Bill DeWitt liked to claim, just a three-cent stamp (the price of postage for the postcard DeWitt used to "sign" the pitcher).

St. Louis figured it was getting a quality pitcher who could stick around for years. Sewell later said that if not for problems with alcohol, Jakucki could have hung around for five or six years in the majors. Of course, the Browns thought they were getting a 31-year-old pitcher, which is what the *St. Louis Post-Dispatch* reported his age to be. Jakucki even listed his year of birth as 1912. The Browns should have known better, though. During his first stint in St. Louis, Jakucki cited 1911 as his birthdate.

DeWitt related how he found Jakucki in the July 7th edition of *The Sporting News*. "A player who had been with us, and was working in the Galveston shipyards, sent me word that a pitcher named Jakucki down there was showing enough stuff to warrant the belief he could win in the American League," DeWitt explained in the article. "I knew something about Jakucki. We had paid $12,500 for Jakucki to Shreveport [actually Galveston], and had released him after the training season. I wrote for more dope on the pitcher. My correspondent insisted Jakucki could win the American League, not only this year, but in the circuit as it was before the war. I finally sent for Jakucki. Look at him now - the man who will win the pennant for us, the greatest bargain in the history of the big leagues."

Of course in July, DeWitt had no idea that Jakucki, if he beat New York while Detroit lost to Washington, could indeed literally win the pennant for St. Louis. Jakucki, however, always had confidence in his talents. When the Browns reached out to sign him, Jakucki, who hadn't pitched in the majors in eight years and had yet to win a game in the big leagues, asked for a clause in his contract that rewarded him for each win over 10 he accumulated. The rules of the era however prohibited any bonuses based on accomplishments, allowing only for those dealing with attendance.

Despite losing out in his bid for a bonus based on wins, Jakucki still boasted during spring training that he was going to win between 12 to 15 games for the Browns. While some may have scoffed, Jakucki reached his prediction when he posted victory No. 12 with his 1-0 win over Boston on September 26th.

What Jakucki knew was that he found a new trick the previous year to help his performance on the mound. Before warming up, Jakucki held a four-pound metallic ball in his right hand for 10 to 15 minutes. With this exercise, Jakucki said the baseball felt as light as a feather.

Now all his teammates had to worry about was that Jakucki didn't put any liquor bottles in his hand the night before the game against the Yankees, as he was prone to do during the season. Clary once recalled that there was some discussion in the lobby of the Melbourne Hotel, where many of the players lived in St. Louis, on whether or not the Browns were better off with either Galehouse, Potter, Kramer or Muncrief pitching. Coach Zack Taylor spoke up in Jakucki's defense, saying that whether the pitcher was full of liquor or not, he was going to give the Yankees all they could handle. Jakucki had even promised Taylor he wasn't going to take a drink that night. The players wanted to make sure.

"Prior to his final game on Sunday in the regular season, a lot of us older ones got to him and said, 'Now, hey, we know you like to drink, but for goodness sake stay sober tonight and be ready for tomorrow. We've got a chance to win the pennant and you can be a big part of that if you can do just that,'" remembered Galehouse. "So he promised he would. And the next day, just before the game, one of us, I don't know who now, gave him a little two-ounce jigger to take and loosen him up. And that was it. But he kept his word that night and didn't drink."

All during the season, despite the Browns continued placement near the top of the standings, St. Louis still didn't draw good crowds to Sportsman's Park. The doubleheader against the Yankees on September 29th saw just over 6,000 spectators. Slightly more than 17,000—12,982 paying—showed up the next day, a good number for the Browns but still small for such an important contest.

With a chance for the Browns to win the American League pennant, fans arrived at Sportsman's Park on October 1st by 7 a.m. For a short time, a fan could walk up and purchase one of 4,000 available bleacher seats for $1.25 or 3,000 pavilion seats and standing room only tickets at $3.75 a piece. For those who couldn't get tickets through the box office, there was always scalpers and ticket brokers. But going those avenues wasn't cheap. It was reported that some single game tickets were running between $12-$17 while one scalper was selling a block of six tickets, valued at $37.50, for more than three times the original cost.

The government was supposed to receive 20 percent of all markups on scalped tickets so the Internal Revenue Service had 25 of its agents combing the streets surrounding Sportsman's Park—Dodier St., Sullivan Ave., Grand Blvd. and Spring Ave.—on the lookout for ticket transactions.

An hour before game time, all of the stadium's general admission seats were occupied. The crowd eventually blossomed to 35,518 paying customers, the largest home attendance ever for a Browns game. "Because of the past history of not winning, they just weren't believers until the last few days I guess," remarked Galehouse.

In Detroit, there was another important game to be played that day. The Tigers-Senators matchup started even before the Browns-Yankees contest. Opposing Detroit's Dizzy Trout for Washington was Dutch Leonard. The 35-year-old knuckleballer was in his 11th season in the majors. He had been with Washington since 1938 and had won 20 games as recently as 1939. He also posted 18 victories in 1941. Leonard brought a 13-14 record into the game with Detroit.

He also carried a secret.

Washington was staying at the Book-Cadillac Hotel in Detroit. Prior to heading over to the ballpark, Leonard received a phone call in his room from an unidentified man who pitched a proposal to the Tigers hurler. After the man had Leonard confirm he was pitching that day, he told the pitcher it might be worth his while if he didn't give it his best effort. The man said he had been authorized—by whom he didn't say—to give Leonard in excess of $20,000 if the Senators lost.

Leonard hung up on the caller, but was still a bit fearful. He shared his story in confidence with teammate George Case. Leonard was starting to think the call was just a joke, but Case convinced the pitcher to tell someone from the team what had happened just in case.

He waited until the team reached Briggs Stadium before finally telling coach Clyde Milan. Milan immediately informed manager Ossie Bluege of the situation. Leonard waited,

uncertain of whether or not he was still going to pitch. All doubts were removed when Milan returned from his conversation with Bluege and handed Leonard a brand new baseball with which to begin warming up.

Ed Rommel knew a little something about the pressure before big games. He pitched 13 seasons in the majors, from 1920-32, all with the Philadelphia Athletics. The A's played in three World Series in that span, all late in his career, Rommel pitching in two of them.

Rommel's last year in the majors was 1932. In 1938, he became a major league umpire. He happened to be one of the four umpires—an extra ump had been added to the usual crew of three because of the crucial nature of the series—designated to officiate the St. Louis-New York contest.

Rommel knew of the anxiety that was probably pumping through the Browns players and he decided to help ease their nerves. The *St. Louis Post-Dispatch* reported that "the tension in the Browns dugout was broken by ump Ed Rommel, who walked through with his eyes closed and his arms extended, as though he were blind. Several players laughed, and another yelled, 'You never could see beyond the end of your nose.'"

St. Louis players stayed loose without Rommel's help as well. Avid golfer Al Zarilla used a box of sand, normally reserved as a depository for the player's tobacco juice, to practice his golf swing. Zarilla had a golf club and was pretending he was hitting out of a sandtrap.

Although details have become muddled over the years, Ellis Clary supposedly helped everyone relax during the game. Don Gutteridge remembered Clary secretly listening to a football game on the radio while the Browns were playing their pivotal contest. Recalled Gutteridge: "Clary was (playing the radio). He kept everybody loose. He was really good for us. He was a rabid football fan. The Chicago Bears were the hot team and he was a Bear fan. Sewell would go out to the third base line to coach and he'd sneak out that radio and turn on the radio to listen to the Bears football game. We'd all listen, 'Hey, what they'd do? So and so made an end run.' Then Sewell would come in and he'd (Clary) turn it off right quick and set it behind him. Sewell would go back out and he'd turn it back on again. He kept us all loose and cool, Clary did. He was our pepper upper."

Over fifty years after the incident, Clary remembered the details a little differently. "No, it wasn't in the dugout it was in the clubhouse," Clary said. "And Dizzy Dean (who broadcast Browns games on the radio) was upstairs in the press box giving signs as to who was winning and losing. That was Saturday before the game ended on Sunday. That thing has been exaggerated. But it was like that to some extent, yeah."

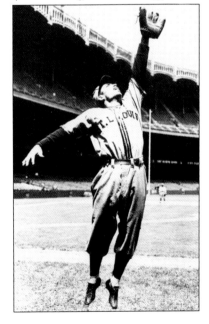

Luke Sewell filled out his lineup card nearly the same way each of the first three games in the series and the fourth game was no different. He batted his catcher eighth and, for the finale, as it had been for two of the previous three games, Sewell selected Red Hayworth over Frank Mancuso. George McQuinn was at first base, but as he had considerably weakened over the course of the season Sewell batted him sixth instead of third, his usual slot in the order for the majority of the year. As usual, the middle infielders were Don Gutteridge, at second base and leading off, and Vern Stephens, the shortstop and cleanup hitter. Mark Christman played third and batted seventh.

DON GUTTERIDGE. Don Gutteridge has a good view of the final out of the pennant-clinching game, a moment Luke Sewell called the most memorable of his career. It took 15 minutes for Gutteridge and George McQuinn to fight their way through a crowd and make it back to the clubhouse. (NBH)

Sewell put Milt Byrnes in right field and batted him fifth in the doubleheader on September 29th, but inserted Gene Moore in the same position and lineup spot for the final two games. Mike Kreevich played center field and batted second, a spot Sewell had put him in 17 of the previous 19 contests. Chet Laabs' playing time had increased throughout the September stretch yet Sewell was going to bench him for the New York series until he saw Laabs swinging the bat during batting practice before the doubleheader. Sewell thought Laabs' swing was looking the best it had all season and, on a hunch, put him in left field and batted him third.

Joe McCarthy trudged out the following lineup: Stuffy Stirnweiss, second base; Bud Methany, right field; Herschel Martin, left field; Johnny Lindell, center field; Nick Etten, first base; Frank Crosetti, shortstop; Oscar Grimes, third base; Mike Garbark, catcher; Mel Queen, pitcher. Of the nine starters, six had played on the Yankees' 1943 World Series championship team. Garbark was a rookie in '44 while Martin had been out of the majors since 1940, but came into the game hitting .298 with 11 doubles, three triples and nine homers in just 84 games. Queen appeared in four games for the Yankees' 1942 A.L. pennant winners. He was 6-2 in 1944, allowing just 64 hits in 77 innings.

Jakucki started the game by retiring both Stirnweiss and Methany, but then Martin clubbed a triple. Lindell, the next batter, poked a grounder, deep into the hole at short that Vern Stephens fielded but subsequently threw over the head of George McQuinn at first. Lindell was given a single and an RBI while Stephens charged with an error for allowing Lindell to reach second.

The Browns misplays continued in the third. After striking out Queen to begin the inning, Jakucki got Stirnweiss to hit a grounder to third. But Christman couldn't handle the ball, the error allowing Stirnweiss to reach first. The speedy Yankee second baseman didn't stay at first very long, stealing second base then advancing to third as Red Hayworth's throw to Vern Stephens was low and scooted into center field.

St. Louis caught a break when Stirnweiss tried to score when Methany bounced to Christman. The third baseman and Hayworth got Stirnweiss into a rundown and eventually tagged him out, although Methany was able to reach second during the play.

While Stirnweiss was out, the error that allowed him to reach base was looming big. If not for Christman's miscue, the inning would have been over. But now with two out, Martin stood in against Jakucki. For the second consecutive at-bat Jakucki didn't fool Martin, the Yankee batter plastering a pitch all the way to the screen in right-center field. Martin wound up with an RBI double and New York had itself a 2-0 lead.

The Browns hadn't touched Queen for a hit in the first three innings, but Mike Kreevich finally broke the spell by lacing a single. Up stepped Laabs, the power-hitting outfielder who had shown little of his strength during the season. Queen delivered a fastball and Laabs crushed it, sending it far and deep over the bleachers in left field. His home run tied the game, 2-2.

Shortly after that blast, as Laabs circled the bases, the scoreboard operators decided it was time to post the final score from the Detroit-Washington game: Senators 4, Tigers 1. The crowd erupted even more, the hooting and hollering lasting for an estimated five minutes.

Tigers manager Steve O'Neill had been confident the night before, saying "We figure the Yankees ought to take the Browns once anyway, but if they don't we'll just have to do it ourselves Monday, that's all." His mood most certainly changed after the Tigers lost. Now the only way there was going to be a playoff game was if St. Louis lost.

Queen got out of the fourth without surrendering any more runs and he retired the first two batters in the fifth when again Kreevich ripped a single. Facing Laabs for the third time in the game Queen threw a curveball, a pitch that Laabs had trouble with his entire career. But this time Laabs connected, sending the Queen offering 400 feet into the left-center field seats.

"Those two balls he (Laabs) hit that last day, there was no doubt about it when they left his bat," remembered Don Gutteridge. "They were way up in the bleachers. He hit the hell out of it."

Knowing the importance of the game, McCarthy took out Queen and replaced him with Hank Borowy, his top-flight starter who limited the Browns to just two hits in a 1-0 loss to Potter two days earlier. It didn't really matter who McCarthy brought in to pitch because

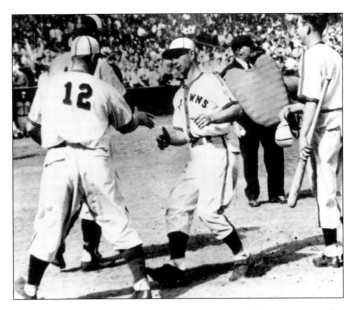

CHET LAABS AFTER HOME RUN. Chet Laabs gets congratulated after hitting the first of his two home runs against the Yankees in the pennant-clinching game. They were likely the biggest hits in the history of the Browns. (NBH)

Jakucki was on his game. After the third inning, he allowed just one Yankee baserunner to reach third base. None scored.

Stephens added some insurance by popping his 20th homer of the season, a shot that went on top of the right-field pavilion, in the eighth. Jakucki took a 5-2 lead into the ninth. Sensing the dramatics of the situation, he strolled slowly out to the mound, soaking in the atmosphere and electricity that was buzzing throughout the crowd.

Lindell led off and blasted a Jakucki pitch that sent right fielder Gene Moore all the way to the right-center field wall, but the ball settled into Moore's glove just shy of the fence. The crowd of 35,518, all seemingly holding their breath as they watched the ball fly off Lindell's bat, exhaled with relief when the near homer merely turned into a long out.

Nick Etten ripped a single by second baseman Gutteridge, but Jakucki got Frank Crosetti to line out to Kreevich in center for the second out. That brought up Oscar Grimes, who then took part in what Browns manager Luke Sewell later called the most memorable play in his baseball career.

The *St. Louis Post-Dispatch* captured the moment: "Grimes sent a high twisting foul toward the Yankee bullpen. McQuinn circled back and there was hardly a sound until George found the ball firmly in his glove. Then the uproar began."

"It finally got down to where he popped up to George McQuinn who caught the ball behind first base," recalled Gutteridge. "It was a foul ball and it went way high and I run over there, I was playing second, I run over there and I hollered, 'Squeeze it George, squeeze it George, squeeze it!' And old George squeezed it and we won the pennant."

With that catch, pandemonium broke loose.

"It took me about 15 minutes to get back to the dugout because the minute that last ball hit into George's glove we were swamped," said Gutteridge. "George and I had to fight our way over to our dugout because our dugout was on the third base line. There was a lot, a lot of people on that field long before we ever got there. I think (the fans) already jumped over the wall and they swarmed us."

The Browns celebration continued in the clubhouse where Jakucki, who allowed just six hits and one walk while striking out four, and Laabs ("Laabs for Mayor" exclaimed one headline the next day) hugged each other. Owner Don Barnes had tears of joy and kissed the baseball responsible for the final out. "The clubhouse was a complete storm," recalled Babe Martin. "Everything was thrown everywhere. We had champagne, beer, they had everything up there."

While the Browns players celebrated, their luggage sat in another part of the clubhouse. The team was to leave for Detroit right after the game if there was need of the one-game playoff. "We carried our bags to the ballpark that morning to go to Detroit as soon as the game was

over," recalled Ellis Clary. "But it never happened because they lost and we won. But we were packed up and ready to go."

The fans had a celebration of their own as well. Some stayed in the ballpark for up to a half hour after the final out to soak in the moment, others "were unashamedly weeping," according to the *St. Louis Post-Dispatch*. Also, "two automobile parades were formed by Brown fans. One group tied wash tubs and tin cans to the back of their cars and made brief tours of the mid-town theater district after the game." The other convoy of cars made its way down Seventh Street in St. Louis. Both were cut short, though, because of gas rationing that occurred during the war.

Partiers everywhere in St. Louis surely toasted the Washington Senators and Dutch Leonard. Washington and St. Louis had a few altercations during the season, but the Senators didn't lay down against Detroit, beating them twice. "We were (worried) a little bit and said, 'Hey, we had a fight with them and they don't like us, they might not play very hard'," Gutteridge explained. "But they did and of course you know the story, they beat 'em."

Despite being rattled by his early morning phone call, Leonard shut down the Tigers and limited Detroit, one of the better hitting teams in the league, to just one run. "He had the nerve enough to go out there and pitch a great game," said Denny Galehouse. "And we'll always be thankful to him."

Laabs, remembering the accusations of a certain radio announcer, summed up the Browns feeling upon clinching the pennant. "How about that guy, Bill Stern? What's he got to say," said Laabs.

The Browns had started the season 9-0, fell out of first place, regained it, and then slipped out again. Then with reports circulating that the Browns were trying to lose, they won their first American League pennant in glorious fashion, by sweeping a four-game series from the defending World Champion New York Yankees. "To the Browns went the American League pennant in one of the most stirring climax drives in all the annals of the game," penned New York based writer Dan Daniel.

The fans continued the celebration into the wee hours in St. Louis taverns while the Browns had a team party at the Chase Hotel that night. But the celebration was short lived. After all, there was still a World Series to play.

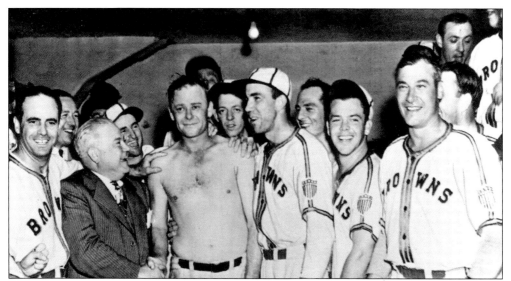

CLUBHOUSE SCENE. Sigmund Jakucki (*shirtless*) gets congratulated by manager Luke Sewell (*left*), owner Don Barnes (*second from the left*), and teammates after the pennant-clinching win over the Yankees on the season's final day. (NBH)

Eleven

Ninth Inning
The Series

Winning the American League pennant was no easy task, but an even greater challenge stood before the Browns if they wanted to be World Champions.

While the Browns had to go down to the wire to earn a berth in the World Series, the St. Louis Cardinals ran away with the National League pennant. The Cardinals went 5-15 in September and still finished 14 1/2 games ahead of their nearest competitor, Pittsburgh. The Cardinals rested atop the standings for all but four days during the year. At one point they were 73-27, eventually finishing with a 105-49 record (.682 winning percentage). The Cardinals won their 90th game—more than the Browns recorded for the season—August 28th, the earliest date that win total had been reached since the 1906 Chicago Cubs, a club that won 76.3 percent of its games—which is still the best winning percentage in major league history.

The St. Louis Cardinals were not a one-year wonder. The 1944 season marked the third consecutive pennant for the club and the third straight year the team amassed over 100 wins. Manager Billy Southworth became the first National League manager to guide a team to such a feat. New York Giants manager John McGraw saw his club top 100 wins in both 1904 and 1905 as well as 1912 and 1913 while Frank Chance, player-manager of the Cubs, led Chicago to over 100 victories in 1906 and 1907 and then again in 1909 and 1910. In 1908 the Cubs won 99 times. Only the venerable Connie Mack had previously directed a team to three straight 100-win seasons, accomplishing the feat with the Philadelphia Athletics from 1929-31.

Despite the fact that the Cardinals had bested second place Cincinnati by 18 games in 1943, *The Sports Encyclopedia* proclaimed the '44 team "Won [its] third pennant in a row in the most one-sided race in the NL in 40 years."

The Cardinals had it all—hitting, pitching and defense. Their composite .275 batting average, 100 home runs and .402 slugging percentage all were tops in the major leagues. The 26 shutouts tossed were nine more than the next National League club while the team's 2.67 ERA was well below the 3.09 ERA Detroit recorded in leading the American League. The Cardinals' .982 fielding percentage not only was the best in either league, but also their 112 errors committed broke the all-time record for fewest errors by one team in a season.

The Browns' strength was their pitching. In the final nine games of the season, the Browns allowed just 10 runs. For the season they finished with a 3.17 ERA, had 16 shutouts, second only to Detroit, and led the A.L. in strikeouts. The Browns' fielding was an adequate .972, although both George McQuinn and Mark Christman led the AL in fielding at their respective positions. However, the Browns had the second worst batting average in the league, .252. That marked the lowest batting average for a team that made it to the World Series since the 1918 Boston Red Sox hit just .249. If Mike Kreevich hadn't collected two hits on the final day of the season, pushing his average to .301, the Browns would have become the first team in history to win the pennant without a single .300 hitter or 20-game winner on the squad.

Of the Browns, Kyle Crichton wrote in *Colliers*, "They have a rickety-looking pitching staff and an outfield that has the appearance of something discarded by the Salvation Army."

The Cardinals, or Cards or Redbirds as they also were known, had basically the same team that won 105 games in 1943 before falling to the New York Yankees in the World Series. The lineup was intact except for Emil Verban, the team's third second baseman in three years, taking over for Lou Klein, and Johnny Hopp, a backup outfielder and first baseman in '43, who took over for Harry "The Hat" Walker in center field.

At first base the Cardinals had Ray Sanders, who batted .295 with 12 homers and 102 RBI, tied for the fourth most in the league. He also led National League first basemen with a .994 fielding percentage, a figure also posted by the Browns' George McQuinn. Verban hit .257, which made him the weakest link on the squad.

At shortstop was Marty Marion, also known as "Slats" or "The Octopus." Marion hit just .267 with six homers and 63 RBI, but enough was thought of his defense—he led the NL with a .972 fielding percentage—that he was eventually named the league's Most Valuable Player for 1944.

At third was steady Whitey Kurowski, who hit .270 with 20 homers —tied for fourth most in the NL—and 87 RBI. Rounding out the infield was catcher Walker Cooper, a good hitter who possessed a terrific throwing arm. Cooper hit .317 with 13 homers and 72 RBI in '44.

Hopp had a fantastic first year as a starter. He led the league in fielding percentage (.997) and finished fourth in batting average (.336). Hopp also hit 11 homers, scored 106 runs, drove in 72 and stole a team-high 15 bases. "Back in our day we didn't do much running," Marion recalled. "We had a pretty fast team but our manager believed in first and third and all that kind of stuff. We didn't do much stealing."

Left field belonged to Danny Litwhiler, a power hitter the Cards picked up in 1943 to fill the void of Enos "Country" Slaughter, who entered the military prior to that season. Litwhiler hit .264 with 15 homers and 82 RBI.

Then there was the right fielder, Stan "The Man" Musial. Musial was just 23 years old and eligible to be drafted but he had yet to be called, much to the Cardinals' (and their fans) delight. Musial, who won the MVP in 1943, hit .347, second in the league, in 1944. Musial led the league with 197 hits, 51 doubles and a .549 slugging percentage. He also had 14 triples (tied for fourth in the NL), 12 homers, 112 runs (second in the league), and 94 RBI while drawing 90 walks (third best in the NL), and striking out just 28 times.

The pitching staff was also intact from previous seasons, with rookie Ted Wilks the only new pitcher that had a possibility of starting in the series. The rotation was led by Walker Cooper's older brother Mort, who won the 1942 MVP when he went 22-7 with 10 shutouts and a 1.78 ERA. The 1944 campaign marked Mort Cooper's third straight 20-win season. He finished with a 22-7 record, 2.46 ERA and a league-high seven shutouts.

Rounding out the starting staff was Max Lanier (17-12, 2.65), Wilks (17-4, 2.65) and Harry Brecheen (16-5, 2.85). Al Jurisich (7-9, 3.39) split his time between starting and coming out of the bullpen while Freddy Schmidt (7-3, 3.15) and Blix Donnelly (2-1, 2.12) were used mainly in relief.

"The World Series Cardinals had Stan Musial, Whitey Kurowski, Marty Marion, Walker Cooper, Mort Cooper . . . they had pretty much a big league team. They weren't an easy squad," recalled Denny Galehouse.

Said Ellis Clary in 1994: "I'd like to take my chances with that outfit today. They didn't have nobody but Stan Musial and Marty Marion and Whitey Kurowski and Walker Cooper, Mort Cooper and Harry Brecheen. Goddamn they had a hell of a team."

Browns manager Luke Sewell faced the decision of who would start October 4th, the first game of the World Series, against Mort Cooper. Unlike the previous two World Series, and thanks mostly to the Browns and Cardinals playing in the same park, the first six games were to be played on consecutive days. The only off day scheduled was between the sixth and seventh games. That meant the opening game starter most likely would not start three games, unless he was pitched on just two days' rest for what would be a deciding seventh game.

Still, there was a tremendous amount of prestige for the pitcher selected to start the World Series opener. Many believed Nelson Potter had the best chance to get the nod from Sewell. Despite his 10-game suspension earlier in the year, Potter led the Browns with 19 wins and

DENNY GALEHOUSE. Despite finishing with a losing record (9–10), Denny Galehouse was Luke Sewell's choice to start the first game of the World Series. Galehouse was just 3–4 in September, but allowed only two runs in his last three regular-season starts. (SM)

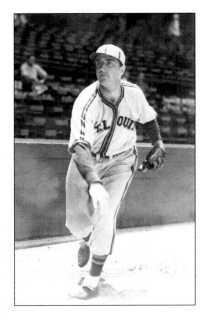

also had a 2.83 ERA. Potter had performed well down the stretch, going 6-1 in September including shutouts in his final two starts. The *St. Louis Post-Dispatch* wrote, "Observers believe Potter is almost a sure shot for the opening game."

New York based writer Dan Daniel, in a story datelined October 3rd, said Jack Kramer was going to oppose Mort Cooper in Game One. Kramer also had a fantastic September. He completed all six games he started, winning five of them. Kramer pitched a total of 58 2/3 innings in the month and allowed only eight runs on 39 hits and five walks while striking out 26. For the season, Kramer was 17-13 with a 2.49 ERA, lowest among St. Louis starters.

Both Kramer and Potter had each pitched one game in the Browns' doubleheader sweep over New York on September 28th, meaning either one would have four days of rest before the start of the World Series.

What the media, fans and other Browns players didn't know was that Sewell had made his decision on his Game One World Series starter before the Browns had even locked up the American League pennant. But neither he nor the pitcher told a soul until Sewell made the announcement October 3rd. Denny Galehouse was his choice.

Denny Galehouse probably should never even have been a member of the St. Louis Browns. He started his major league career with Cleveland. After seeing brief duty with the Indians in 1934 and 1935, Galehouse made it to the big leagues for good in 1936. With the Indians, Galehouse had three mediocre seasons—8-7 with a 4.85 ERA in '36, 9-14 with a 4.57 ERA in '37 and 7-8 with a 4.34 ERA in '38—before being traded to the Boston Red Sox in December 1938 along with shortstop Tommy Irwin, who played just three games in the majors in his career, for outfielder Ben Chapman, coming off a season in which he batted .340.

Galehouse didn't improve on his numbers while in Boston. He went 9-10 with a 4.54 ERA in 1939 and 6-6 with a 5.18 ERA in 1940. Still, he was being counted on as a part of the Red Sox pitching staff in 1941 and wasn't being offered around by Boston. Yet the Red Sox received a trade offer for Galehouse and another pitcher, Fritz Ostermueller, they just couldn't refuse.

"The (baseball winter) meetings were held in Atlanta and the last day of the meetings they had the big bust out at the Coca-Cola factory," Galehouse explained. "And the president of the Browns came up to one of the officials of the Red Sox and was crying on his shoulder because he hadn't been able to make a deal and he asked the Boston (official) what he'd take for me and Fritz Ostermueller. And the Boston guy put up a pretty high price, what he thought would be enough to stall him, and the (Browns) guy said I'll take him. And that's how I went to the Browns."

The deal occurred December 3, 1940 with the Browns, by one account, giving Boston approximately $30,000 for the two players. While Galehouse still struggled to win games in St. Louis, his pitching got much better. In 1941, Galehouse was 9-10 with a then career best 3.64 ERA. He finished 12-12 with a 3.62 ERA in '42 then topped that with an 11-11 record and 2.77 ERA in '43. Eleven times Galehouse held opponents to two or fewer runs in 1943, including two shutouts.

But instead of joining the team in spring training of 1944, Galehouse announced his intention of working at a war plant job in Akron, Ohio. While his teammates worked out at

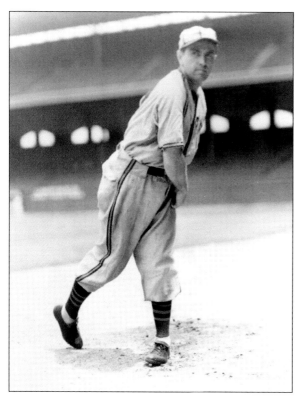

NELSON POTTER. Nelson Potter won a team-high 19 games for the Browns in 1944, but his critical error helped cost the Browns game two vs. the Cardinals and possibly a World Series title. (SM)

Cape Girardeau, Galehouse spent his time as the pitching coach of the high school baseball team in Cuyahoga Falls, Ohio.

When Steve Sundra was called to the military in early May, the Browns reached out to Galehouse and signed him up as a part-time, weekend pitcher. "I worked during the week (at Goodyear aircraft)," Galehouse remembered. "We'd get Saturday afternoons off. I'd catch a train to wherever the team was and get there Sunday morning and pitch the first game and then go back to the (train) station and go back home."

Galehouse made his first appearance May 14th, pitching 1 1/3 innings of scoreless relief at Philadelphia. He pitched in two more games in May—including one start—but lost his only decision. His troubles continued in June when made three starts, losing twice. Galehouse managed to pitch just 11 1/3 innings giving up 11 runs on 17 hits while walking six and striking out just three.

"My spring training was just around home," Galehouse recalled. "Playing catch with people and doing my running on the streets. At first I was almost with them (his teammates). But then (with) the rest of the team playing every day and working out every day, I soon fell behind in conditioning. And after about four weeks or so I didn't have much luck."

To help himself stay in shape, Galehouse signed on with the Akron Orphans of the Akron-Barberton-Cuyahoga Falls League. He made his first start for the club June 21st, beating the Barberton Genets 8-2. The Genets didn't appreciate having to face a major league pitcher, administering a complaint to the league office shortly after the contest. Two weeks after Galehouse had pitched for Akron, league officials ruled that the Browns pitcher could not appear again for the Orphans or any other team in the circuit.

Galehouse pitched in relief for the Browns on July 4th, giving up two runs on three hits and two walks in 1 2/3 innings in a St. Louis 8-3 loss at Philadelphia. That marked Galehouse's last appearance as a weekend pitcher. Assured that he was not going to be drafted until after the season was over, he officially left the Goodyear factory in Akron and joined the Browns on a full-time basis July 16th. "When I figured that the Browns had a chance to win the American League pennant, I contacted my draft board and asked them if I quit and was with the team full time, would I be taken before October," recollected Galehouse. "And they said no, it would be after October sometime."

Galehouse still wasn't in true pitching form, but he won three games in July after rejoining the Browns. But, as in the past, Galehouse found victories hard to come by. He ended the year with a 3.12 ERA but still managed to finish with more losses (10) than wins (9). However, Galehouse felt that perhaps he should have had fewer losses if not for a teammate.

"I know a player that shall be remain nameless who cost me three games in Yankee Stadium one year," explained Galehouse. "I was with the Browns and this one player made three mistakes. He charged a ball and it went over his head. Laid back the next time and it hit in front of him. Charged the next one and it went over his head. All in the late innings of different games. With runners on and beat me. I was ahead in the score and those things beat me. I'm afraid it was [in 1944]."

While best available evidence indicates the player in question was Gene Moore, Galehouse pitched at New York just twice in 1944 and lost only one game that season to the Yankees.

While on the surface Galehouse's overall 9-10 record and his 3-4 mark in September didn't look as impressive as either Kramer or Potter's performances, Galehouse allowed just two runs in his final three starts. On the second to last day of the season Galehouse shutout the Yankees, allowing just five singles, keeping the Browns pennant hopes alive. Following the contest, manager Luke Sewell laid out his plans to Galehouse.

"Of course after my game on Saturday when I shut the Yankees out, the manager came to me and told me that if we got into the Series I was going to start it," Galehouse remembered. "I knew way ahead of time and nobody else did. Nobody else knew who it was. We were told to keep quiet, yeah. She (his wife) knew enough to keep quiet.

"When he told me I was in the shower. I was always a heavy sweater and whenever after I pitched I'd sit around in the clubhouse and probably everybody would be gone. The rest of the players, until I got through showering and quit sweating and everything, they were getting dressed. So I was in the shower when he (Sewell) was in the shower and he said, 'If we're in it, you're it.'

"So I said, OK, if that's the way you want it. I didn't say if that's the way you want it, I said OK, fine. And everybody was asking around, who was going to pitch. Nobody knew but me."

Sewell didn't make his announcement after the Browns won the pennant by beating the Yankees October 1st. Instead he waited until after the team completed a two and a half hour workout October 3rd. His decision shocked the baseball world.

The *St. Louis Post-Dispatch* declared in a headline: "GALEHOUSE SURPRISE CHOICE TO PITCH FOR BROWNS."

Said Galehouse: "It's just the fact I couldn't get into as good as shape as the guys who played all the time. But after I went back, the rest of the year was a pretty good year for me. In fact that's why I was considered by the manager, being the best pitcher at the final part of the season. So it's the reason I was chosen to start the World Series. It probably was (a surprise to the public) because Nelson Potter had won 19 games and here I had won nine and lost 10, because most of my losses were while I was commuting back and forth."

Sewell also announced that catcher Red Hayworth and outfielders Chet Laabs and Mike Kreevich were going to play every game no matter what the situation.

Sewell had one decision already made for him—where he was going to stay during the series. He and Cardinals manager Billy Southworth shared the same apartment on Lindell Avenue during the regular season. Since the St. Louis teams shared the same stadium, one club was always at home and the other on the road. Sewell expressed his concerns to Southworth during the final weekend of the regular season, wondering what the two should do if the Browns ended up winning the pennant. Southworth put Sewell's mind at ease.

"I don't want to go into any ifs with you. The Browns are going to win the pennant, so you go right ahead [and stay at the apartment]," Southworth reportedly told Sewell on the morning of October 1st, prior to the regular-season finale. "I have rooms available at a hotel, and I'll just move in when we return home, and we'll proceed just as if we were still out of town. Don't worry, you'll win the pennant."

While the two opposing World Series managers ended up staying in different quarters, they still left together from the ballpark after each game.

Fans in St. Louis couldn't wait for the World Series to start. The series marked just the seventh time teams from the same city played each other in the Fall Classic. The Chicago Cubs and Chicago White Sox squared off once while the New York Yankees played either the New York

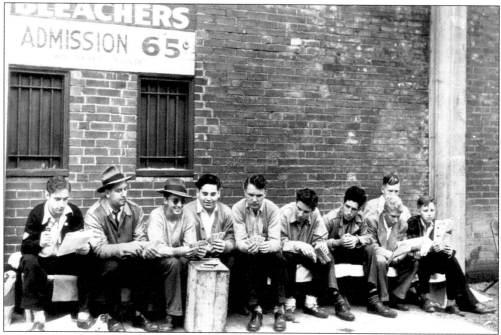

WAITING FOR GAME ONE. Fans spend their time playing cards and reading as they wait for the bleacher gates to open prior to the first game of the 1944 World Series. (SM)

Giants or Brooklyn Dodgers on six occasions. The Browns-Cardinals series was dubbed "The Streetcar Series" because of all the trolleys in St. Louis at that time.

People gathered around Sportsman's Park the night before the opening contest in hopes of purchasing tickets that ranged in price from $7.50 for a box seat to $1.25 for a seat in the bleachers. First in line for pavilion tickets was Art "Happy" Felsch. Felsch situated himself on Grand Boulevard for six days in order that he be the first to purchase tickets, something he had accomplished at 15 of the previous 16 World Series.

The large contingent found ways to entertain itself during the evening, playing cards and even some craps and dancing the jitterbug to music played by students from Soldan High School. Some enterprising children took advantage of people's desire to have a place to sit by selling cartons and boxes for 25 to 50 cents. The *St. Louis Post-Dispatch* reported that "a Negro boy rented 19 of 25 collapsible chairs for 50 cents."

Dark clouds entered the area shortly after sunrise and some rain even fell around 8:15 a.m., almost six hours prior to the first pitch. The weather didn't deter the throng of fans outside the stadium. "This rain doesn't bother me," said one of the fans, 16-year-old Bill Schneider. "A loyal baseball fan would sit through a snowstorm."

A couple of familiar faces were missing among the 33,242 fans that paid to attend the first ever World Series game for the St. Louis Browns, two thousand less than the Browns drew for their pennant clinching game on the last day of the season. Because of a bad cold, Judge Kenesaw Mountain Landis, the first baseball commissioner, was not in attendance. It marked the first World Series Landis missed since being hired in 1920. Landis died nearly one and a half months later, on November 25th, five days after his 78th birthday.

Even though Landis wasn't in St. Louis, he still made sure radio broadcaster Dizzy Dean, who regularly broadcast St. Louis games, didn't take the airways. Dean had a very colorful style, too much so for Landis, and he often butchered the English language, saying such things as a ballplayer "slud" into a base. Landis felt that Dean's style was inappropriate for such a national setting.

Among the notables in attendance were Luke Sewell's brother, Joe, and Major Billy

Southworth Jr., the son of the Cardinals manager who in December of 1940 became the first professional baseball player to sign up for the military.

New sod had been placed on the Sportsman's Park infield which had been torn up after being used nearly every day during the season. Twenty-five cent programs were being sold at a brisk rate as Don Gutteridge stepped in the batter's box to face Mort Cooper to become the first St. Louis Brown to ever bat in a World Series contest

GAME ONE

Prior to Gutteridge leading off the game, the only members of the St. Louis Browns that had ever appeared in a World Series game were the club's three coaches, Luke Sewell, Fred Hofmann and Zack Taylor. The Browns faced Mort Cooper, arguably the best pitcher in the National League and who had four World Series starts under his belt, including the first game of the 1942 series.

Gutteridge took the first offering from Cooper for a ball and then after watching two strikes go past him, the Browns second baseman popped out to shortstop Marty Marion. Cooper struck out both Mike Kreevich and Chet Laabs to finish off the top of the first inning.

When Denny Galehouse trotted out to the mound for the Browns he became the pitcher with the worst season winning percentage (9-10, .474) to start a World Series opener. The record lasted until 1973 when Jon Matlack of the New York Mets (14-16, .467) was sent to the hill in Game One of that year's World Series.

Galehouse, who not only hadn't appeared in a previous World Series but also hadn't ever witnessed one in person, was able to shake off any nerves quickly. The Cardinals' first batter, Johnny Hopp, swung at Galehouse's first pitch, flying out to Laabs in left field. Galehouse then struck out Ray Sanders on three pitches for the second out. Stan Musial accounted for the first hit of the series, bouncing a 1-2 pitch over Galehouse and up the middle for a single. But, like Hopp, Walker Cooper was first-pitch swinging and he lifted a fly ball to center, Kreevich making the play for the final out.

The Browns couldn't get anything going against Cooper in the second. Vern Stephens bounced back to the pitcher to open the frame. After Gene Moore walked, George McQuinn was jammed by an inside fastball and flew out while Mark Christman took a called third strike.

Galehouse retired Whitey Kurowski and Danny Litwhiler to start the bottom of the second, but Marion doubled. Emil Verban then singled up the middle but Gutteridge was able to get to the ball to prevent Marion from scoring. Galehouse then fanned Mort Cooper to get out of the inning.

After Red Hayworth grounded out to lead off the third, Galehouse drew a walk after being behind in the count 0-2. However Mort Cooper got Gutteridge to fly out and Kreevich to bounce one back to the mound.

While the Browns were having trouble with Cooper, the Cardinals were about to mount the first scoring threat of the series. Hopp opened the Cardinals half of the third by sending a grounder through a hole between first and second. Sanders then drilled a liner to right that Gene Moore caught up with and jumped for but couldn't hang on to. Hopp, waiting to see if the ball was going to be caught, could make it only to second base.

Cardinals manager Billy Southworth had Stan Musial execute a sacrifice bunt, which Musial almost beat out, to put runners at second and third with just one out. Despite it being just the third inning, Browns manager Luke Sewell preferred not to face Cardinals catcher Walker Cooper, a .317 hitter in 1944 and a combined .289 in two previous World Series, in this situation, deciding to have him intentionally walked to load the bases. The move also set up a potential double play on a grounder. However the next hitter, Whitey Kurowski, was no slouch at the plate either, batting .277 in 1944 with 20 homers. Galehouse got Kurowski to foul off the first two pitches then blew a fastball by him for strike three. Galehouse then got another power hitter, outfielder Danny Litwhiler, to ground to third baseman Mark Christman for an inning-ending force out.

The fourth inning started just like the previous three for the Browns, Mort Cooper inducing Laabs to fly out and Stephens to pop up to Marion. With two out, Gene Moore laced a single

DANNY LITWHILER. Cardinals outfielder Danny Litwhiler was the only player to hit a ball over the double deck left-field bleachers at the Polo Grounds (505 feet). He hit 15 HRs for the Cards in 1944. (AC)

to right field for the first-ever St. Louis Browns hit in a World Series.

That brought up George McQuinn, who had flied to shallow left field with Moore on first base in the second inning. McQuinn's bad back had bothered him more and more late in the season and he had just 10 hits in 60 at-bats (a .167 average) in the final month of the regular season.

McQuinn knew he had the reputation of being an opposite field hitter, hence the inside fastball he received from Cooper on the first pitch of his at-bat in the second inning. This time Cooper started McQuinn off with a pitch out of the strike zone, low and away. McQuinn thought Cooper was setting him up for an inside pitch, the same pitch he threw in the second inning. McQuinn guessed right. Cooper's second pitch to McQuinn was a fastball inside. This time McQuinn was waiting for it and didn't get jammed, instead clubbing the ball over the wall in right field and almost on top of the roof. The Browns had a 2-0 lead.

Galehouse didn't give the Cardinals many opportunities to cut the lead. He retired the National League champions in order in the fourth, allowed a one-out walk in the fifth that was quickly erased when Stan Musial hit into a double play to end the inning and gave up a harmless two-out walk in the sixth. The Browns couldn't stretch their lead as Vern Stephens' two-out walk in the sixth accounted for the team's only baserunner through the seventh inning.

Augie Bergamo pinch hit for Emil Verban to lead off the bottom of the seventh against Galehouse and drew a walk. Southworth sent up another pinch hitter, Debs Garms, for Mort Cooper and he grounded out, Bergamo moving to second base, the first time the Cardinals had a runner in scoring position since the third inning. But Bergamo got no further as Galehouse got Johnny Hopp to fly out to center and Ray Sanders to line out to first.

Blix Donnelly was the new pitcher for the Cardinals and the Browns had just as much luck hitting him as they did Mort Cooper. Donnelly set aside the Browns in order in both the eighth and ninth innings. The Cardinals received a two-out single in the bottom of the eighth off the bat of Whitey Kurowski, but he was stranded at first.

Marty Marion led off the ninth for the Cardinals by lining the ball into center. Mike Kreevich dove for the ball but couldn't come up with it, Marion ending up at second base with a double. Bergamo grounded out to Gutteridge, the second baseman ranging to his left to make the play, to move Marion to third. Pinch hitter Ken O'Dea ruined Galehouse's shutout by flying out to Kreevich in deep center field, easily scoring Marion from third. But that's all the runs the Cards got as Galehouse retired Hopp to end the game, the Browns winning their inaugural World Series contest, 2-1. After the final out, Galehouse retreated to the Browns clubhouse with a police escort, but first stopping for a kiss from his wife.

McQuinn, with his two-run homer, and Galehouse, with his superb pitching, were undoubtedly the heroes for St. Louis. The Browns managed just two hits off Mort Cooper, Gene Moore's single prior to McQuinn's homer being the other. Galehouse allowed seven hits while walking four and striking out five. He got stronger as the game went on. Galehouse allowed five of the seven Cardinal hits in the first three innings. In the ninth inning he threw 20 pitches, 17 of those were for strikes.

"We were lucky, we had the breaks and I freely admit it," Browns manager Luke Sewell said after the game. "You have to be lucky to win when a pitcher holds you to two hits. But I'm

proud of the game Galehouse pitched. George McQuinn's home run was really something and I'm proud of the way the entire Browns team performed."

The *St. Louis Post-Dispatch* ran a cartoon showing a large boulder in the shape of a baseball labeled "Browns' momentum" rolling down a hill with a worried looking baseball player, labeled "Cards" standing at the bottom close to being run over.

Game Two

The Browns added some lucky charms to that momentum. The St. Louis Beer Company gave 25 silver horseshoes to the team, one for each player to put over his locker.

Nelson Potter, Luke Sewell's choice for his Game Two starter, had a superstitious habit of his own. He never shaved on a day in which he was going to pitch. But for some reason, Potter decided to shave prior to appearing in Game Two of the World Series.

The Browns luck turned quickly. With no score, Emil Verban led off the bottom of the third by singling.

Starting pitcher Max Lanier then bunted, the ball popping up high in the air. Potter didn't make the catch because he was slow off the mound. He probably shouldn't have tried to pick up the ball, as third baseman Mark Christman was charging in on the play and had a better angle to throw to first. Potter would have to pick up the ball, then turn and pivot and throw.

However, Potter tried to pick the ball up, but couldn't hold on to it, Christman perhaps bumping him — or at least effecting his judgement. After gaining control, Potter then rushed a throw to first that was wide of the bag. Second baseman Don Gutteridge, covering first base on the play, tried to stretch for the ball while keeping his foot on the base but the ball sailed passed him and into right field. A taller George McQuinn probably could have caught the throw, but he had rushed in from first base in case Lanier's bunt headed in his direction.

Verban made it all the way to third base and he scored on the next play, a soft bouncer by Bergamo to Gutteridge. It was the first run scored off Potter since September 21st, a string of 22 innings, and the pitcher was mostly to blame as he was charged with two errors on the Lanier bunt.

The Browns' fielding, which had been flawless in Game One, continued a shaky path in Game Two. With one out and runners on first and second in the fourth, Marty Marion hit a double-play grounder to third base. Sure-handed Mark Christman apparently tried to make a play before he had the ball and as a result he botched it, the ball bouncing off his glove and bounding into foul ground behind the bag, all runners safe on the error. Verban then knocked home Sanders, who was on third, with a fly ball to left field, Sanders just beating the throw to home by Chet Laabs to give the Cardinals a 2-0 lead.

As he did in the first game of the series, Gene Moore accounted for the first Browns hit. Moore, making a rare start against a lefty ("I think he's the man," Luke Sewell said before the game), led off the fifth by pushing a bunt to the right side of the infield past Lanier. Verban made a play on the ball but not in time to get Moore.

The Browns didn't get another hit until there were two out in the seventh, when Moore singled again, sharply to center this time. Red Hayworth followed with a long double to

George McQuinn. The Cardinals' Mort Cooper throws the first pitch of the World Series to Browns' leadoff man Don Gutteridge. (NBH)

left-center field to score Moore and cut the lead to 2-1. Frank Mancuso was sent in to pinch hit for Nelson Potter and he delivered a single to center, scoring Hayworth to tie the game.

The score was still 2-2 when Mike Kreevich led off the eighth inning by doubling off the left-field wall off Lanier. Lanier hadn't pitched since September 22nd because of a sore elbow—and he had lost seven straight decisions—so Cardinals manager Billy Southworth decided to go to his bullpen. He brought in rookie reliever Sylvester "Blix" Donnelly, who pitched two perfect innings of relief, striking out two, in the previous day's game.

Donnelly had a history of being a strikeout pitcher, whiffing 304 batters in 271 innings in the minors in 1941. Chet Laabs stepped into the batter's box after Donnelly had taken his five warmup pitches, but, as the *St. Louis Post-Dispatch* wrote, the hero of the regular-season final game "struck out as though trying to swat butterflies with a pipe cleaner." Donnelly then struck out Vern Stephens and after walking George McQuinn intentionally, he struck out Mark Christman to end the threat.

The game remained tied into extra innings. McQuinn started the eleventh inning by nearly hitting his second homer of the series, instead ending up with a double off the right-field pavillion screen. Christman then bunted down the third-base line, perhaps just a bit too hard. Donnelly pounced off the mound, picked the ball up, quickly spun around and threw to Whitey Kurowski at third to try and nail McQuinn. The throw beat McQuinn, but Kurowski started to fall as he caught the ball and McQuinn was sliding into third. It was a bang-bang play and McQuinn was called out.

In the bottom of the inning, Ray Sanders led off by singling off of Bob Muncrief, who had come into the game after Potter was pinch hit for in the top of the seventh. Kurowski moved Sanders to second with a sacrifice bunt. Marty Marion was intentionally walked to set up the

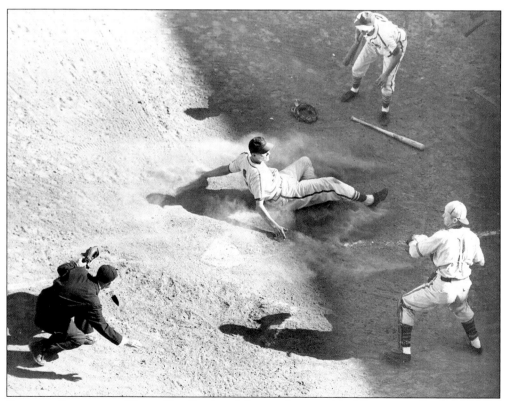

SANDERS SLIDES INTO HOME. Ray Sanders slides into home safely following an Emil Verban fly ball in the fourth inning to give the Cardinals a 2-0 lead in game two. (SM)

double play. Southworth sent up backup catcher Ken O'Dea, the team's top pinch hitter, to bat for Emil Verban. The World Series program had written about O'Dea: "Though not a consistent hitter, he has swat many timely wallops to turn defeats into victories."

O'Dea lived up to his reputation by singling to right to easily score Sanders with the winning run. The hit lifted O'Dea's career World Series average to .500 (6-for-12) in five games.

When looking back at this game, it is not McQuinn's out at third, Christman's error or St. Louis' failure to score after Kreevich's leadoff double that is pointed out as to costing the Browns the game but rather the errors by Potter, who was once described as being "cool under pressure."

"Potter the pitcher threw the ball out into the street and blew the game," said Ellis Clary.

"He bobbled it and threw it away - a double error. That cost us the game," remarked Denny Galehouse. "I never knew until years later that Potter was really disappointed he didn't start the first game. It turned out the manager was right. I did the winning the first game and Potter messed up in the second game. It was just a matter of karma or fate or whatever."

GAME THREE

No games off were scheduled in the series, except for between Games Six and Seven to allow for additional ticket sales, thus Game Three was played Friday, October 6th. The only difference was that the Browns were now the home team for the next three contests.

Luke Sewell chose Jack Kramer to pitch. Kramer was the Browns' streaky pitcher. He started the year winning five straight, eventually had his record drop to under .500 then finished off the year winning his last four decisions.

Sewell also changed his mind about keeping a set lineup. Sewell replaced recent hero Chet Laabs, who was 0-for-8 with five strikeouts in the first two contests, with Al Zarilla.

Billy Southworth trudged out rookie control pitcher Ted Wilks to the mound. Wilks led the National League in winning percentage, winning 17 of 21 decisions for an .810 mark. Despite winning Game Two, Southworth also juggled his lineup, reinserting Danny Litwhiler and batting him leadoff.

Kramer got past Litwhiler and appeared to retire Johnny Hopp, but Vern Stephens booted Hopp's grounder for a two-base error. Stephens chased down Stan Musial's popup to shallow left for the second out but Walker Cooper punched a single just out of the reach of the leading shortstop to score Hopp and give the Cardinals a quick 1-0 advantage. Kramer then walked Ray Sanders and pitched three straight balls to Whitey Kurowski. With the possibility of loading the bases looming and with Al Hollingsworth warming up in the bullpen, Kramer settled down and came back to whiff Kurowski on the next three pitches.

The Browns had their first scoring opportunity in the second. Still trailing 1-0, Wilks uncharacteristically walked Stephens and George McQuinn, throwing just one strike in the process. But Wilks got Zarilla to fly out, Christman to hit into a fielder's choice and after walking Red Hayworth to load the bases, he struck out Kramer to end the inning.

Wilks wouldn't be so fortunate in the third. Again Gene Moore accounted for the first Browns hit of the game, a two-out single to right field. The singles kept coming. Stephens followed with a shot to left and McQuinn a hit to center, scoring Moore and tying the game. Al Zarilla delivered his first hit, a single to left which plated Stephens. Christman made it five consecutive singles with a base hit to center, scoring McQuinn to make the score 3-1, Christman advancing to second on the throw home.

Southworth lifted Wilks in favor of another rookie, Freddie Schmidt, but had him intentionally walk Red Hayworth to load the bases for the pitcher Kramer. Schmidt ran the count to 2-2 on Kramer, but he bounced the next pitch before the plate. Walker Cooper tried to stop the ball, but it bounced of his glove and rolled away. Zarilla scored on the errant toss to make it 4-1. Schmidt then induced Kramer into a ground out to end the inning.

Kramer retired the Cardinals in order for the next three innings, striking out four in the process. The Browns' fielding hurt Kramer in the seventh as it did in the first. Don Gutteridge threw away

a double-play relay throw to first, allowing Whitey Kurowski to go to second base where he scored on a hit by Marty Marion. Now ahead 4-2, Kramer retired pinch hitter Debs Garms but then walked pinch hitter Al Bergamo. Danny Litwhiler, who hit 15 home runs in 1944, represented the go-ahead run. But Kramer got Litwhiler to pop out to Gutteridge to end the inning.

The Browns got Kramer some insurance runs in the bottom of the frame. Gutteridge snapped an 0-for-20 slump by doubling off new pitcher Al Jurisich to start the inning. After Kreevich popped out, Gutteridge moved to third on a ground out by Moore then scored as Walker Cooper committed a passed ball on the fourth ball of a walk to Stephens. McQuinn knocked in Stephens with his third hit of the game, a double into the right-field corner, pushing the Browns lead to 6-2. All 10 Browns runs in the World Series so far had been scored when there were two men out.

In the top of the eighth, Kramer allowed a single to Hopp then one out later a double to Walker Cooper, Hopp going to third. Luke Sewell came out to the mound to check on Kramer's condition. Red Hayworth assured Sewell that Kramer was fine. Sewell took his catcher's advice and left Kramer in. "Handsome Jack" responded to Sewell's confidence by striking out Ray Sanders and getting Whitey Kurowski to fly out. Kramer cruised through the ninth inning as the Browns won 6-2 and took a 2-1 series lead.

However, even years later Browns players lamented that they should have had a commanding 3-0 lead if not for the double error by Potter in Game Two, without which that game never would have gone into extra innings.

GAME FOUR

Another large crowd, 35,455, came out for the fourth game, which was good for the players because this was the last game in which they would get a portion of the gate receipts. All other proceeds were targeted for War Relief funds, as well as the commissioner's share.

Prior to Game One, Sig Jakucki complained of an abscessed tooth, he even had the swelling to go with it. There was a chance the tooth might have to be pulled but by the time Jakucki took the mound for Game Four he said there was no pain.

The Cardinals bats made up for the lack of pain in his tooth. Jakucki opened the contest by striking out Litwhiler, but Hopp chopped a pitch up the middle that Gutteridge was able to flag down but not make a play on.

Next up stepped Stan Musial. Jakucki liked to pitch batters low and that's where he sent his first pitch to Musial. Musial jumped on the fastball and parked it on top of the right-field pavilion roof for a two-run homer. That would be the only home run Musial hit in four World Series appearances spanning 23 games.

The Browns appeared to have closed the gap with one out in the bottom of the inning but Hopp raced to the wall and made an over-the-shoulder catch to rob Gene Moore of a sure double. Mike Kreevich, so sure that the ball was going to fall, had already rounded second base. Kreevich made it back to first safely as Hopp's momentum prevented him from getting off a throw but he was stranded there.

The Browns were robbed of another extra-base hit in the second inning, this time by Litwhiler on a deep fly ball to left by Chet Laabs. Following the out, McQuinn and Christman each singled—it marked the seventh straight time McQuinn reached base—however Red Hayworth hit into a broken-bat double play to end the inning.

In the top of the third with Litwhiler on first with two out, Musial and Cooper each singled, Litwhiler scoring on the hit by the Cardinals catcher. Jakucki got Sanders to ground to Gutteridge, but the Browns second baseman couldn't come up with the ball, Musial scoring on the error to make it 4-0 Cardinals. Jakucki didn't make it to the fourth inning, pulled for a pinch hitter in the bottom of the third.

The Browns never could get anything going against Cardinals starter Harry Brecheen, a onetime American Legion teammate of Bob Muncrief. The only run the Browns scored was on a double play hit by Chet Laabs that scored Gene Moore as the Cardinals tied the series with a 5-1 victory,

Brecheen tossing the first complete game for the Redbirds.

The *St. Louis Post-Dispatch* declared, "For the first time in the series [the Cardinals] showed the power, skill and spirit that led them to their early season lead."

GAME FIVE

Despite a temperature hovering around 64 degrees with a light wind, the chilliest condition so far in the five games, a series high 36,568 fans turned out at Sportsman's Park. The main attraction was a Game One rematch of Denny Galehouse and Mort Cooper. The two didn't disappoint. Umpire Ziggy Sears later said, "Both Cooper and Galehouse really had the stuff."

Neither pitcher allowed a run through the first five innings. With two out in the sixth, Ray Sanders, the Cardinals RBI leader in 1944, stepped up. Over 50 years later, Galehouse recalled the at-bat.

"Yeah, we were neck and neck for a long time," he said. "I got behind Ray Sanders three-nothing and I come in and got two strikes on him. But he hit the (next) one up and on the roof in right field for the first run."

Sanders' home run was the first allowed by Galehouse since August 6th, a span of 102 2/3 innings.

The Browns threatened against Mort Cooper in the bottom of the inning. Kreevich led off with a single but was forced out at second base when Cooper made a great play on a bunt by Moore. It turned out to be a big play because Stephens followed with a single that enabled Moore to move all the way to third. Cooper then walked McQuinn to load the bases.

Southworth came out of the dugout and held a conference with the Cooper brothers, pitcher Mort and catcher Walker. Whatever he said worked. Mort Cooper reared back and got both Al Zarilla and Mark Christman to take a called strike three (Zarilla thought his strike three was inside, giving the ump a look of disgust on the way back to the dugout, while Christman was bailing out of the batter's box on his called third strike).

Litwhiler, who was the only player to hit a ball over the double deck left-field bleachers at the Polo Grounds, which stood 505 feet from home plate, smashed a homer to center in the eighth, although Browns center fielder Mike Kreevich called the blast "wind aided."

It didn't matter because the Browns could hardly touch Mort Cooper—literally. Cooper ended with 12 strikeouts, one shy of the then World Series record, seven of those coming in

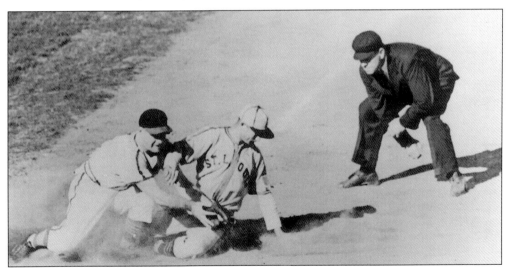

LAABS SLIDES. In game six, Chet Laabs slides in safely at third following a wild pitch in the sixth inning. But Laabs would be thrown out at the plate to end the Browns' last real good chance to score in the series. (NBH)

the final four innings as he blanked the Browns 2-0 to give the Cardinals a 3-2 edge in the series. In the ninth inning, Cooper struck out Milt Byrnes, Chet Laabs and Mike Chartak (Byrnes and Laabs went down looking, Chartak nearly spun himself in the ground swinging at his strike three), the first time three pinch hitters had ever struck out on consecutive at-bats in the World Series.

Galehouse nearly matched Cooper's performance, striking out ten.

"I got into real good shape at that time, was pitching regularly. And I had excellent stuff. I know some of the Cardinals said later on that, one guy was saying too highly, 'They told me he [Galehouse] wasn't very fast'," laughed Galehouse. "Meaning that they were surprised by the speed I had."

Cooper's strikeout trifecta in the ninth enabled the two starting pitchers to set a new World Series record by combining for 22 strikeouts. The old record was 21, set in 1905 by Ed Walsh (12) and Jack Pfiester (9) and again in 1929 by George Earnshaw (7), Lefty Grove (6), Pat Malone (5), Sheriff Blake (1) and Hal Carlson (2).

GAME SIX

Game Six was even colder than Game Five. There was a bit of a frost as temperatures hovered around 54 degrees, 16 degrees lower than the usual for the time of the year. Pitchers in the Browns bullpen huddled under blankets. The crowd of 31,360 was the smallest of the series.

Nelson Potter and Max Lanier faced off again, and this time Potter went back to his old habit of not shaving the day of a game in which he pitched.

The Browns were back to being the visiting team for this contest and they were retired in order in the first by Lanier. Potter did the same to the Cardinals in the bottom of the inning. With one out in the second, Chet Laabs walloped a triple to the wall in right-center, a 422-foot shot. George McQuinn then drove in his fifth run of the series by rapping a single up the middle. It was just the second time the Browns scored the first run in a game, the other time occurring in the first contest.

BROWNS' HANDSHAKES. Congratulations all around after the Browns beat the Cardinals 2–1 in game one. (SM)

The Browns put runners in scoring position in the third and fourth innings but couldn't score. With two out in the third, Kreevich doubled and Moore walked. But Lanier got Stephens to ground into a force out to end the inning. In the fourth, Laabs led off with a walk, was sacrificed to second by Moore then moved to third on a grounder to Verban by Christman. But Southworth intentionally walked Hayworth to get to Potter and the Brownie pitcher bounced out to second for the third out.

Potter hadn't allowed a run through three innings but did allow three singles. The Cardinals had back-to-back singles in the third with one out, but Potter struck out Litwhiler and Hopp.

Musial led off the fourth by flying out but Walker Cooper drew a base on balls. Sanders singled, sending Cooper to third. Kurowski grounded to Stephens who tried to turn a double play, but in his haste he threw away his toss to Gutteridge at second. Gutteridge was able to snare the ball but only by coming off the bag. The play allowed Cooper to score the tying run. Potter got Marion to foul out but Verban came through with a single to left field to score Sanders and put the Cardinals up 2-1. Lanier then singled to score Kurowski to make it 3-1. That was enough for Sewell, who took Potter out and replaced him with Bob Muncrief. Muncrief got the third out, but the damage was done. The Cardinals were up 3-1 heading to the fifth.

Lanier retired the Browns in order in the fifth while Muncrief allowed a single and a walk with two outs before getting Kurowski to fly out to end the inning.

In the sixth, Lanier got a little wild. With one out he walked both Laabs and McQuinn then with Christman up he uncorked a wild pitch which moved both runners up.

Southworth came out of the dugout and decided to bring in Ted Wilks, the Cardinals starter in Game Three who the Browns pounded, to face Christman in the middle of the at-bat. Christman was the best clutch hitter in the American League and had connected for an RBI single off Wilks earlier in the series, but on this occasion he hit a grounder to Kurowski at third. Laabs was off and running to the plate and Kurowski threw home. For some reason Laabs decided not to slide and he was thrown out. Wilks retired Hayworth on a fly to end the Browns threat.

The Browns didn't have another baserunner in the game. Wilks shut them down. The last hit by a Brown in a World Series had come in the third on Kreevich's double. Wilks retired all 11 batters he faced, striking out four including the final two batters, pinch hitters Milt Byrnes and Mike Chartak.

After Chartak swung and missed to end the game and the series, the celebration began. Verban, who knocked in the go-ahead run in the clinching game, made his way to the Browns box and to team president Donald Barnes. Verban's wife was given an obstructed view seat by the Browns and when Verban tried to have the ticket changed Barnes told Verban it was too late. Verban didn't forget that, going up to Barnes after the Cardinals victory exclaiming, "Now you can sit behind a post."

Cardinals owner Sam Breadon was able to breath a sigh of relief as well. The thought of losing the World Series to the crosstown Browns, once baseball's laughingstock, was not a pleasant one.

"If we had lost that one we'd have had to leave town," said a relieved Breadon after the Cardinals had won their fifth World Series title.

"We had a good ballclub, too, in '44 and they almost beat us. Although anything can happen in a short series, I'm glad it didn't," reminisced Marty Marion. "We would have left town [if the Browns had won the series]. Well, it would have been embarrassing to tell you the truth. They weren't highly regarded, but they were that year. They were the Cinderella club."

Fifteen records were set in the World Series and ten tied. Among the notable was that not one base was stolen. There wasn't even an attempt to steal a base during the six games.

The most impressive of the records were the strikeout totals. Cardinals pitchers posted 49 strikeouts, a record for a six-game series that wasn't tied until 1980 by the Philadelphia Phillies. The Browns' 49 strikeouts in the six-game series broke a 33-year old-record, 44 set by the New York Giants in 1911. The two teams combined for 92 strikeouts, the most by two teams in any length of series, a mark that has been topped since but only in a seven-game series.

The stark increase in strikeouts was largely due to the influx of fans at Sportsman's Park. "All season long we had nobody sitting in the center-field bleachers," explained Marion. "That particular series, they filled the stadium, they had customers sitting in the bleachers in center field and they're all (wearing) white shirts. And we had a heck of a time seeing the ball. And there were a lot of strikeouts in that series and not a great deal of hitting because the background was so bad."

One mark for futility that wasn't set was the Browns' .183 average. The 1911 Giants hit just .175 in a six-game series.

The total attendance for the six games was 206,708 earning $906,122 in gate receipts (the lowest total since 1939) plus $100,000 for broadcasting rights. The commissioner's cut of this was $68,826. War relief received $391,619.80 with the clubs and the leagues splitting the rest.

Each Cardinal player received $4,626, the lowest amount for a winning ballclub in 11 years. The Cardinals had shares of $6,192.50 when they won in 1942 and $4,321.96 when they lost in 1943.

The Browns handed out 29 full shares to 24 players, coaches Luke Sewell, Freddie Hofmann and Zack Taylor, trainer Bob Bauman and secretary Charles DeWitt. They also voted half shares for Steve Sundra, Tom Turner and Tom Hafey and gave a small cash award to Willis Hudlin plus other members of the Browns staff, including one-armed batting practice pitcher Orville Paul.

One source had the Browns earning $2,840 a share, another $2,744 a share. Either way it was the first time a losing World Series team took home less than $3,000 per man since 1920, when the Brooklyn Dodgers earned just $2,419 a share. Sewell had earned $3,019.86 in 1933 as a member of the losing Washington Senators ballclub. And each St. Louis Brown had to take at least 10 percent of his earnings in war bonds.

"By the time Uncle Sam got his share, we wound up with about $2,400 cash," Mark Christman once declared. "That was terrible, worst I ever saw."

The scuttlebutt among Browns players was that Sig Jakucki blew his entire series winnings before he even left St. Louis.

LAABS STRIKES OUT. Chet Laabs strikes out swinging in game one. The Browns whiffed 49 times in the series and the two teams combined for 92 strikeouts, both setting World Series records. (SM)

Twelve

Extra Innings
Gray Times and No More Next Years

Despite losing the World Series, 1944 was a successful year for the St. Louis Browns franchise.

Even though the Browns sold out Sportsman's Park just once during the regular season, the team drew 508,644 fans, the first time since 1924 the Browns had an attendance of over a half-million people. The Browns combined attendance from 1941 to '43 had been just 646,249. What makes the Browns' 1944 attendance more impressive is that fewer fans went to ballgames in '44 than they did in '41, when the Browns drew just 176,240 customers. Attendance around the majors in 1941 was 10 million; 8.8 million in 1942; 7.7 million in 1943 and 9 million in 1944.

The Browns rewarded their fans by winning 54 times in 77 tries at Sportsman's Park, a resounding .701 winning percentage, a major factor in them finishing in first.

Along with a newfound fan base was a string of praise from the baseball world, a rare occurrence in the history of the club.

The Associated Press named the Browns as the "comeback" of the year and the surprise team in all of sports. Leo Peterson of United Press chimed in with similar thoughts, labeling the Browns "baseball's Cinderella kids."

Current Biography heaped praise upon manager Luke Sewell, naming him as the key factor for the Browns success. They wrote: "'No man has ever did so much with so little' was the typical reaction to Sewell's 1944 team. His 'odd assortment of talent' consisted mainly of 'guys nobody heard of and nobody wanted.'"

While the Current Biography description of Browns players may have been a little strong, the overall belief was that luck carried a great deal of weight with the Browns winning the pennant, a view not shared by the players themselves.

"When you go in and out of first place four or five times in September like we did and still come back and win the pennant, I think that's proof enough that we were a good ballclub," stated Don Gutteridge.

And to top it all off, for the first time since 1922 the team made a profit, albeit a slight one.

Things were not all rosy, however. Despite the high fan turnout at home, the Browns still ranked just fifth in attendance in the American League.

Club officials thought that a winning ballclub wasn't enough for the team to draw fans, especially when competing against the St. Louis Cardinals, whose large popularity was sure to only rise with yet another World Series championship. They needed someone to get people to the ballpark. They thought they needed Pete Gray.

Gray was indeed a curiosity. Gray, whose birth name was Peter Wyshner, lost his right arm in a childhood accident. Despite having just one arm, and even because of it, Gray advanced through the minors and had numerous major league scouts follow him while he was with Memphis of the American Association in 1943.

On paper, Gray's statistics did stand out. He hit .333 with 21 doubles, nine triples and five home runs with Memphis. His 221 total bases was fourth in the league while his 119 runs were

three behind the leader. One thing Gray definitely had was speed. His 68 stolen bases tied the all-time league record set in 1928.

While Brooklyn and other teams had an interest in Gray, it was the Browns that ended up signing the one-armed outfielder. On September 29, 1944, the Browns announced they had signed Gray as well as teammate Ellis Kinder, a pitcher, from Memphis and left-handed pitcher Charles Johnson from San Diego.

The Browns paid $20,000 for Gray, which was much higher than the normal signing price for minor leaguers. The cost was even more inflated considering that Gray couldn't be considered a prospect. He was going to be 30 years old by the start of the 1945 season, although at the time of his signing it was announced that he was just 22.

It turns out that Gray wasn't much of a ballplayer. He was able to boost his average in the minors by bunting for hits - something he couldn't do as much of in the majors - and generally playing against a lower caliber of players. He also was a constant distraction to the Browns.

"Even though he was a miracle man in a lot of ways, he still couldn't do as good a job as a guy with two arms, let's face it, there's no question he cost us quite a few ballgames," George McQuinn told author Kit Crissey. "I'll be frank with you and say we did get to resent Gray being played over a player with two arms just to draw people into the ball park. We felt it was unfair to do that when we were trying to win a pennant."

Adding to the frustration was the apparent favoritism shown Gray by official scorers. Press clippings touted Gray as being proficient in catching fly balls with a glove on his left hand, then shifting the glove to under the his right arm pit (Gray had a slight stump where his right arm once was) and throwing the ball back to the infield in such a quick manner that baserunners dared not try to test his throwing ability. Whether or not that was true, Gray did have problems on non-fly balls hit to him.

"The trouble he had in the outfield - he was pretty quick - was on a low ball he had to stoop over and he couldn't keep his balance if it was at his knees," recalled former Detroit outfielder Jimmy Outlaw. "Like a low line drive, he had trouble with that one."

Resentment for Gray was rampant, especially when he was on the field.

"He screwed up the whole team," Ellis Clary said. "If he's playing, one of them two-armed guys is sitting in the dugout pissed off."

The player who saw his playing time dip the most

AL ZARILLA. By 1948, Al Zarilla was the only player left on the Browns roster who had been on the 1944 World Series club. Zarilla would be traded to the Red Sox in 1949. (SM)

was Mike Kreevich, the team's leading hitter in 1944. The sparkplug of the Browns offense late in the '44 season played sporadically in '45, the inactivity affecting his play. In 81 games with the Browns he hit just .237. Kreevich didn't want to be in St. Louis anymore and he was finally sold to Washington on waivers August 8, 1945. Playing regularly with the Senators, Kreevich hit .278.

"Having him on the team was a publicity stunt as much as anything," Kreevich later said.

The Browns finished in third place in 1945 with an 81-70 record, six games in back of pennant-winning Detroit. Gray played in 77 games hitting .218 with six doubles, two triples, 26 runs, 13 RBI and five steals. Even worse, he hadn't provided the attendance boost the club expected. The Browns drew 482,986 fans in 1945, 25,685 less than they had the previous season despite a 2.1 million increase in overall attendance in the major leagues.

Whether or not the Browns could have won the pennant if Gray wasn't on the roster is up to debate, but former Browns players believe the team should have won the American League flag in 1945.

"It's possible they would have (repeated in 1945)," said Denny Galehouse, who didn't play that season because of a military commitment. "There was a very disturbing influence in that Pete Gray was there, that one-armed guy, and he tended to hurt things, I think.

"They might have been able to do the same thing (as in 1944) but they got a little too complacent about things. And then the Pete Gray thing kind of interrupted the normal routine of things."

Said Babe Martin: "Nelson Potter, he said ... that the worst thing that happened to our ballclub in 1945, which we should have won the pennant, was Pete Gray. And honestly I think if we hadn't had Pete ... we could have won the pennant in 1945."

Players started to return from the military in 1945 and by 1946 there was a major infusion of past talent coming back to the game. As players returned, others had to leave. Several players who toiled during the war years, such as Ellis Clary, were farmed out and never reached the majors again.

By 1948, the Browns of 1944 were all but broken up. Only Al Zarilla remained on the Browns roster just four years after the team won the pennant. As in the pre-war years, Browns owners became strapped for money and had to sell off their best players. By the time Zarilla was dealt May 8, 1949, the numerous selling of players had already transformed the Browns from American League champions back into also-rans.

By 1953, it was more than apparent that St. Louis was not a two baseball team town. The Browns trudged through one more last-place campaign, the 11th and final time the franchise ended the season with the worst record in the American League, finishing with a 54-100 record. Bill Veeck sold the team and the club was moved to Baltimore where they were renamed the Orioles.

The Baltimore franchise quickly tried to sever itself from its St. Louis past. While several players made the move from St. Louis to Baltimore, an 18-player trade in the winter of 1954 helped erase the Browns identity. Even in today's Oriole media guides, despite the roots of the club, there is little mention of the Browns, any of their great players or the 1944 American League pennant.

In 1966, just 12 years after moving from St. Louis, the Baltimore Orioles did something the Browns could never do in their 52-year existence. They won the World Series.

Appendix
Statistics

Player	AVG	SLG	OBP	G	AB	H	2B	3B	HR	R	RBI	BB	K	SB	CS	FA
Floyd Baker	.175	.206	.259	44	97	17	3	0	0	10	5	11	5	2	0	.957
Milt Byrnes	.295	.393	.396	128	407	120	20	4	4	63	45	68	50	1	7	.976
Mike Chartak	.236	.333	.304	35	72	17	2	1	1	8	7	6	9	0	0	1.000
Mark Christman	.271	.353	.332	148	547	148	25	1	6	56	83	47	37	5	2	.972
Ellis Clary	.265	.327	.410	25	49	13	1	1	0	6	4	12	9	1	0	.978
Frank Demaree	.255	.294	.333	16	51	13	2	0	0	4	6	6	3	0	0	.969
Hal Epps	.177	.226	.338	22	62	11	1	1	0	15	3	14	14	0	1	.962
Don Gutteridge	.245	.342	.304	148	603	148	27	11	3	89	36	51	63	20	8	.957
Tom Hafey	.357	.500	.400	8	14	5	2	0	0	1	2	1	4	0	0	1.000
Red Hayworth	.223	.289	.222	89	239	60	11	1	1	20	25	10	13	0	0	.966
Mike Kreevich	.301	.405	.348	105	402	121	15	6	5	55	44	27	24	3	3	.986
Chet Laabs	.234	.378	.330	66	201	47	10	2	5	28	33	29	33	3	7	1.000
Frank Mancuso	.205	.262	.271	88	244	50	11	0	1	19	24	20	32	1	0	.953
Babe Martin	.750	1.000	.750	2	4	3	1	0	0	0	1	0	0	0	0	1.000
George McQuinn	.250	.376	.357	146	516	129	26	3	11	83	72	85	74	4	3	.994
Gene Moore	.238	.349	.282	110	390	93	13	6	6	56	58	24	37	0	0	.964
Len Schulte	—	—	1.000	1	0	0	0	0	0	0	0	1	0	0	0	—
Joe Schultz	.250	.250	.250	3	8	2	0	0	0	1	0	0	1	0	0	.818
Vern Stephens	.293	.462	.365	145	559	164	32	1	20	91	106	62	54	2	2	.954
Tom Turner	.320	.360	.370	15	25	8	1	0	0	2	4	2	5	0	0	.969
Al Zarilla	.299	.448	.375	100	288	86	13	6	6	43	45	29	33	1	1	.977

Pitcher	W	L	SV	PCT	ERA	G	GS	CG	SH	IP	H	BB	K	HRA	OBA	OOB	WHIP
George Caster	6	6	12	.500	2.44	42	0	0	0	81	91	33	46	5	.284	.351	13.8
Denny Galehouse	9	10	0	.474	3.12	24	19	6	2	153	162	44	80	6	.266	.316	12.2
Al Hollingsworth	5	7	1	.417	4.47	26	10	3	2	92.2	108	37	22	3	.291	.357	14.2
Willis Hudlin	0	1	0	.000	4.5	1	0	0	0	2	3	0	1	0	.300	.300	13.5
Sigmund Jakucki	13	9	3	.591	3.55	35	24	12	4	198	211	54	67	17	.268	.318	12.2
Jack Kramer	17	13	0	.567	2.49	33	31	18	1	257	233	75	124	3	.241	.297	10.8
Bob Muncrief	13	8	1	.619	3.08	33	27	12	3	219.1	216	50	88	11	.258	.302	11.0
Nelson Potter	19	7	0	.731	2.83	32	29	16	3	232	211	70	91	6	.244	.301	10.9
Tex Shirley	5	4	0	.556	4.15	23	11	2	1	80.1	59	64	35	4	.203	.348	13.9
Steve Sundra	2	0	0	1.00	1.42	3	3	2	0	19	15	4	1	1	.211	.253	9.0
Lefty West	0	0	0	.000	6.29	11	0	0	0	24.1	34	19	11	1	.366	.478	20.0
Sam Zoldak	0	0	0	.000	3.72	18	0	0	0	38.2	49	19	15	1	.310	.384	15.8